THE ART *of* KIM ANDERSON

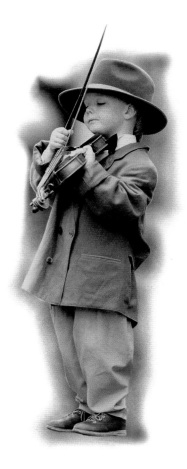

WORKMAN PUBLISHING · NEW YORK

"The Red Wheelbarrow" by William Carlos Williams,
from *Collected Poems: 1909–1939*, Volume I.
Copyright © 1938 by New Directions Publishing Corp.
Reprinted by permission of New Directions Publishing Corp.

Library of Congress Cataloging-in-Publication Data
Anderson, Kim.
The art of Kim Anderson / photographs by Kim Anderson.
 p. cm.
ISBN 0-7611-1062-3
1. Photography of children. 2. Children—Portraits. 3. Anderson, Kim. I. Title
TR681.C5A52 1999
98-18890779' .25092—dc21 CIP

Workman books are available at special discounts when purchased in bulk
for premiums and sales promotions as well as for fund-raising or educational use.
Special editions or book excerpts can also be created to specification.
For details, contact the Special Sales Director at the address below.

Workman Publishing
708 Broadway
New York, NY 10003-9555

Printed in the United States of America

First printing September 1999
10 9 8 7 6 5 4 3 2 1

For my children,
Nicola and Manuel

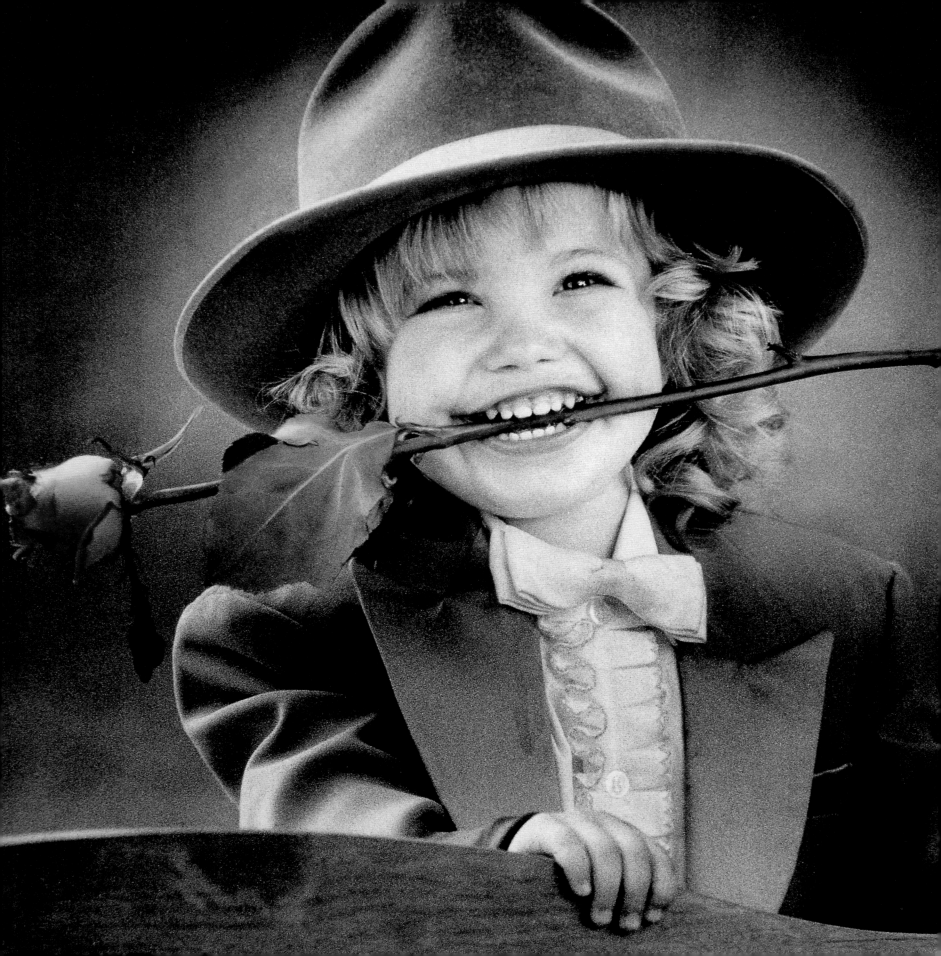

CONTENTS

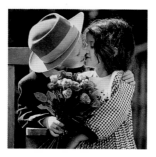
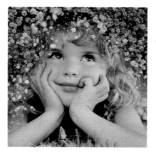
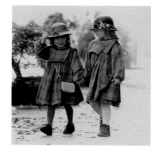
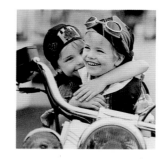
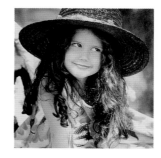
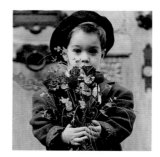

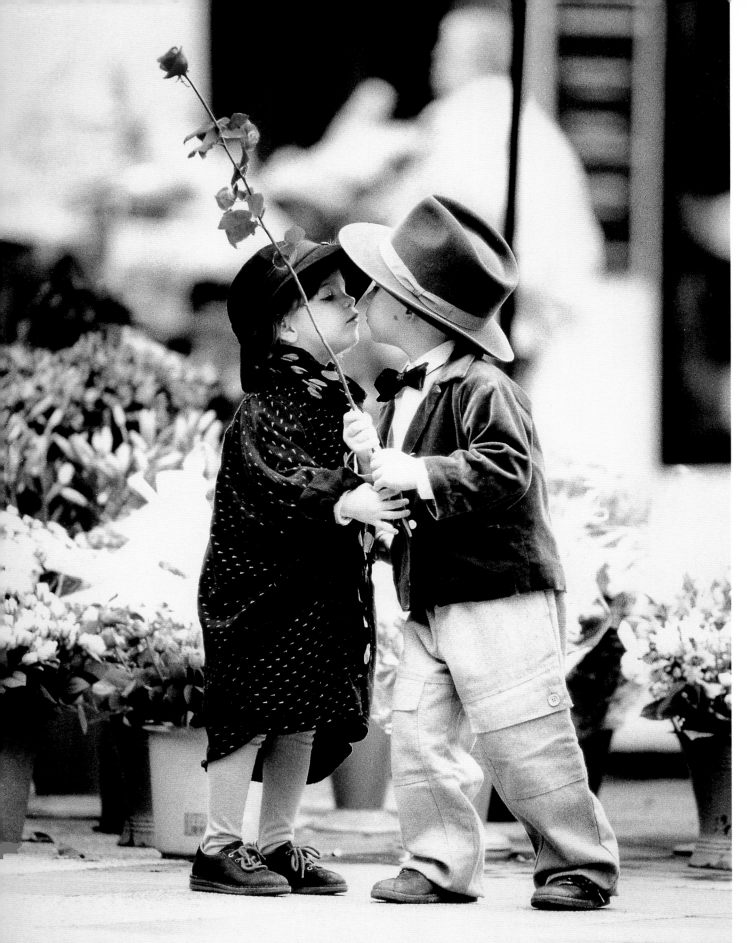

Budding
romance

FIRST LOVE

Essay by Phillip Lopate

To the child, Love is both real and a pretense: a necessity sometimes, a role at other times; instinctive, yet learned behavior. I see my little girl offering her hand to be kissed, in a very la-di-da manner. She is trying on the gallantries of love, just as she tries on the petulance of childhood. How quickly they master the social codes of love, hugs and kisses, and hearts—as quickly as they learn to manipulate the heartstrings by refusing such tokens. All around children, there are cultural signals, prompts to express and receive love: in fairy tales, it is the ultimate reward for being discovered as who you really are, the beauty under the cinders, the prince beneath the frog. In advertisements, every product is sold with the promise that its purchase will bring or enhance true love.

At the same time that these diaphanous romantic feelings are being planted, there is the hot, urgent need of the child to be listened to, have needs attended to, right away. "Mommy I need a pair of scissors *ANTZ* is coming out on videotape I'm hungry I pooped in my pants change me no stupid daddy not that kind of crayon the other kind!" All demands are on the same plane of importance, and worthy of tears. The child does not prioritize but asks only to be obeyed, pronto—with all due respect to the "magic words" please and thank you, those road-bump nuisances placed by parents,

who are slow-witted and don't understand that they are your servants. It's frustrating sometimes that they won't acknowledge it; they do so much for you as it is, why won't they just come clean and admit they are your abject slaves? And in return you love them, distractedly, wholeheartedly, ambivalently ("I hate you Mommy! I'll never kiss you again for the rest of my life!"), and in the best possible way, organically, like a heliotropic plant.

So your first love as a child is for your parents. The thermodynamic model seems to be: love in, love out. If the parents' love has been expressed cleanly, without mixed messages or scary anger or abandonment (it almost never is, the psychologists tell us), the child will grow up into a serene, unconflicted adult; and if there are complications (there almost always are), the child will probably grow up to have "unresolved issues." But some confusion is inevitable: before you even reach kindergarten, you may very well have conceived the idea of marrying one of your parents later on (and why not?—he/she is so conveniently present, so attractively devoted to your needs); and you may have experienced jealous annoyance at their displays of affection to each other. As my four-year-old daughter Lily said to me this morning, when I had the nerve to kiss her mother in front of her, "That was the longest, rudest kiss I ever saw!"

My daughter went through a quandary around the time she turned three. Who should she marry? she began to fret. I was an early candidate, I am happy to say. She enjoyed slow-dancing with me to Ella Fitzgerald and got a dreamy look in her eyes when I held her aloft in my arms. But she accepted (all too sanguinely, it seemed to me) the information that she could not marry her daddy because it just wasn't done.

So her attention turned to other suitors. Her principal beau was the boy next door, Dominick. This kid is a lout. He barely speaks except to grunt, he is fixated on trucks, he regularly gets into trouble at play school for fighting. I tell you frankly, he is beneath my daughter in intelligence and deportment. Yet she professes to love him and plans to marry him. She tells me he will not always be so wild, he will make a good man when he grows up. He seems to possess that masculine *je ne sais quoi,* that essence of machismo that even four-year-old girls are attuned to. I try to interest her in the more intellectual boys in her circle, but she pays them no mind. I will say this for young Dominick: he does seem to behave better around Lily, and, in his own way, appears fond of her. Still, I wonder how to protect her from the pain of unrequited love.

The other day, Lily wanted to go to the neighborhood park because she thought Dominick might be there. "He loves the park, almost as much as he loves me," she said confidently. When we finally caught up with him, he seemed, from my vantage point, to ignore her—tearing back and forth on his bike, while she pretended he was chasing her. When she got tired of running from his approach, she sat on a bench and watched him. She was in no way put off by his self-absorption; rather, she seemed able to weave his mere presence into her ongoing fantasy that he is crazy about her.

When she first began asking "Who should I marry?" I was not the only one to tell her the question might be a little premature. Our assurances did nothing to quell her sense of urgency. Obviously she had reached a developmental stage in her own mind when the act of deciding about something big—the choice of a life partner—had to be undertaken, at least in practice. I knew where some of the romantic suspense was coming from. She had chronically watched five different versions of *Cinderella* on tape,

from Betty Boop to Brandy, then had graduated to obsessions with *The Sound of Music,* *Funny Face, Gigi,* and *My Fair Lady*. One day, she remarked, like a precocious narratologist, "You know, they're all the same story." It was true: in each variation, a lowly girl had been plucked from the chorus, so to speak, to marry the top man.

A few other candidates for Lily's hand had to be evaluated. Lily's great-uncle Reuben regularly proposed that they run away and get married, but he was over seventy and had a hearing aid; and besides, there was Aunt Florence, his wife of forty-five years, to consider. Then her pediatrician, Doctor Monti, expressed interest, but he was always so busy. No, it would have to be Dominick. Now that that dilemma was settled, Lily began mulling over her wedding gown, tiara, pumps, jewels, boa, tutu. Wedding announcements would have to be sent out, ribbon bows tied, handwriting of name practiced. She began to tell everyone who came to visit: "I have a boyfriend named Dominick and we're going to get married."

Did this mean that she was infatuated with Dominick? On the contrary, during this time she had little contact with the actual boy, nor did she seem to want more. Meanwhile, I witnessed her daily eruption of intense feelings for another love object altogether: her cat, Newman. She could not get enough of catching him, snuggling with him, holding him captive by the paws, tying kerchiefs on his head, strapping blankets to his body, tormenting him in every possible fashion, and sobbing when he ran away. Here, I thought, was the real thing: love without the romantic gauze, but with the cruelty and appetite of attraction that one sees in film noir. She would kill for him—or kill him! How often my wife and I have had to intervene to protect the creature, removing from his neck harnesses and cravats that could have easily turned into nooses. Yet he always comes back

to her, like the poor sap Glenn Ford used to play in those films noir, for more punishment. He craves her attention; and she, in turn, relates to him fearlessly, accepting whatever scratches may come her way.

Lily loves Newman in a deep, passionate manner. It is like a cross between her instinctual, inadvertent love for her parents and her elective affinity for the little boyfriend next door. Though the Abyssinian has been with her all her life, her feelings have increasingly focused on and matured toward him: she talks to him regularly as though he were her child, her honey, her one and only. The problem is that Newman is twenty years old—ancient by cat standards. Already he is arthritic, cataracted, and worrisomely skinny. He sleeps for much of the day, curled up in a ball, until Lily comes around to prod him into motion. As parents, we can try to protect our child from viciousness and harm, but not from the con- 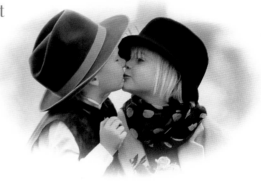 sequences of tender attachment. We shudder to think of what will happen when he dies. Then she will really know the sorrow that is so often inextricable from first love.

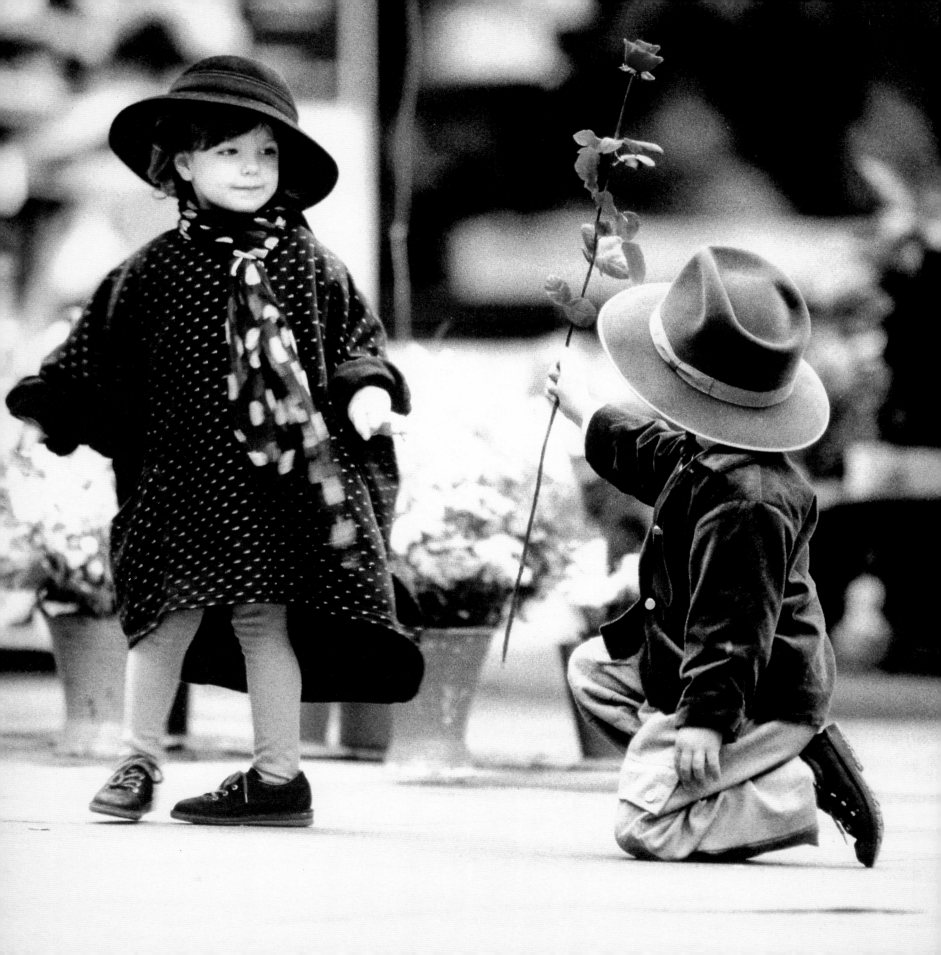

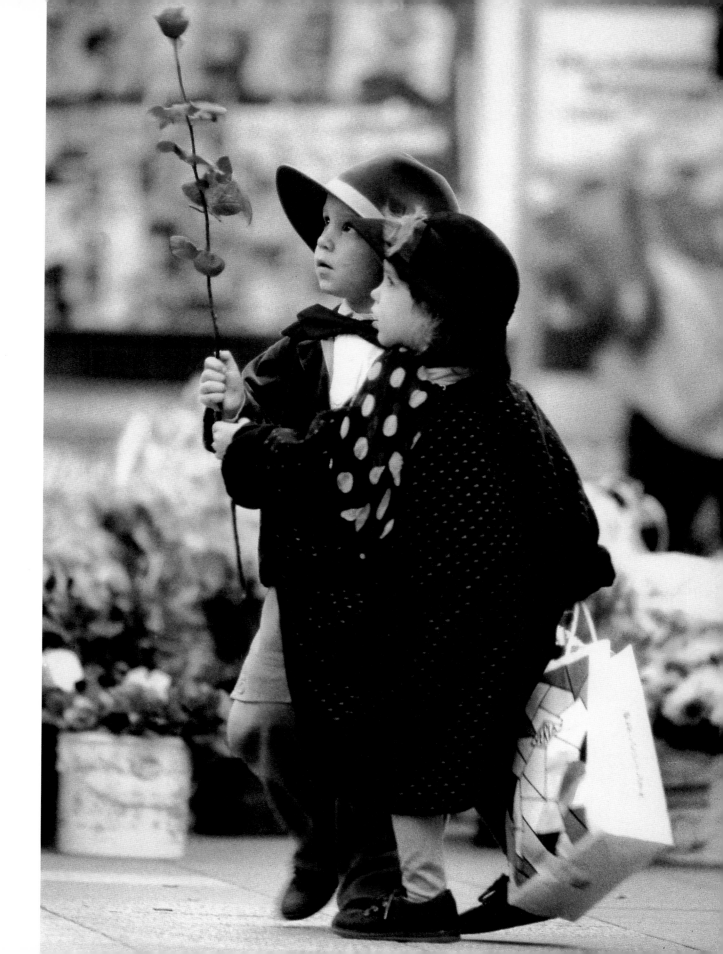

Modest proposal

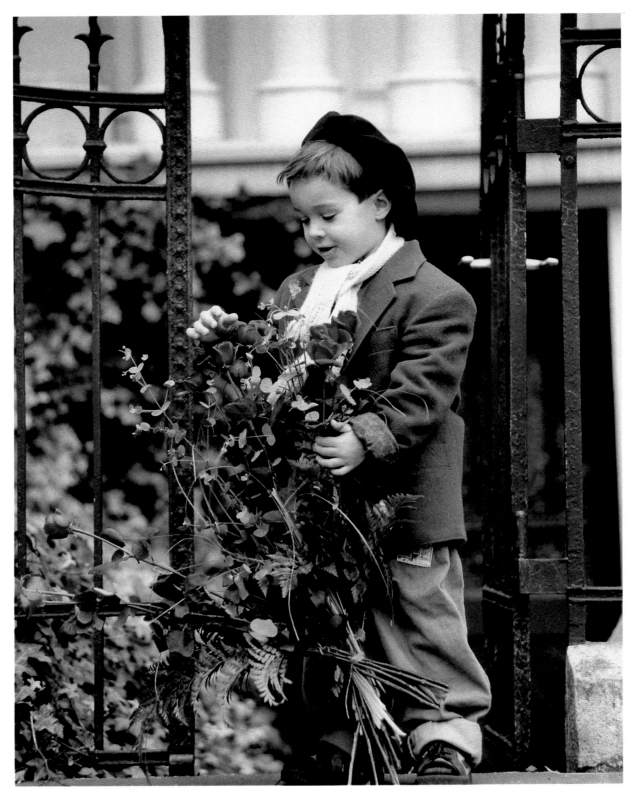

*Between
you, me,
and the
gatepost*

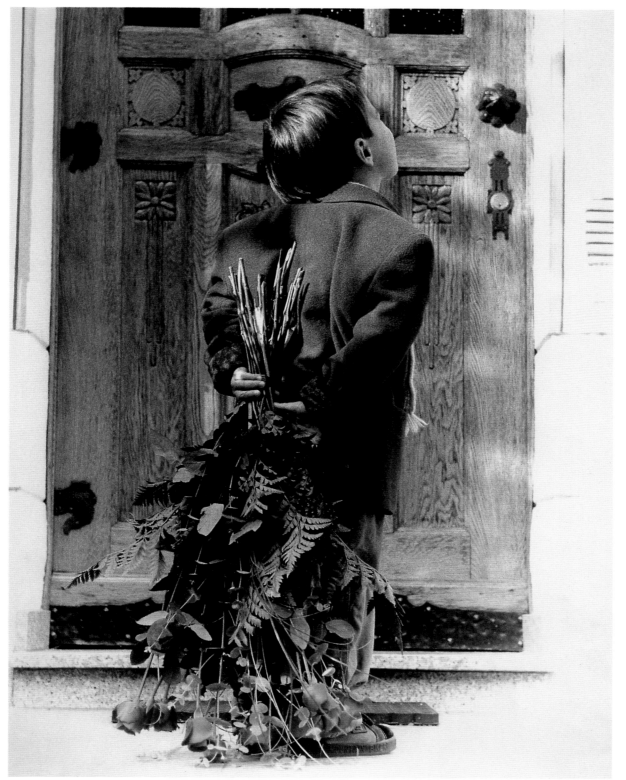

*Gentleman
caller*

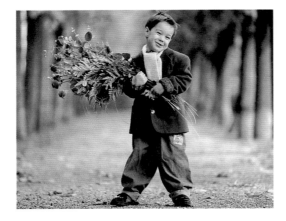

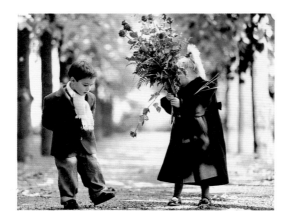

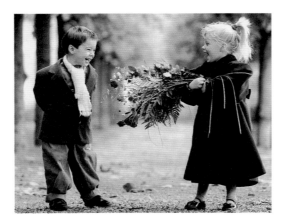

"O that the beautiful time of young love
Could remain green forever."

—Schiller

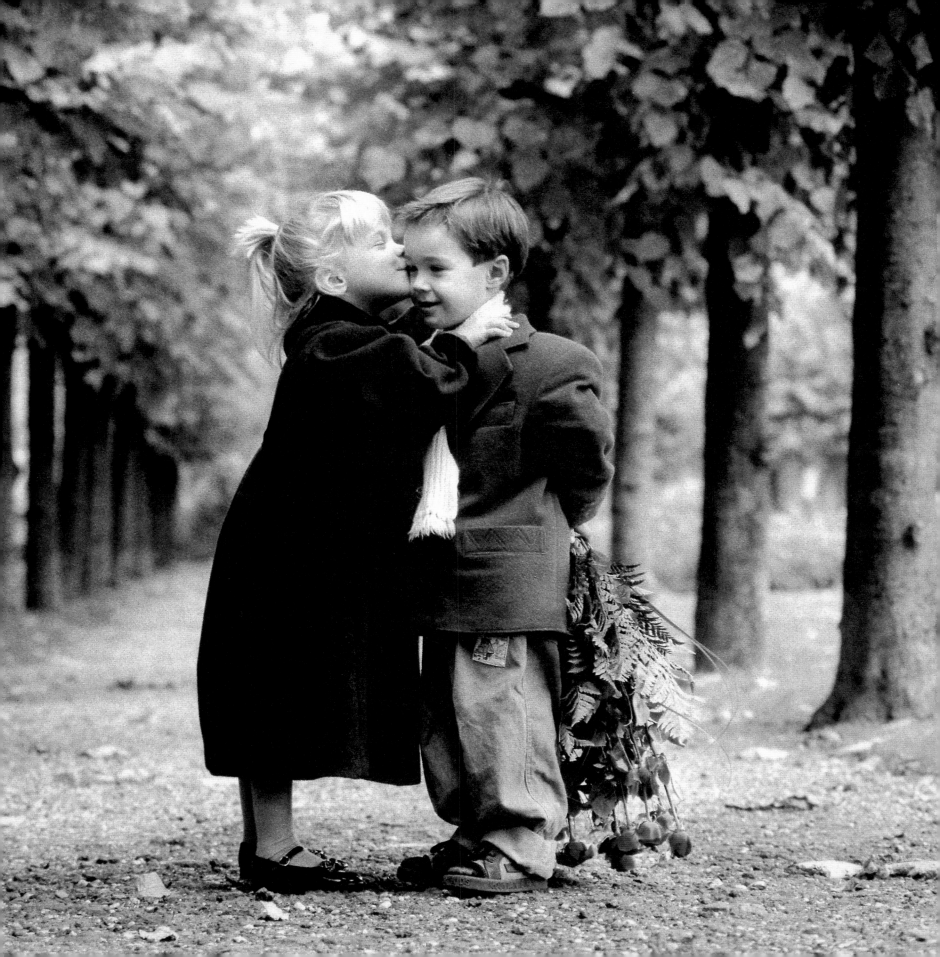

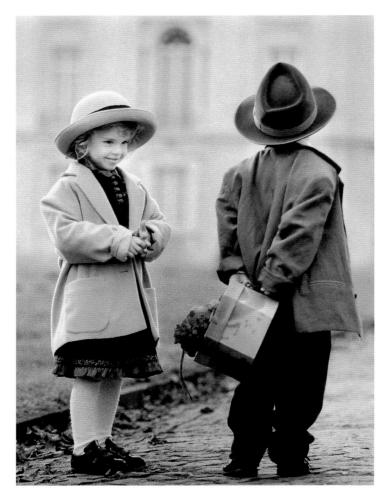 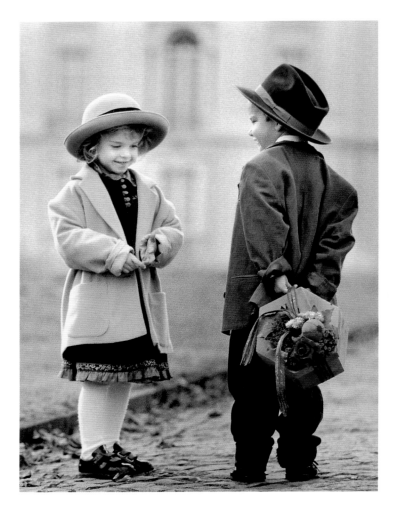

Which hand?

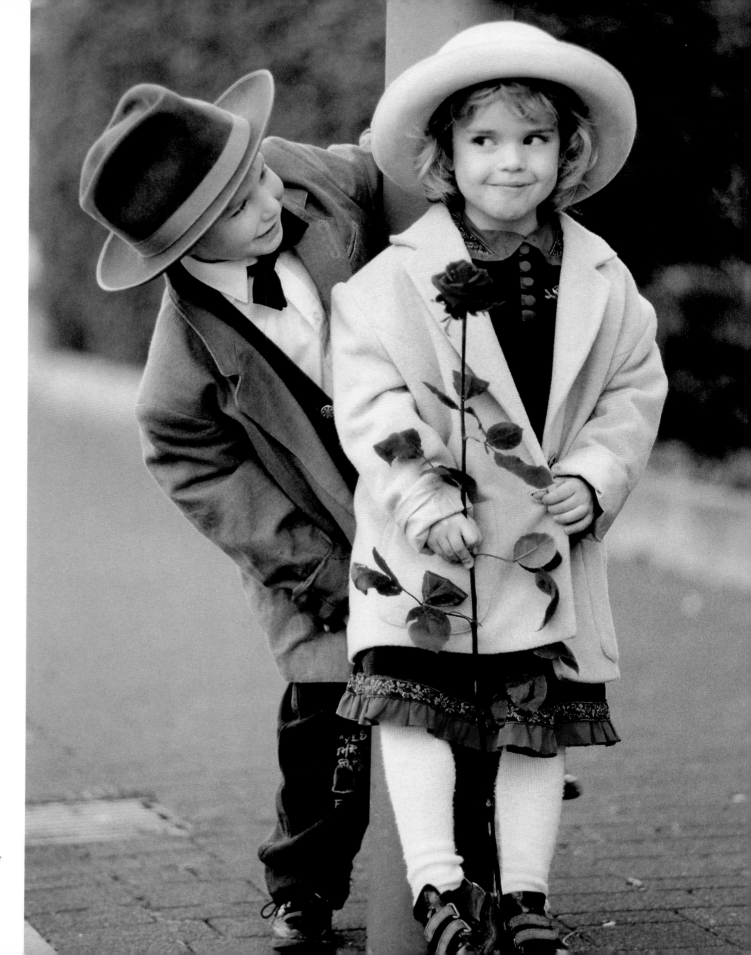

Sweet surprise

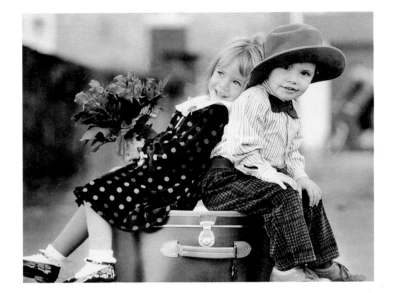

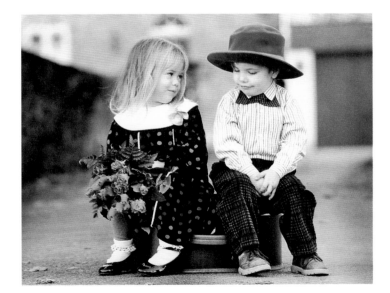

Soul mates

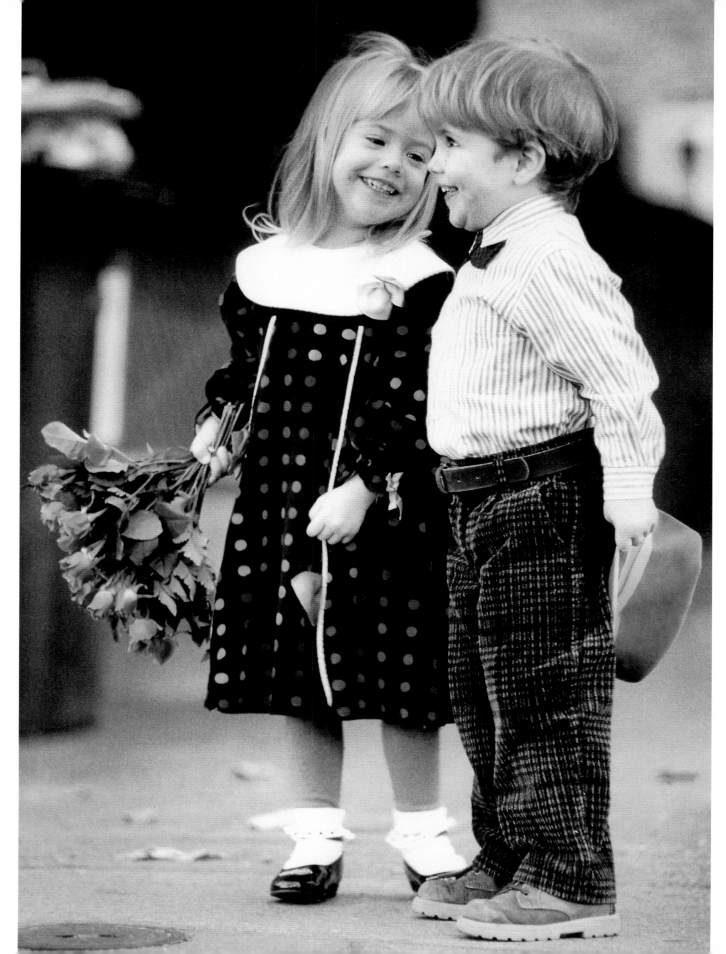

Tickled pink

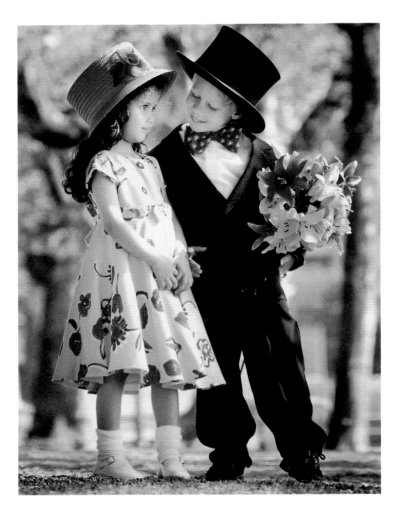 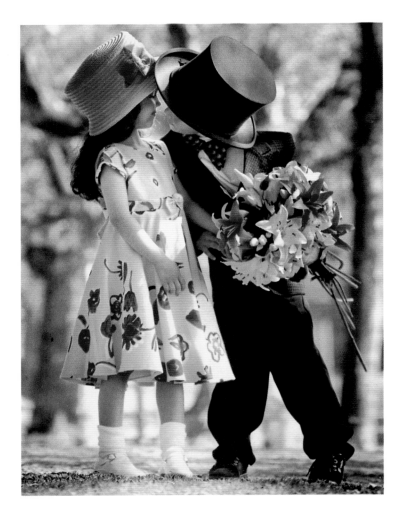

Stolen kisses

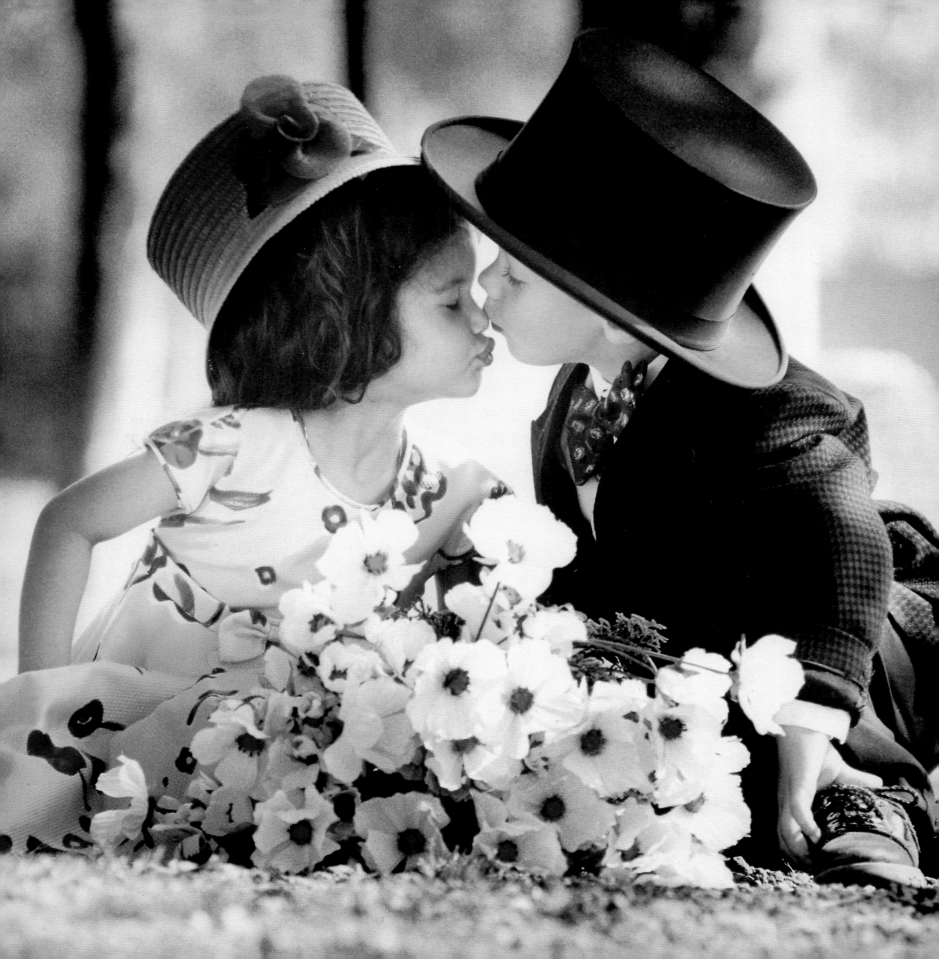

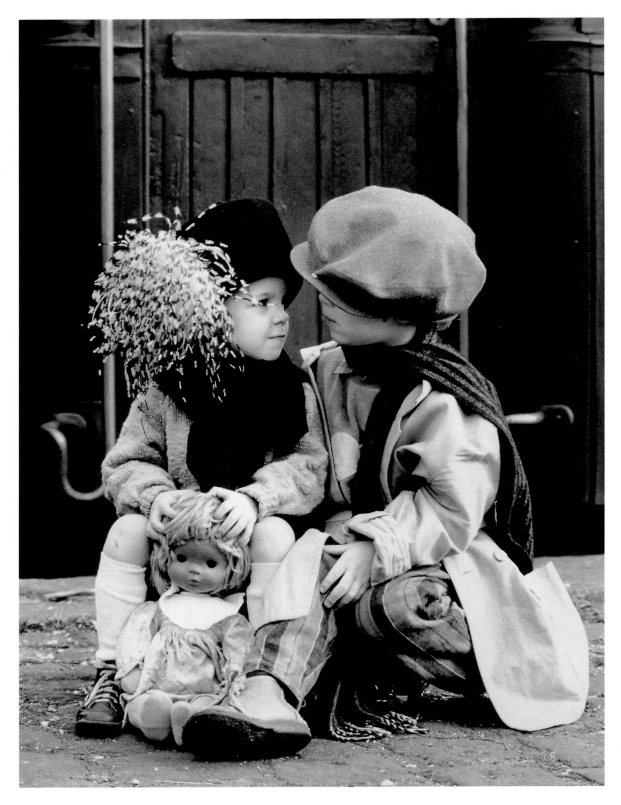

"There is always one moment in childhood when the door opens and lets the future in."
—Graham Greene

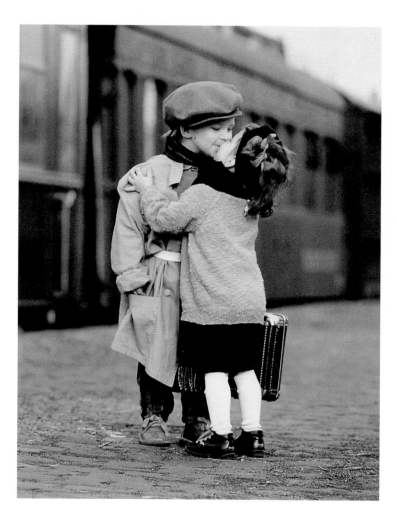

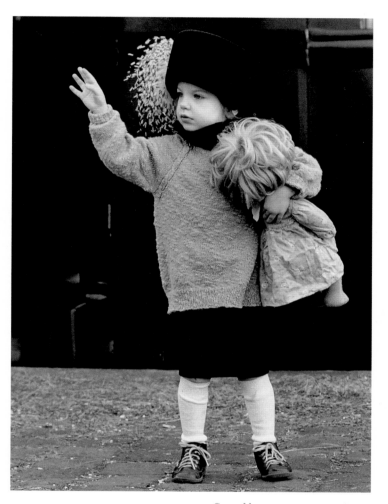

Goodbye, sweet prince

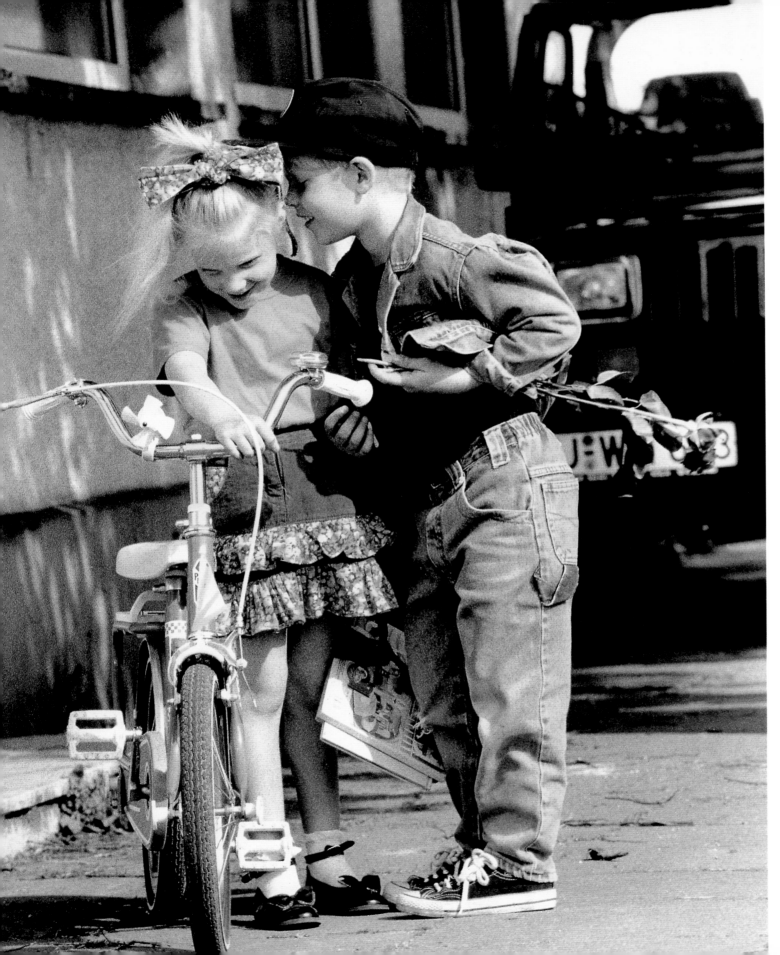

Sweet
nothings

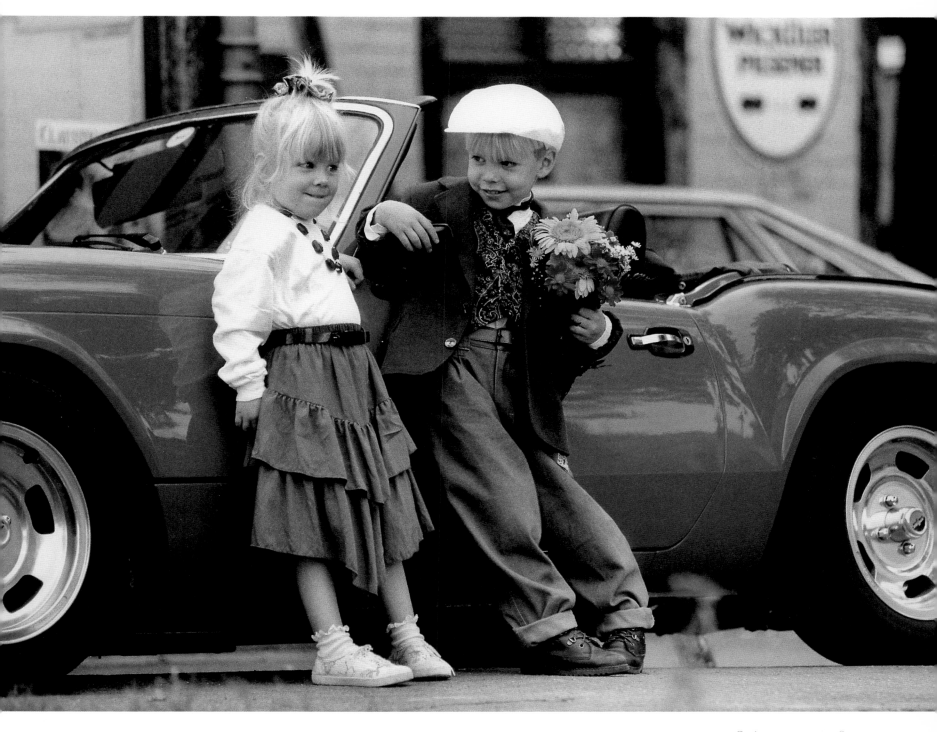

Going my way?

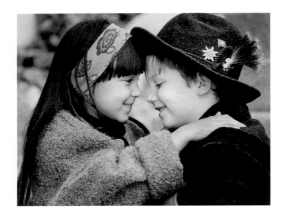

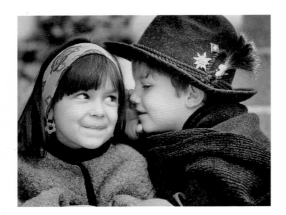

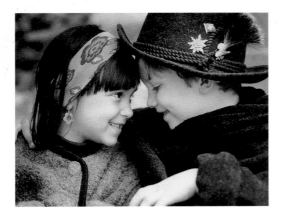

Tête à tête

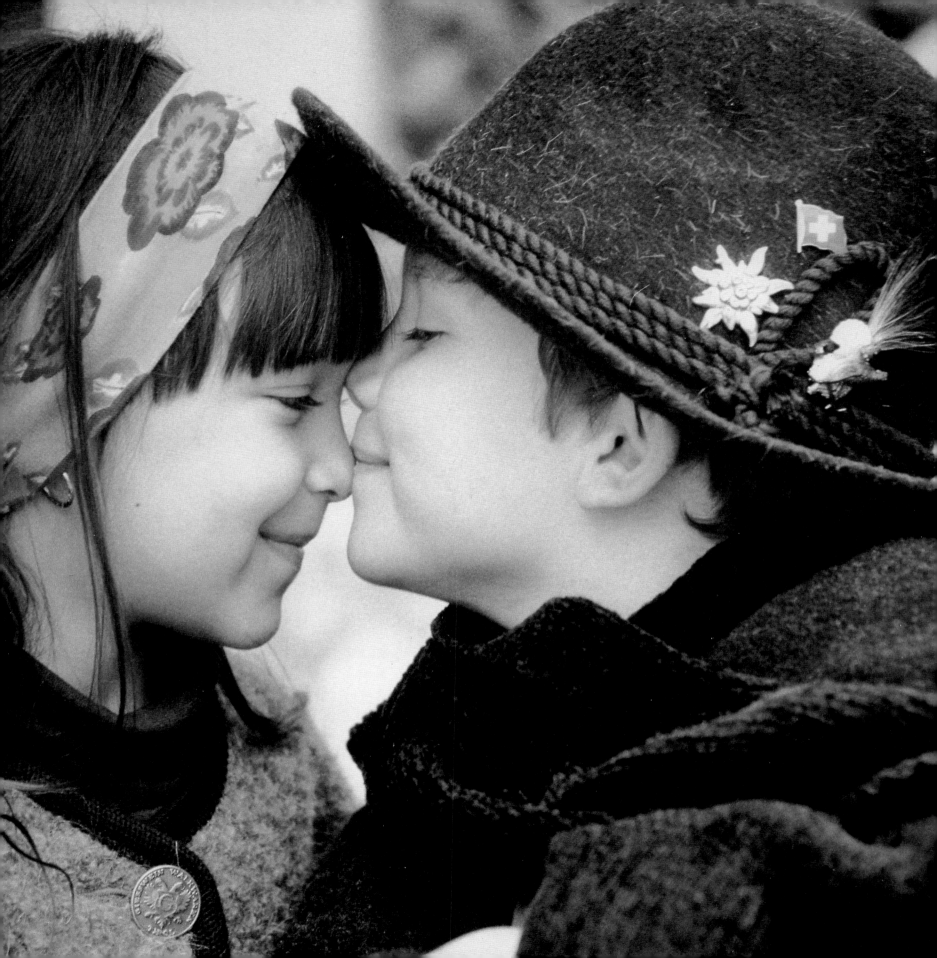

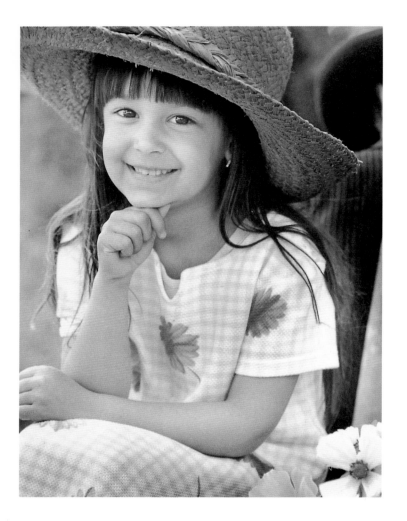
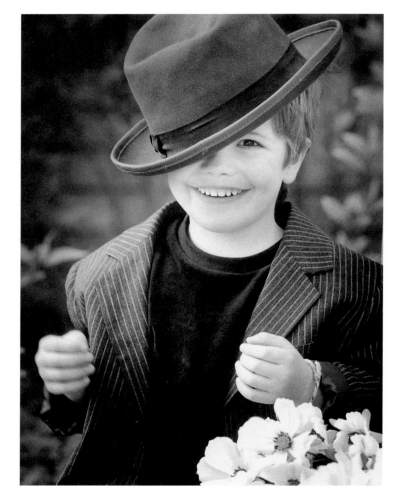

Loves me, loves me not . . .

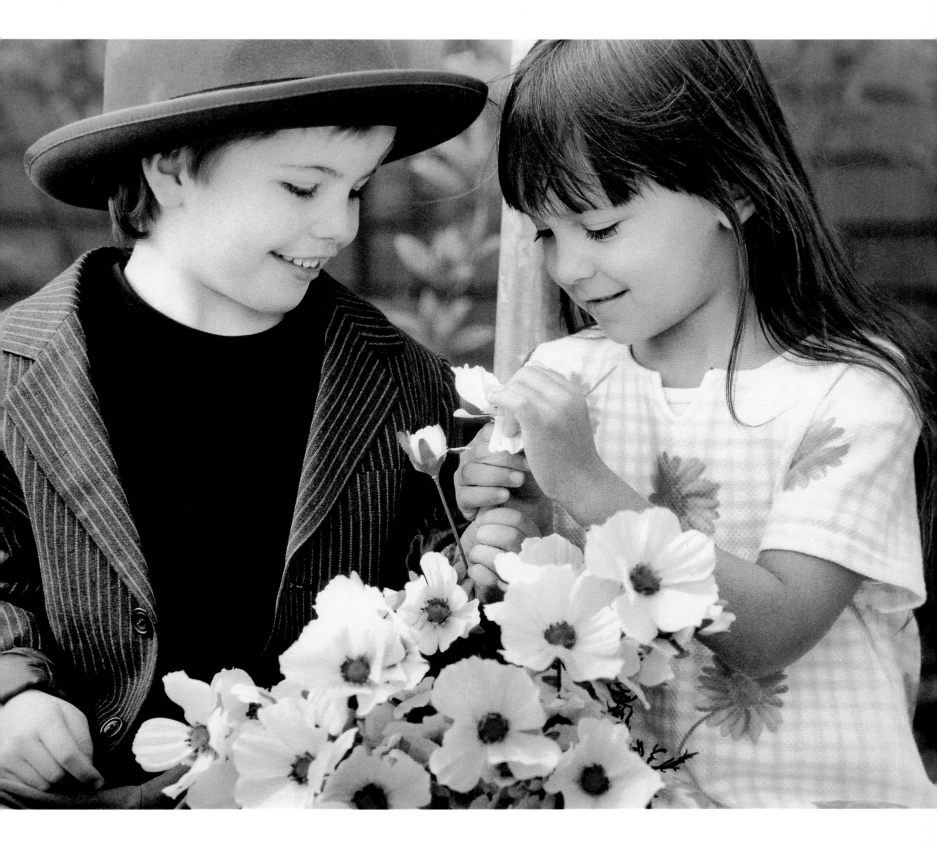

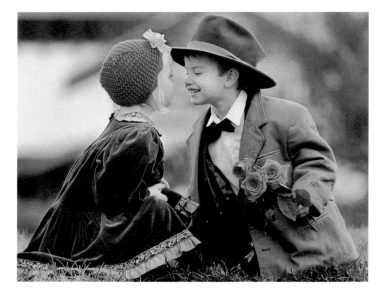

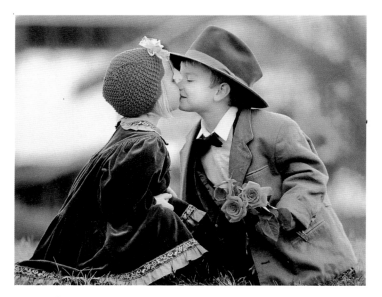

First kiss

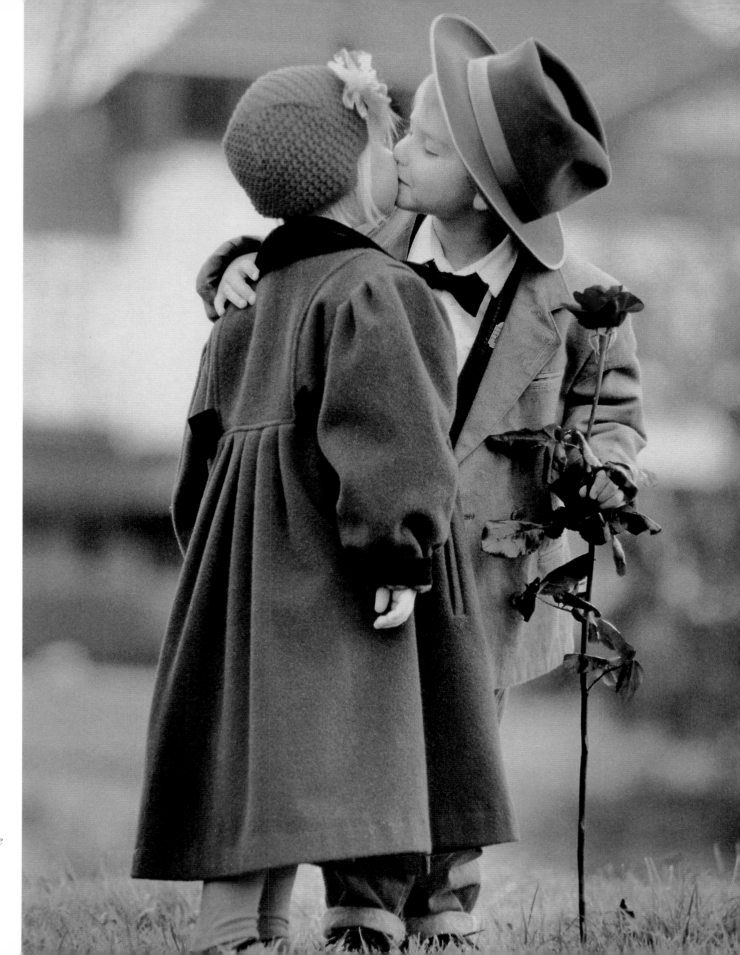

The romance
of the rose

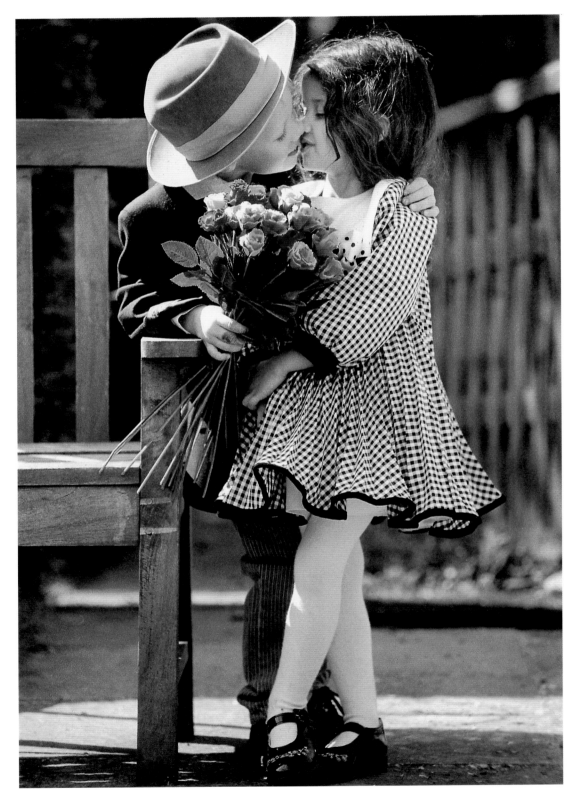

*A young
man's fancy*

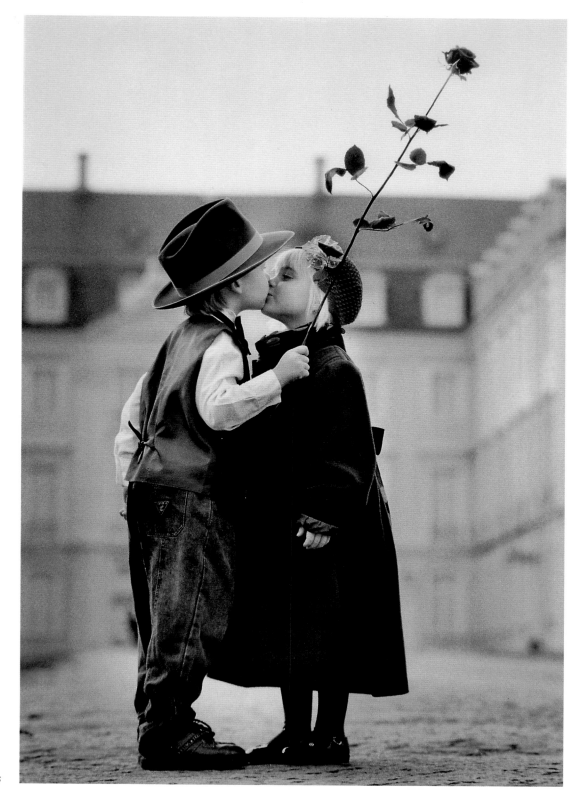

*Love
blossoms*

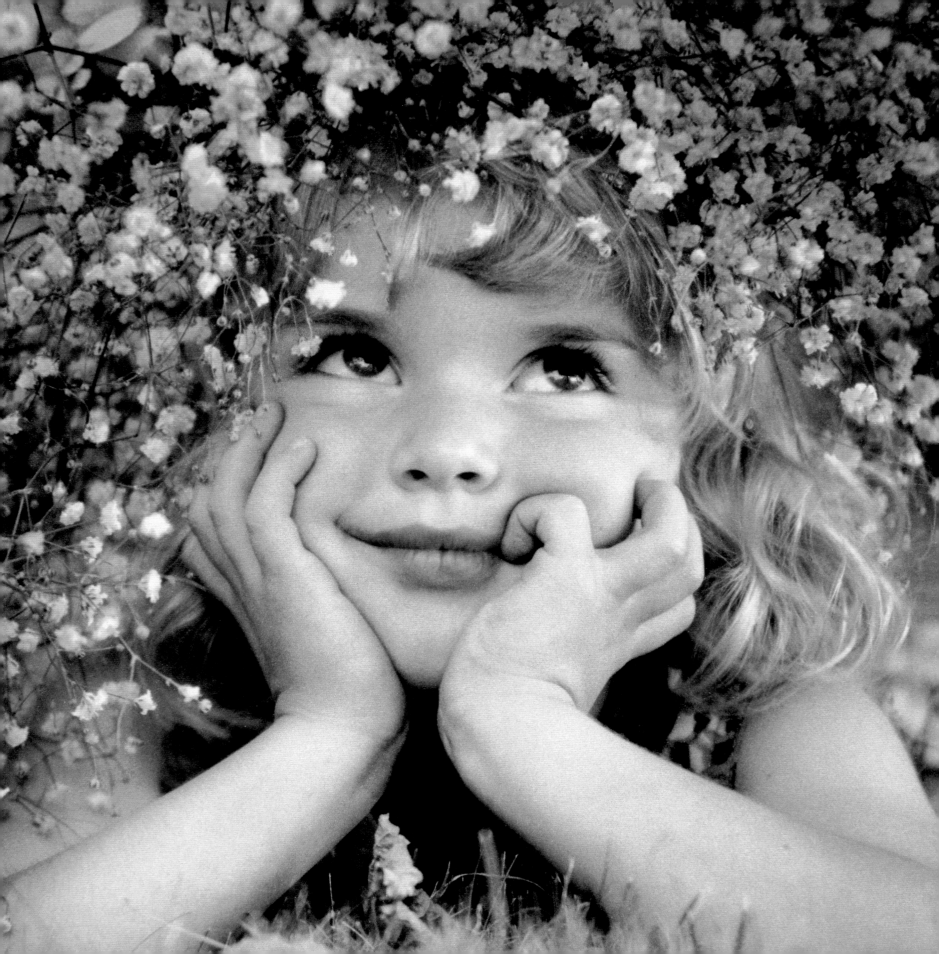

THOUGHTS

Essay by Patricia Hampl

"What were you *thinking?*" My mother glowed with outrage. She held the evidence: a narrow red leather book of poems, one of her few treasures, which I had just finished attending to with a leaky ballpoint. Blue ink looped and clotted its way from page to gilt-edged page. I had circled the columns of each poem's stanzas. The broad margins of the pages were festooned with stars and suns, flocks of V-shapes (ducks in formation), sharp-petaled tulips, dogs with alarming tails, and—my greatest conception—a cat crouched on the final page with peaked ears and very wise whiskers.

Essentially, it was a deeply thoughtless business. But looking back, I realize it was not simply a whim that drove me to what my mother saw as desecration. I wanted to make contact, to communicate with those luscious cream pages and, especially, with the black markings I understood were words but which refused to yield to me in any way. I was not quite five, and I resented the fact that I couldn't read. Everyone else in the family could. My pure motive, as I see it now, was to insinuate myself on those pages, to inscribe my thoughts—visual as they still had to be—next to what I knew were someone else's thoughts stacked atop each other in tidy black rows.

What *was* I thinking? Ah, Mother, it was the effortless float of the mind over sensation,

making this, making that—making sense (also nonsense)—the ballpoint trailing the drift of the mind on the page. The cottage industry of thought had begun—how the dog's tail, ticking back and forth, looks *sharp,* how the tulip is a cup with spiked sides, and the cat is nobody's fool. Once they existed as objects in my mind, these images had to be conveyed.

It was worth the punishment.

Later, there was another red leather book. This one was mine—and I was *supposed* to mark in it any way I liked. My first diary, a gift for my tenth birthday. It was outfitted with a lock and a tiny key, which my brother had no trouble finding in my sock drawer where I carefully hid it. He read my first entries shamelessly and laughed himself silly.

No wonder. Somewhere between the wayward blue ballpoint careening over the pages of my mother's book of poems when I was four and my uncertain sentences in the little red diary when I was ten, I had lost the exuberance of thought. What on earth was I supposed to write about? What was there to say, to think about any given day? "Went to school today. Had dinner at home, hamburgers and mashed potatoes." I crossed out "potatoes" and wrote in "spuds"—a word I'd heard my uncle use. If we ate "spuds" instead of "potatoes," maybe that made them more interesting?

How strange: now that I was invited to have thoughts, to write them down (it was my mother, the injured party of the earlier red book episode, who had given me the little diary), I had nothing in my barren mind at all, it seemed. I was consigned to a lifetime of recounting dinner menus.

In spite of this strange childish writer's block, I loved words already, the sound of them and the stories they brought, my mother reeling out *Charlotte's Web* one summer on

the dock by the side of the lake, tears streaming down my cheeks for the death of a spider. Words did that! And words, I knew, were where thoughts lived.

Thoughts are our most private possessions, unreal estate we cleave to like a native patch of earth, no matter how barren or fugitive the landscape appears to an outsider's cold eye. The inner life, seething with private thoughts, is a diva's life. But these intensely private thoughts resist the public arena of language.

The thoughts of childhood have an especially fateful fascination. This is where the habit of framing sensation began. It is our ancestral home. Here, we can't help believing, is the key to it all—if only we could get back to it. If making thoughts is such an idiosyncratic occupation, then surely the pattern of our peculiar attempts to make sense (or simply to make *something*) starts here, in the filmy moments of waking consciousness. We go back in memory to retrieve that early mental territory that we have forfeited over the years to the colonizing intelligence of adulthood. We trust instinctively what we find there. The archive of our thoughts is not only our truth; it is our integrity.

The earliest thought is the holy grail of memory. We seek it like the lost sacred thing it is. Childhood is the source, we all seem to know, of this human habit of thinking—and creating—our way through time.

In an autobiographical sketch Virginia Woolf wrote privately, just to amuse her friends, she, too, turns instinctively to her earliest memories. She is looking for that first instant of consciousness. Her first memory, she says, had been "of red and purple flowers on a black background—my mother's dress."

But before she has gazed at this floral pattern an instant in memory, she is drawn down another shadowy corridor of the mind. The *real* first apprehension of thought, she decides, is "of lying half asleep, half awake, in bed in the nursery at St. Ives. It is of hearing the waves breaking, one, two, one two. . . . It is of hearing the blind draw its little acorn across the floor as the wind blew the blind out. It is of lying and hearing this splash and seeing this light, and feeling, it is almost impossible that I should be here; of feeling the purest ecstasy I can conceive."

The rapture is real. It is a child's transcendence, but it lasts a lifetime. The bliss is the delight the mind feels in perceiving and rendering these sensations into the shapes we call thoughts. I cannot experience "myself," I can only experience the world passing through me. I think, therefore I am . . . me!

Thoughts—those ingenious containers of sensation and meaning—are where the self and the overwhelming world approach each other and cohere for a wavering moment. The world agrees to humble itself for an instant, to have its picture taken. Our camera keeps snapping and snapping the world. We can't get enough of it—that's how a self is made.

I am talking to my granddaughter Lucy. She is four—"four and a half," she says, already a detail person. I tell her I am writing about the thoughts of children. What should I say? "Birds," she says without hesitation. "Tell about birds. They're part of the environment."

We are at a supermarket in Austin, Texas. I offer to buy her a doughnut. "I'd rather have an *empanada*," she says cheerfully, at home in the great globe of foreignness.

Her world is opening wide, wide. It's already bigger, more inclusive than mine. When did I first understand the concept "the environment?" Sometime after college,

certainly. She gives me a bite of her *empanada* so I'll know what it tastes like. "Good?" she asks, glad to introduce me to the larger world, hoping I will like it as she does.

But we start thinking in the same place, she and I. We belong to the poet's tribe. We subscribe to William Carlos Williams's famous manifesto: "No ideas but in things." That's because, as he says in that small, mighty poem,

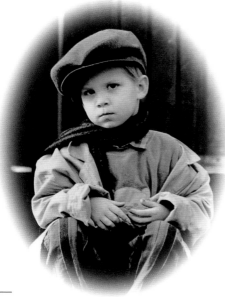

> *so much depends*
> *upon*
> *a red wheel*
> *barrow*
> *glazed with rain*
> *water*
> *beside the white*
> *chickens*

Our thoughts begin with birds, with jagged stars and lopsided suns, with a cat's wise whiskers. An *empanada* is a concept, and the birds, after all, are part of what we're part of— "the environment." Abstract concepts must have colors and feathers to matter. A thought, a child knows, must have a pulse.

Thoughts begin in sensation. But they reach, like birds, for the flight of the mind. As Lucy is saying now, "The thing about thoughts—when you have them, you aren't lonely."

"Thoughts are friends?" I ask, nudging the idea forward.

"Sort of," she says vaguely, not signing up for this package deal. Hopping away from me, with her *empanada,* a mind of her own.

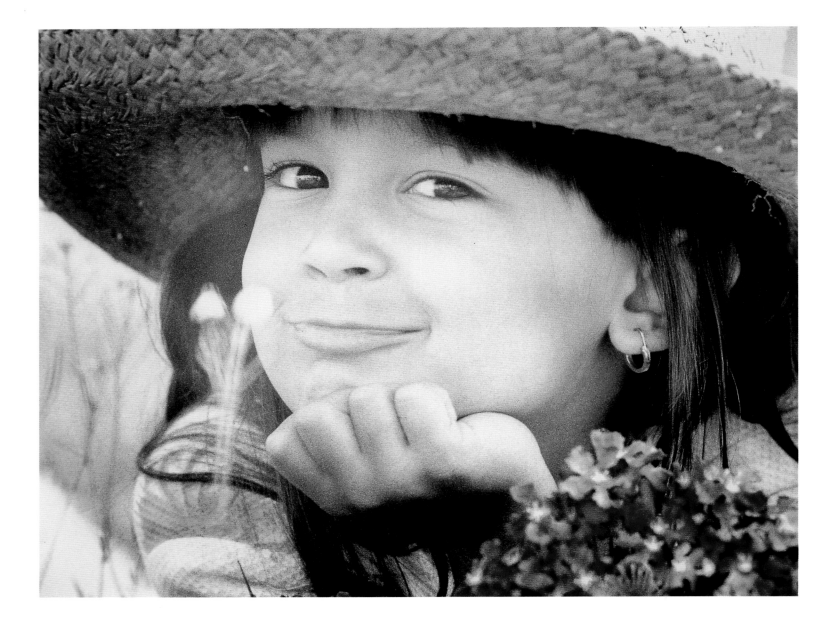

A wish is a dream the heart makes

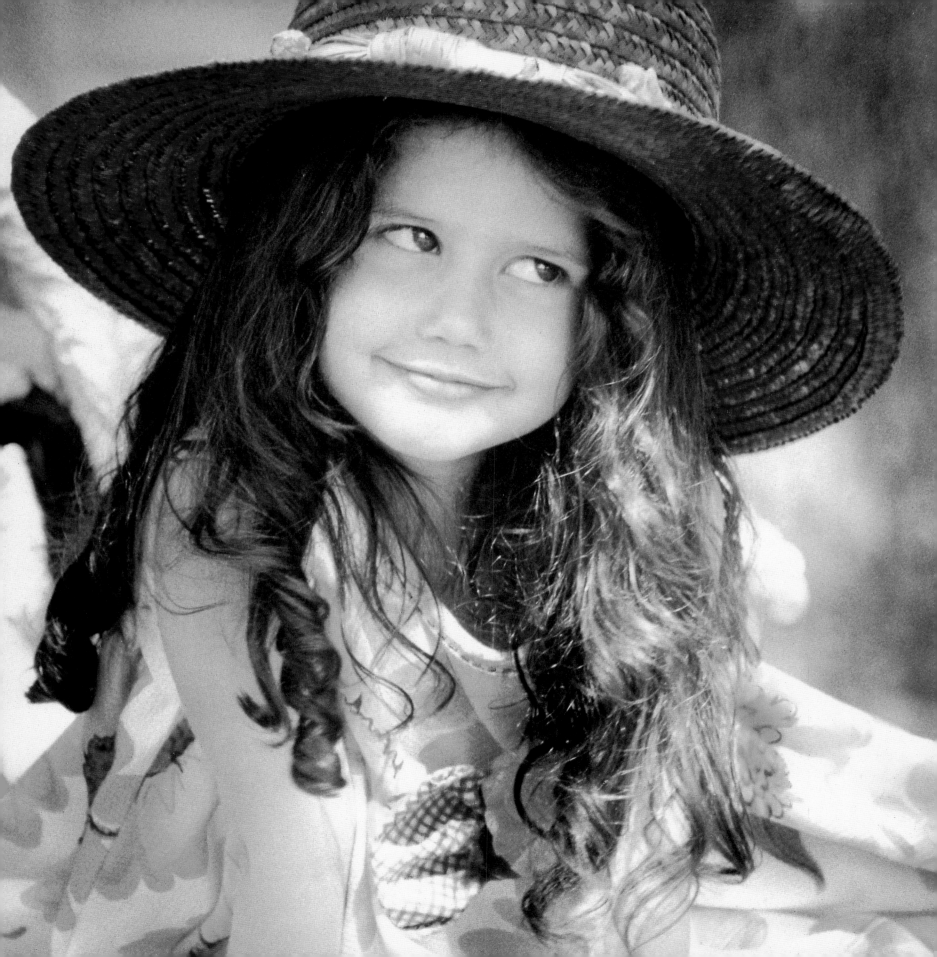

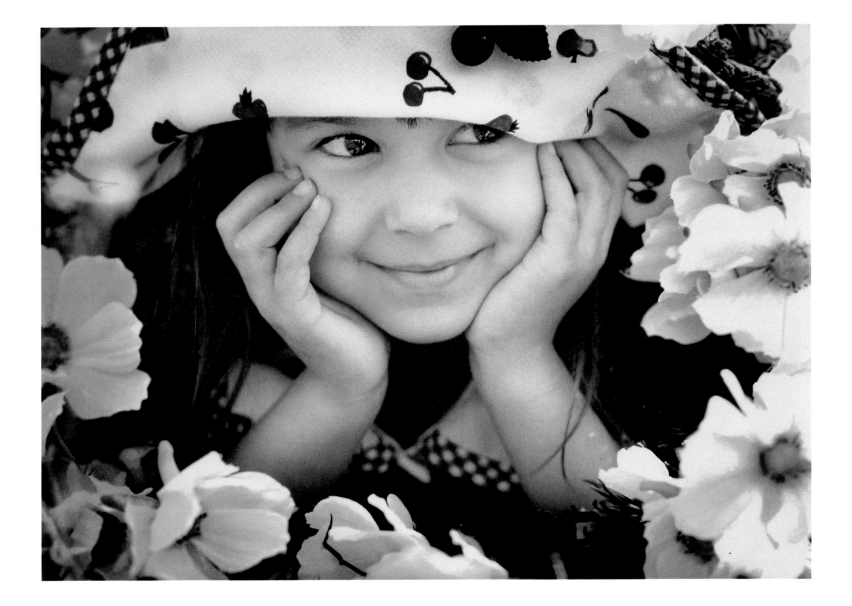

A grin full of mischief . . .

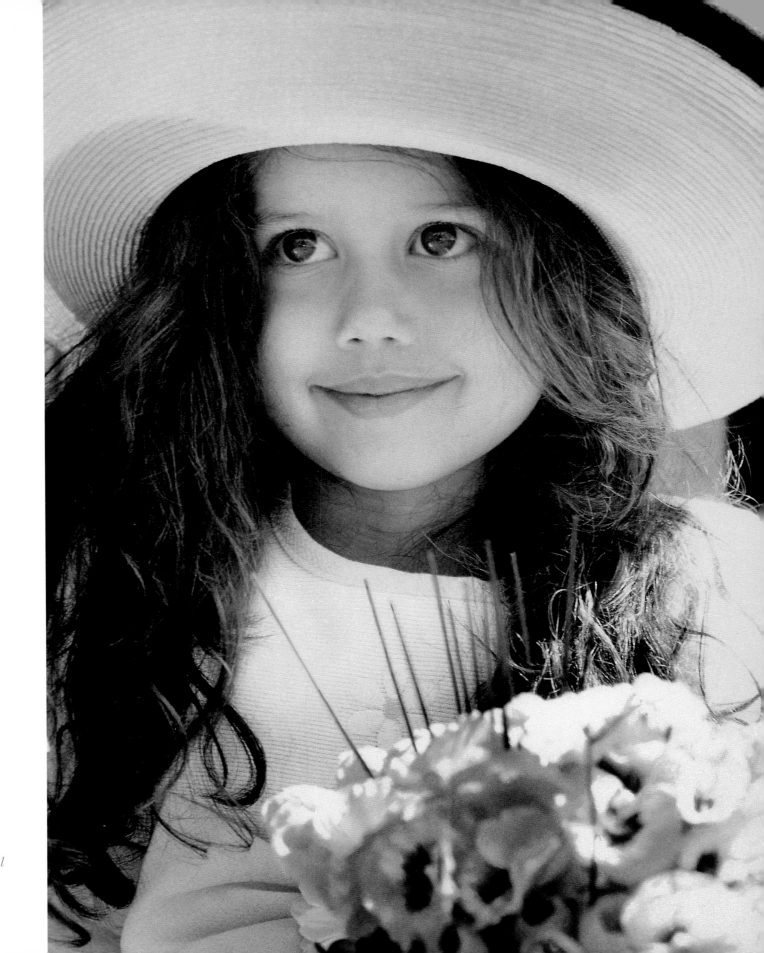

. . . turns magical

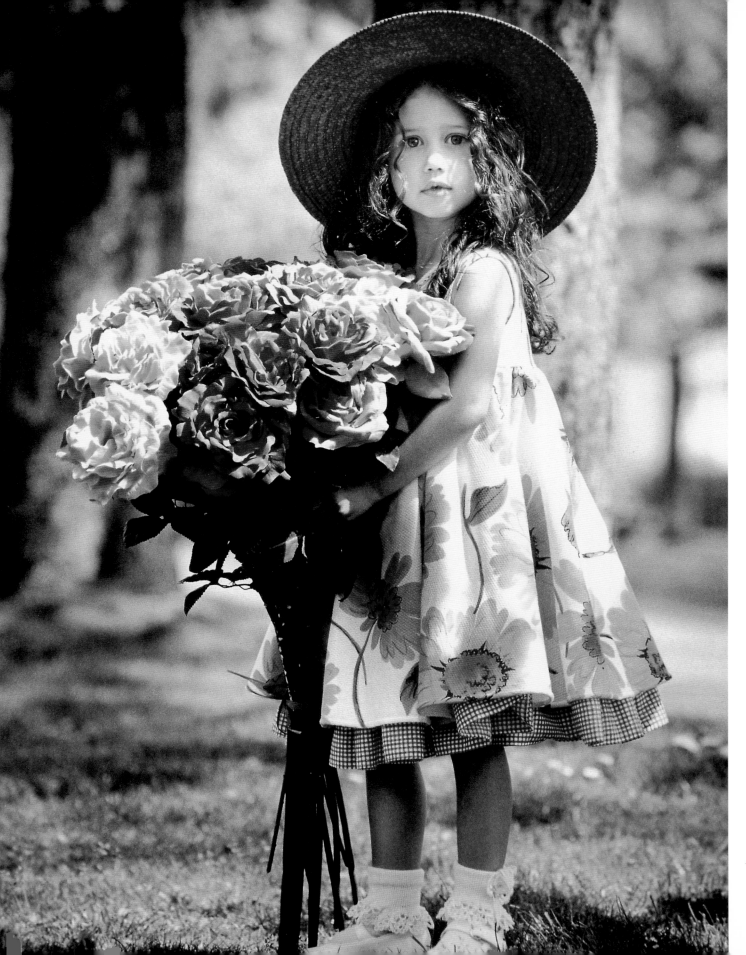

Hold that thought

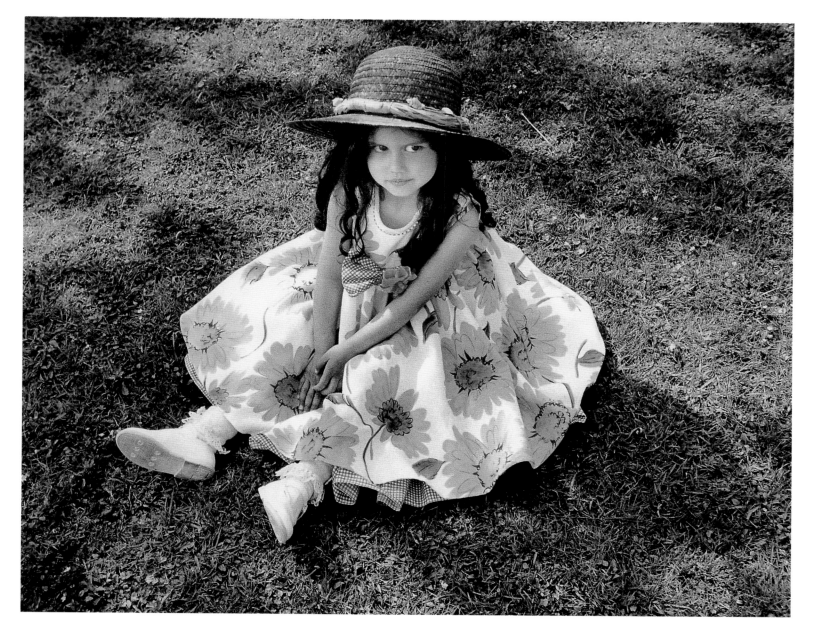

Decisions, decisions

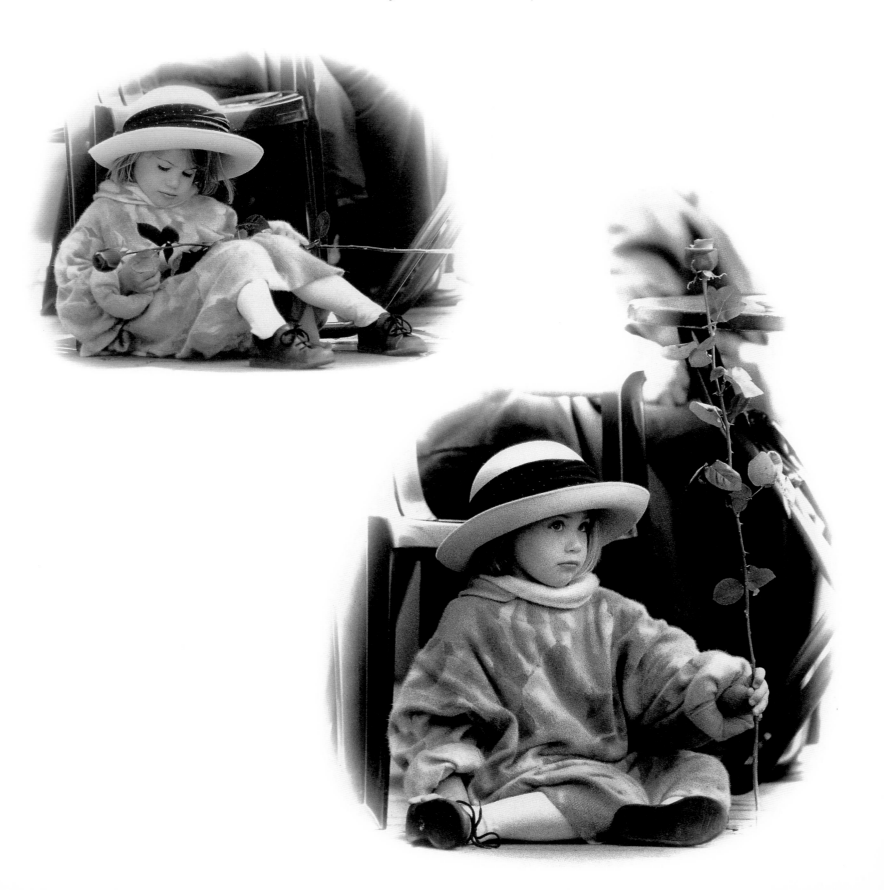

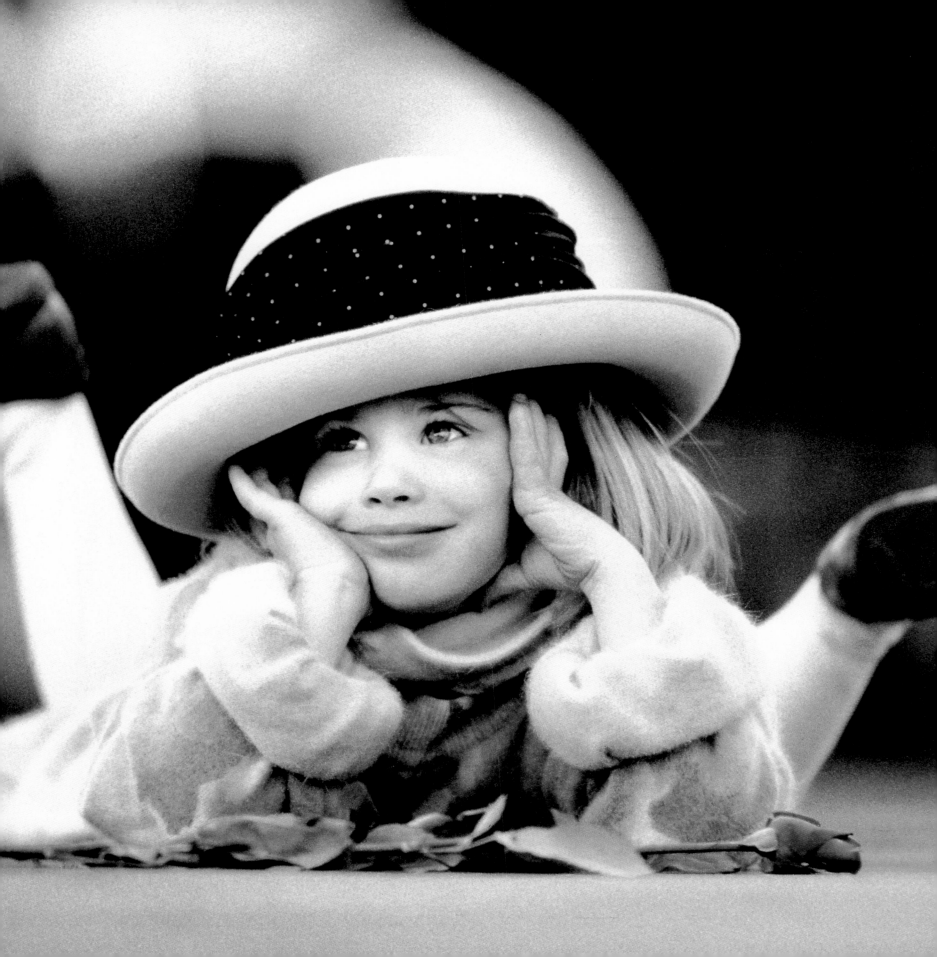

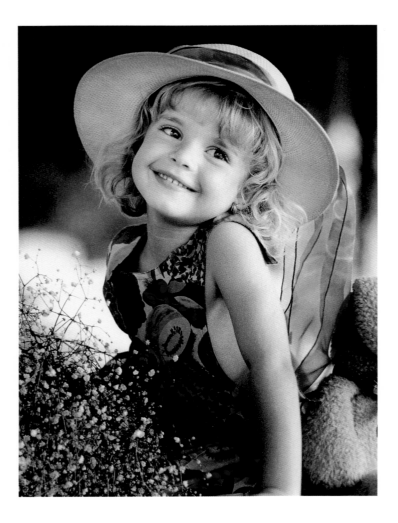

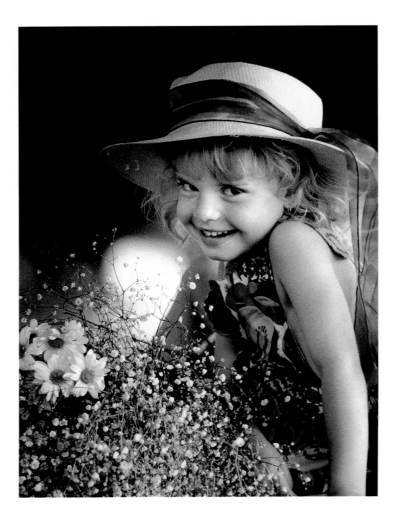

All smiles . . .

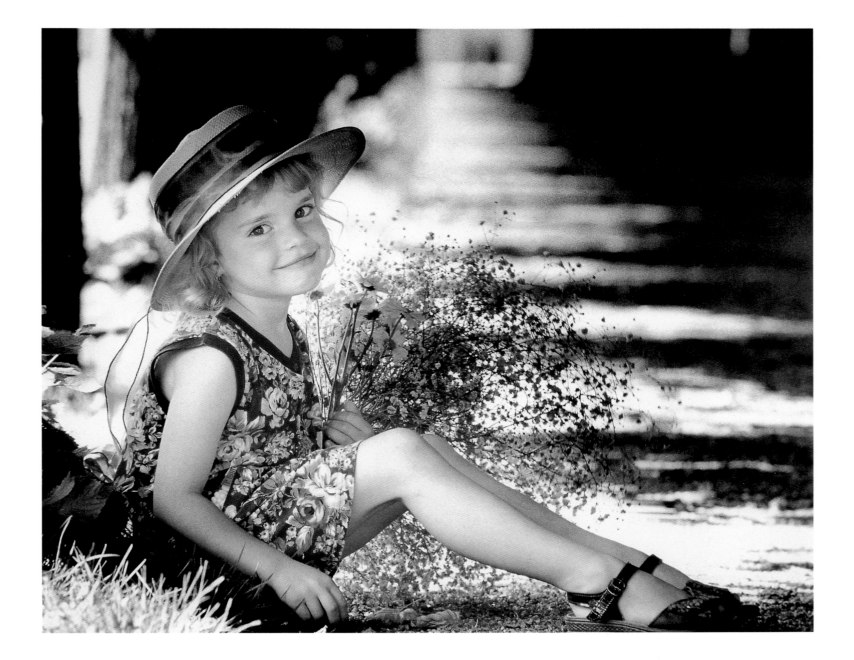

. . . and winsome wiles

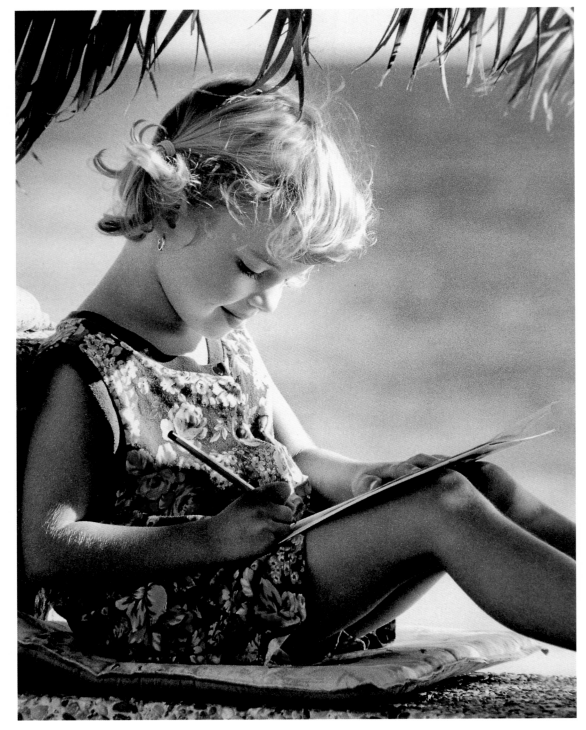

Words are where thoughts live

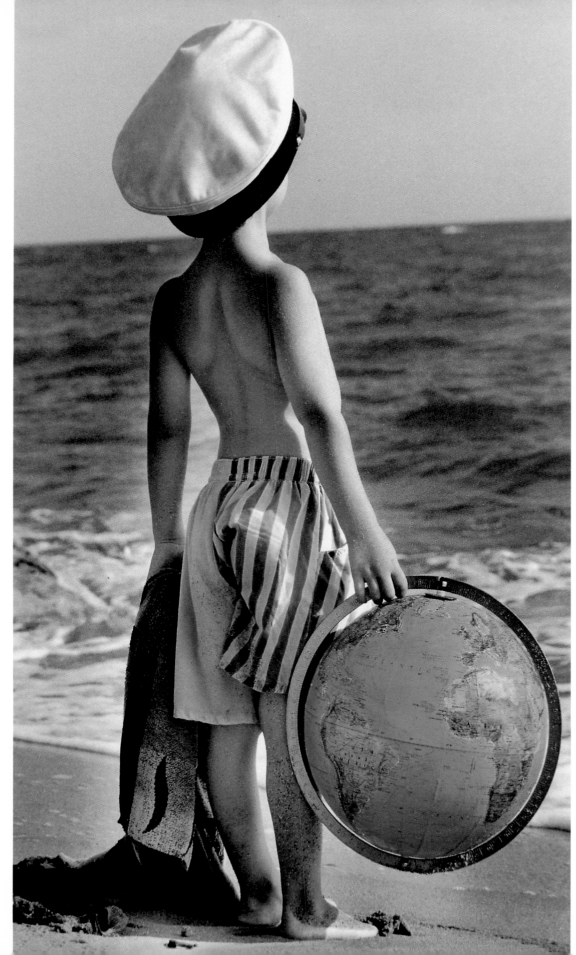

I dream a world

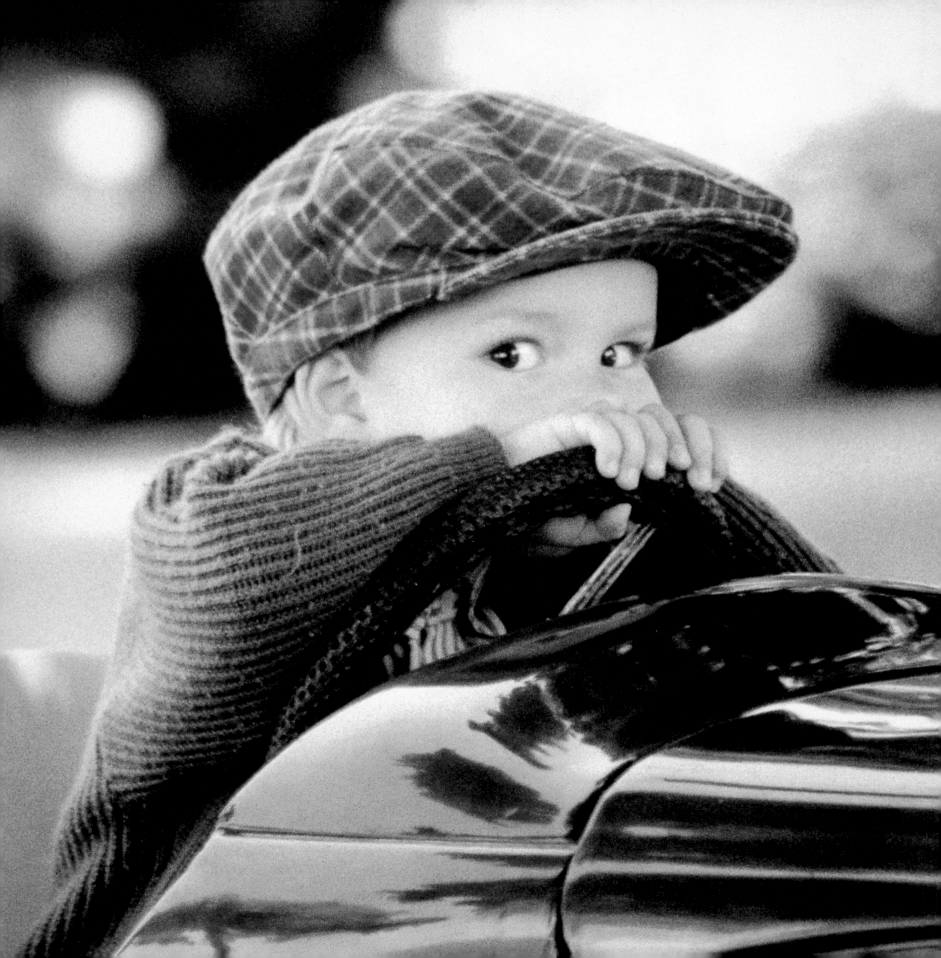

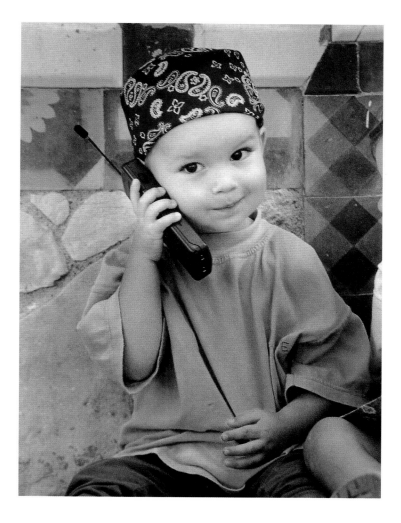 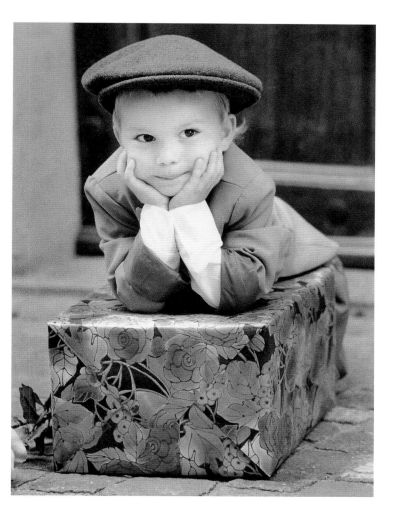

A penny for your thoughts

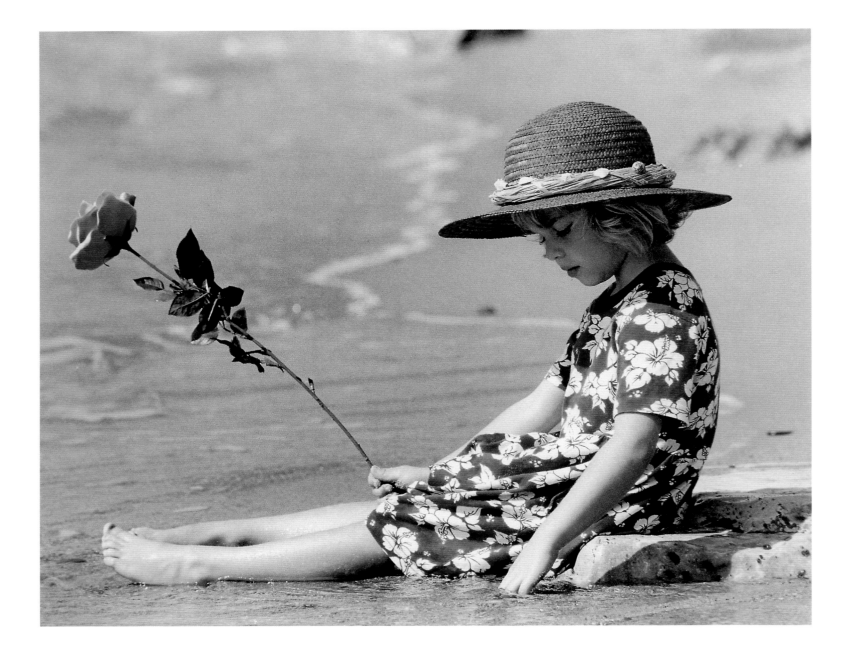

Trespass not on their solitude

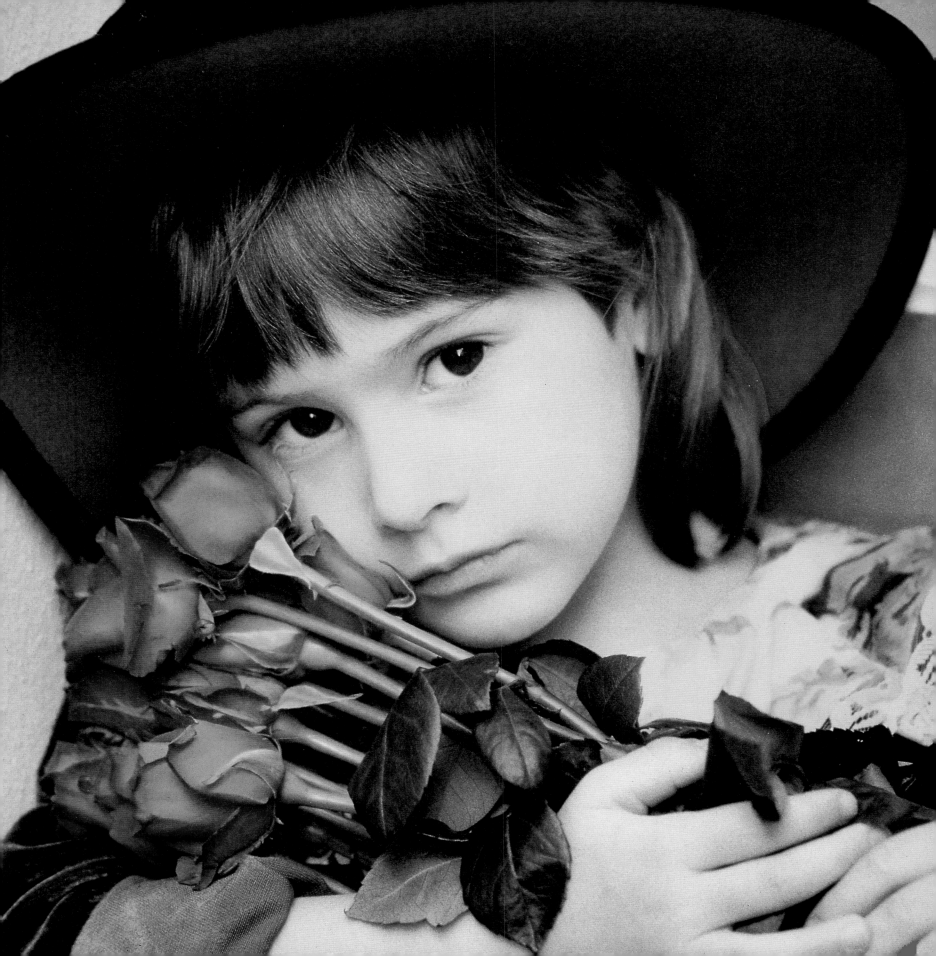

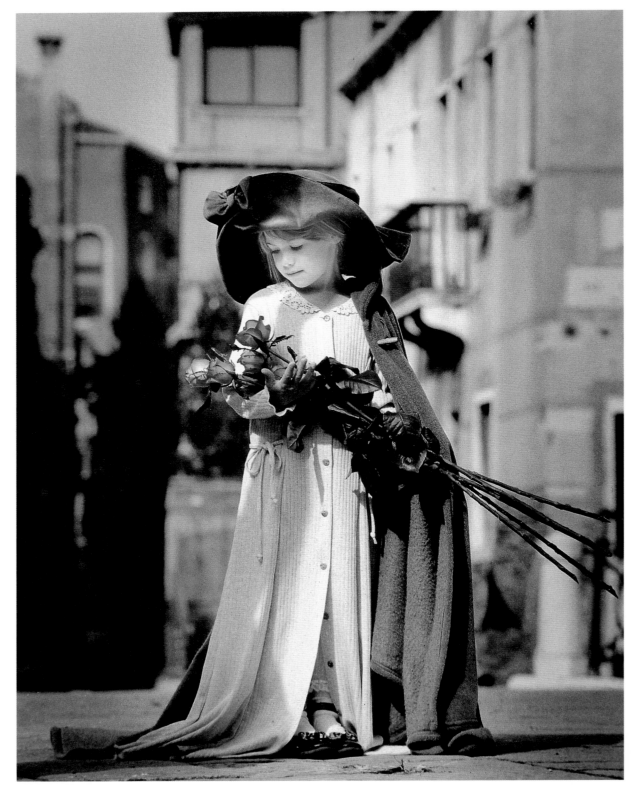

A star
is born

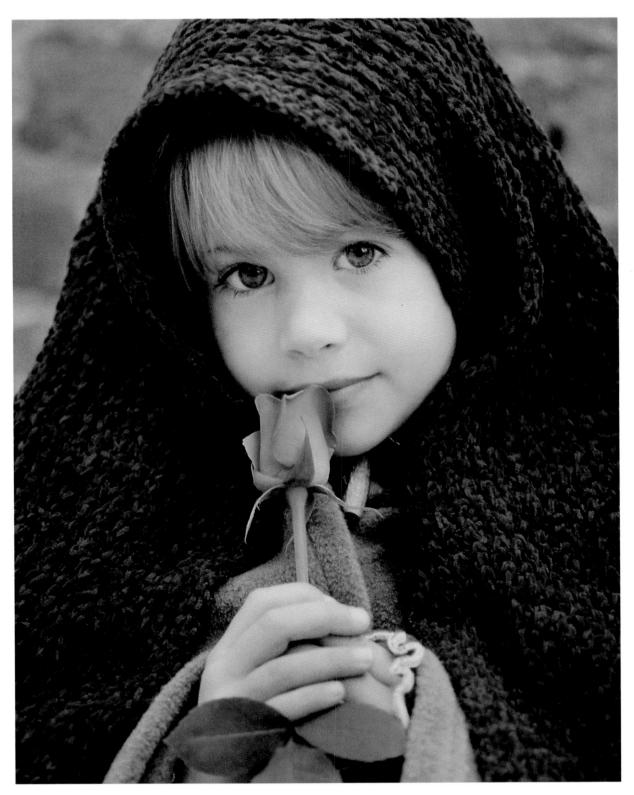

*Just
imagine*

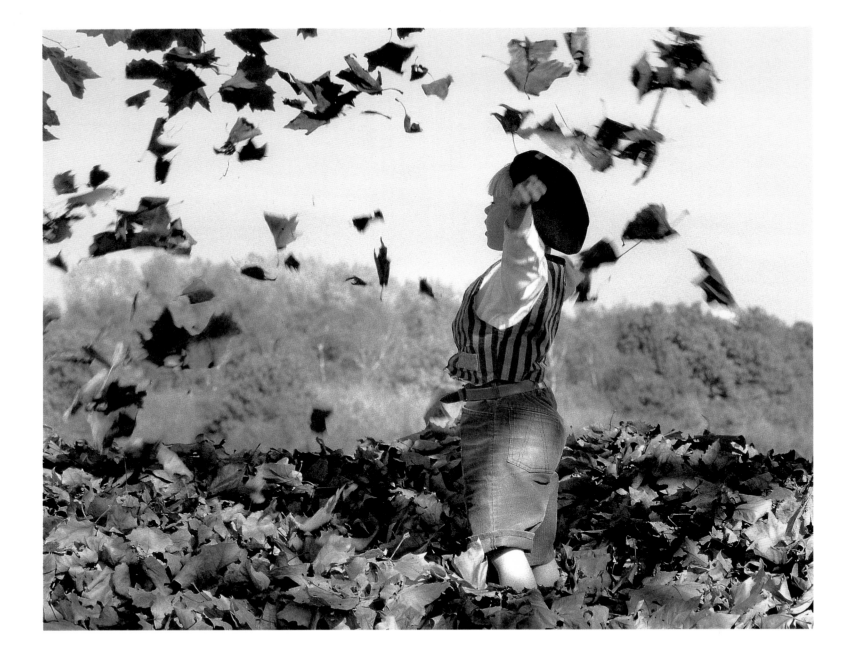

"To see a world in a grain of sand and a heaven in a wild flower,

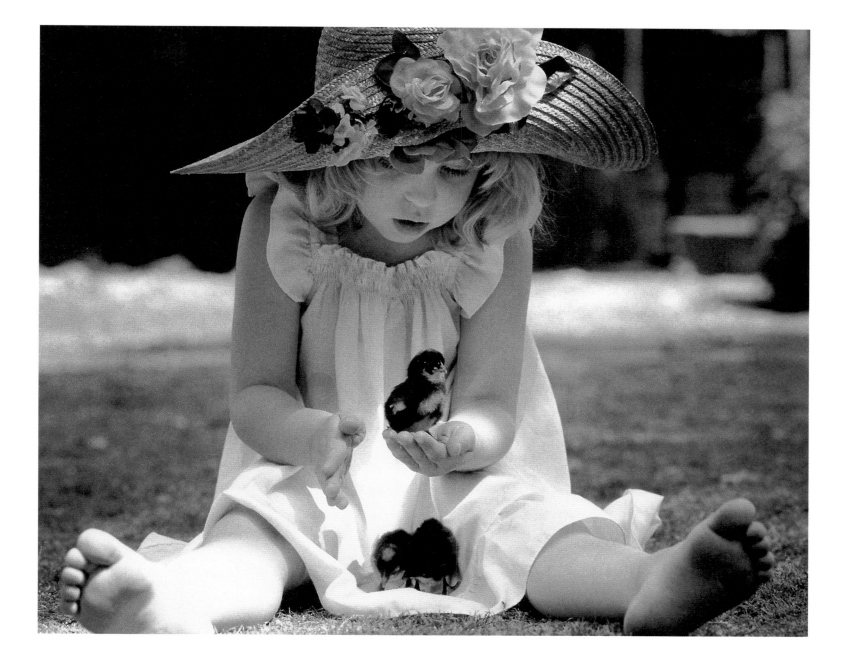

Hold infinity in the palm of your hand and eternity in an hour." —William Blake

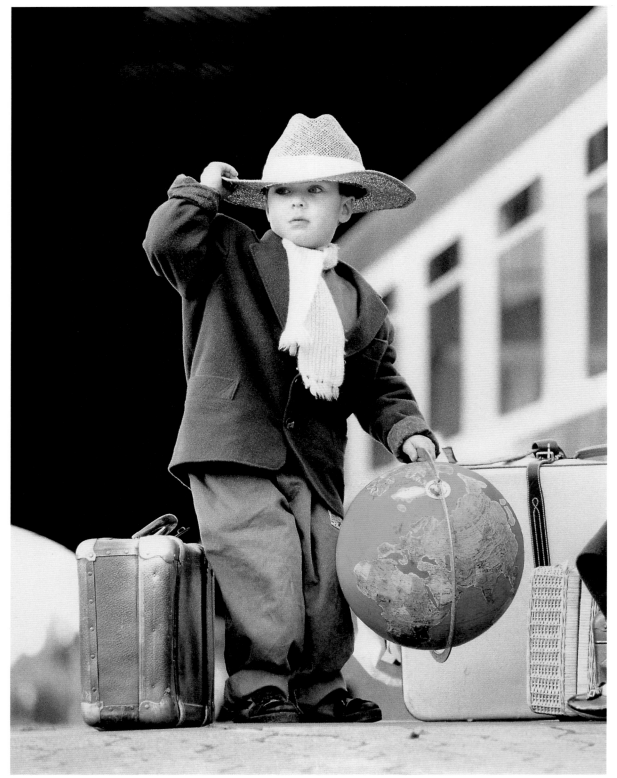

*Globe-
trotter*

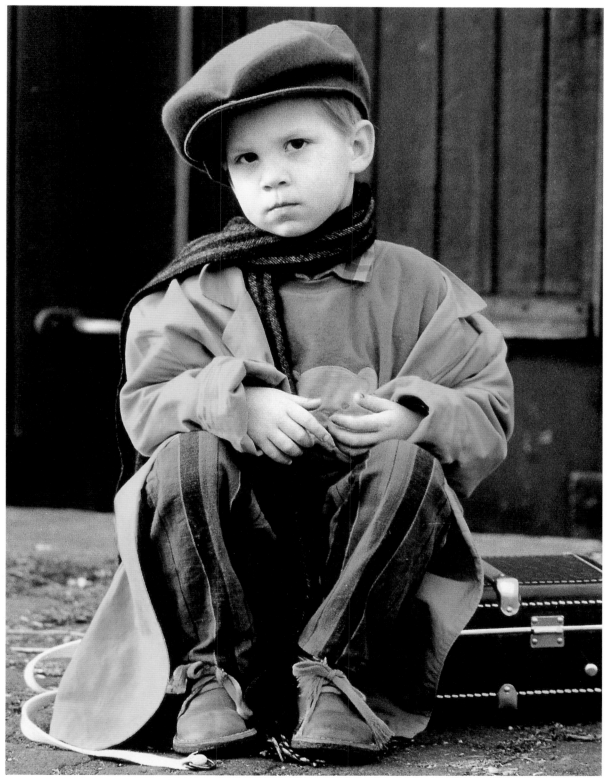

*His
thoughts
are his
own*

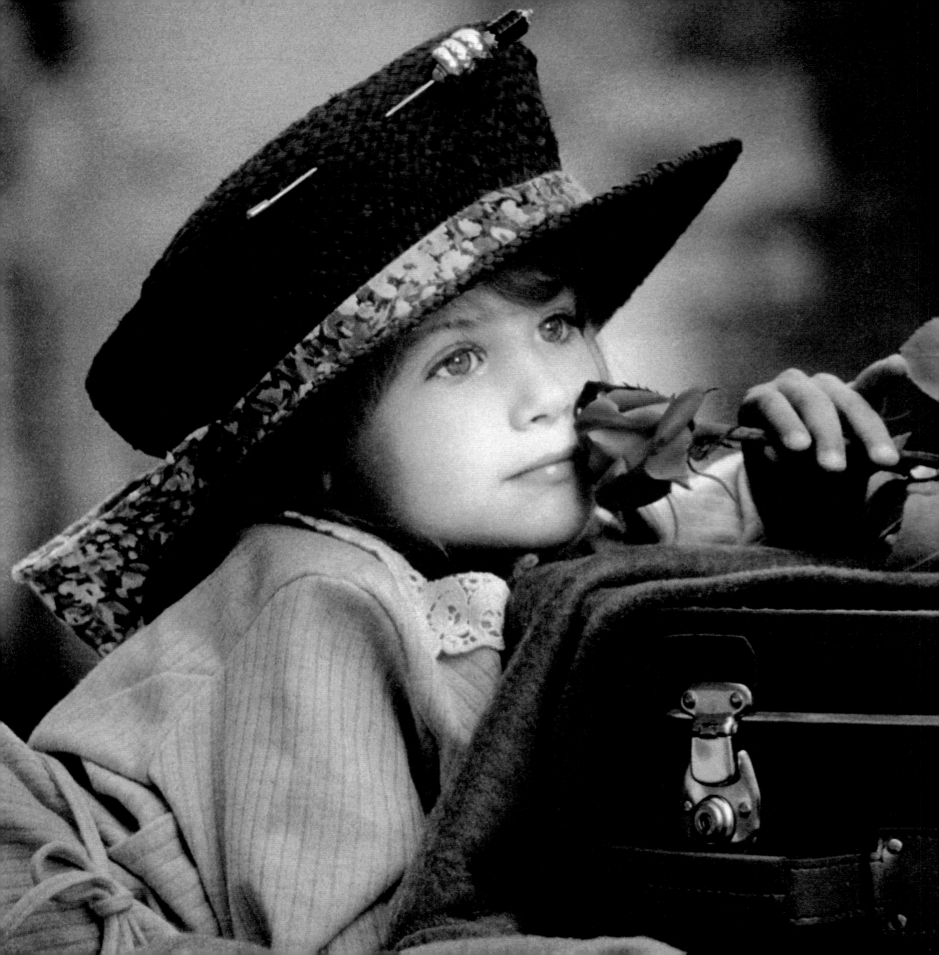

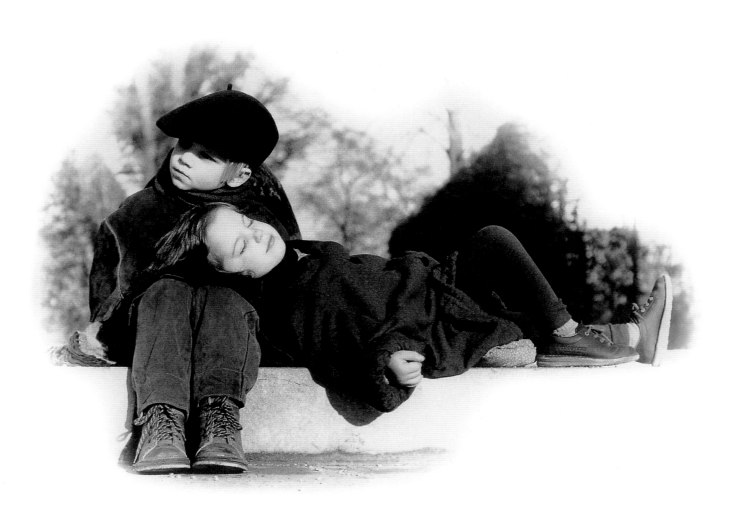

Youth dwells in possibility

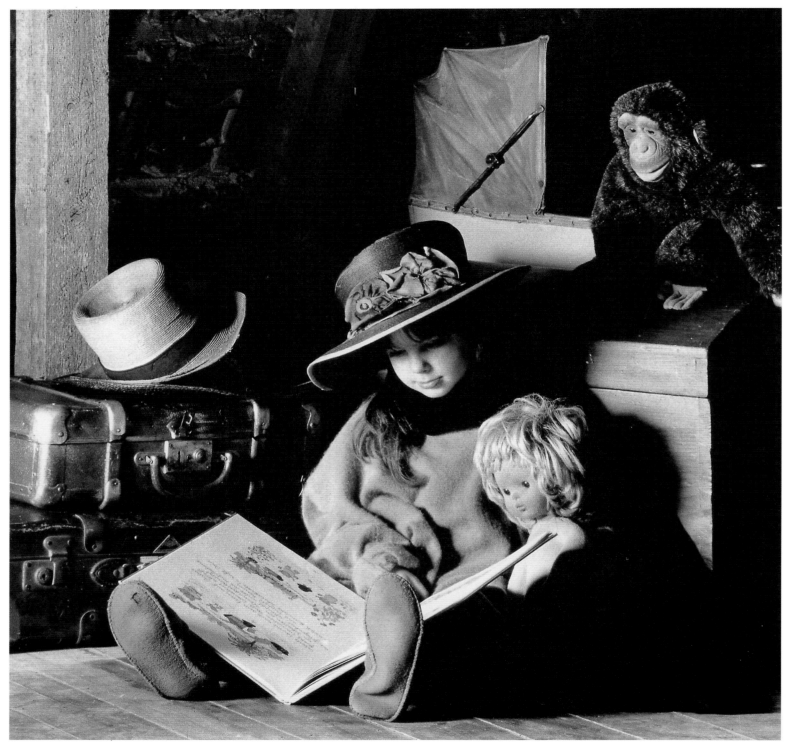

Once upon a time

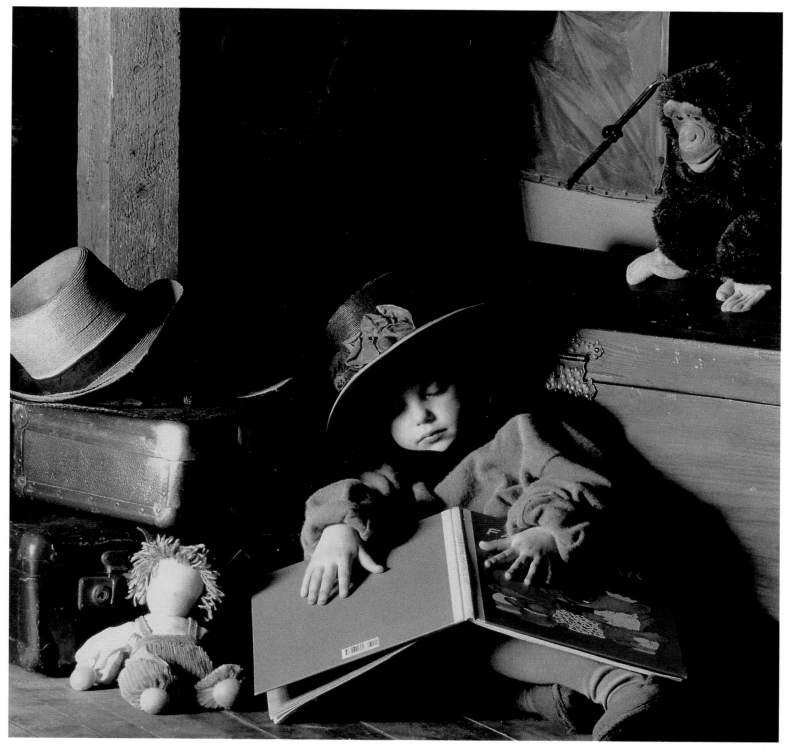

Happily ever after

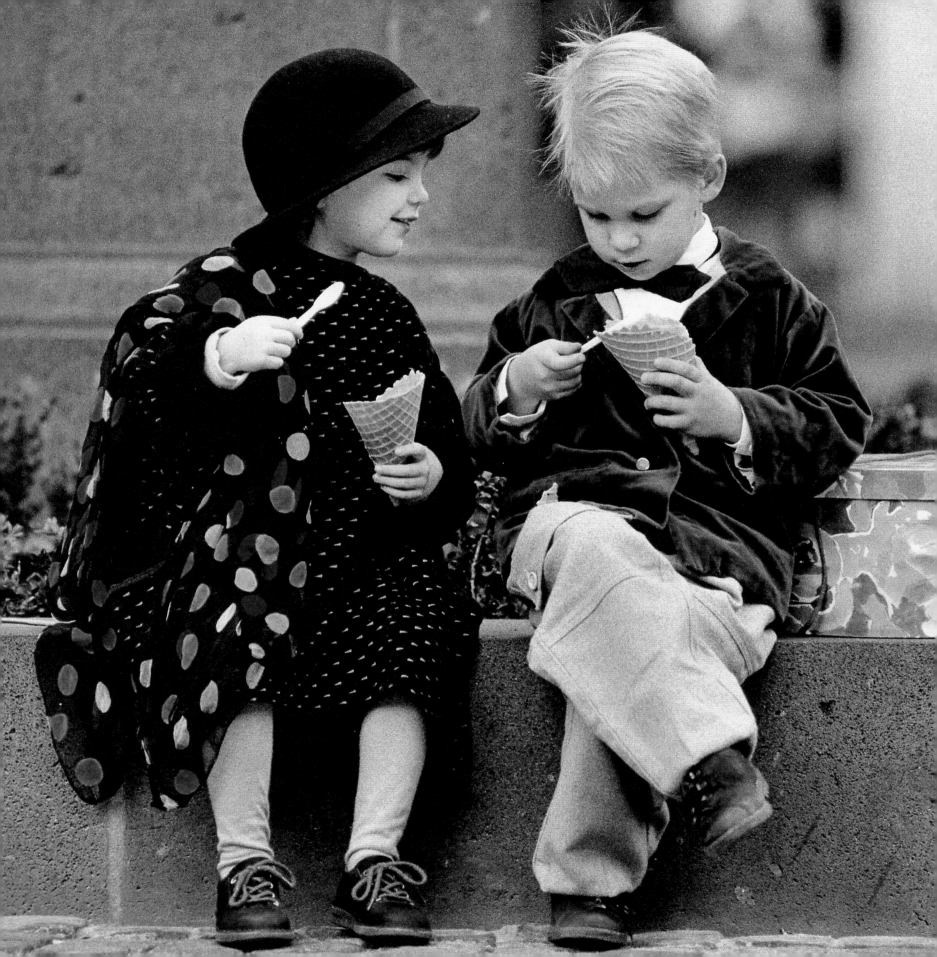

FRIENDSHIP

Essay by Catherine Calvert

Beneath the play of a summer's evening, as children wheel and shout, cluster together then spin off in new formations, lie the friendships that form the pattern of their days. In the country of childhood, there are many laws, but those of friendship—unwritten, *ad hoc*, or universally acknowledged—determine almost everything: where you stand in line, in what order you're picked for the softball team, whether you are one of the gabbing girls at the lunch table or alone at the end, picking at your peanut butter sandwich. Ever-changing or fast forever, friendship yields some of childhood's greatest joys—and torments. In the smoldering furnace of friendship, children forge skills that will last a lifetime and the memories, good or bad, that underlie them.

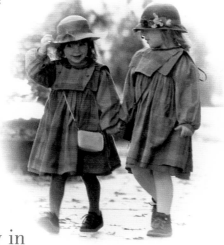

Children are quick to discover each other, stretching out a small hand to the next child in the sandbox. And parents are almost as quick to step in, with their own rules for toddler ties: *"Be nice!" "Don't hit!" "Don't bite!" "Share!"* But the law of the jungle wins out, especially when there's nothing as coveted as a toy in another child's hand. Child psychologists say that toddlers watch each other carefully before they join in play, taking a long look at who's doing what, then sidling alongside and gradually merging in. And there begins the craft of friendship: sizing up the situation and learning the ways of the world through the small universe of the sandbox or the

housekeeping corner at nursery school. Even then, some children seem blessed with qualities that make friendship easier; these few charm from birth, with ways and wiles that make the world smile on them and others seek them out. For some, though, shyness rules from the nursery, and as they take their first tentative steps toward others, they are often spun away, tone-deaf to the ways of friendship, off on the wrong foot, never quite in the dance.

The sight of children in a playground, shouting as they run, or standing clumped or solitary, still stops me when I see it, and in a moment I am nine again in a new school, watching the patterns at play. Bookish, bespectacled, awkward, with "Teacher's Pet" already being chanted in my wake, I forded the playground as if it were treacherous rapids—and, of course, it was. The hierarchy of the playground was—and is—as rigid as any corporation's. There was the Popular Girl and her satellites, pony tails swishing as they walked. The Team Captain and his buddies, skirmishing with a football. The two

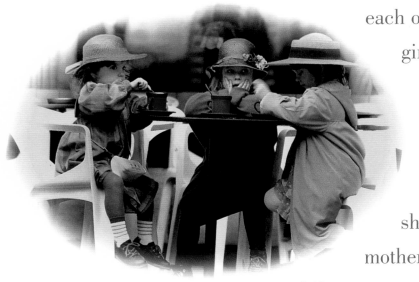

quiet girls, who kept close by the teacher and braided each other's hair. And the mass in the middle, girls and boys who linked up and split apart by the week, hanging from the monkey bars and skipping rope and chanting rhymes I didn't know. And to me it all seemed impenetrable. I had the wrong shoes. My thin pony tail didn't swish. My mother picked out my dress. I had a lunch box, while everyone else carried brown paper bags. So I leaned

against the chain-link fence, trying to look
busy, and listened to the happy shouts,
and wished the day over.

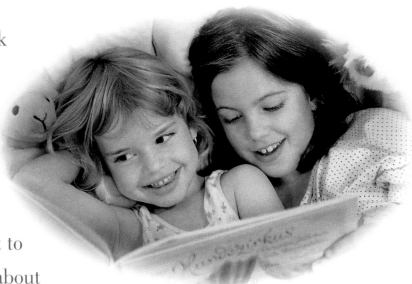

 In a day, a week, perhaps longer,
came the invitation to hold one end of
the jump rope and later to join the lunch
table, with everyone scooching down a bit to
make room and offering some hot gossip about
the Teacher's Lounge. Then the days took on a different color. I know we must have studied
math and put on plays and taken tests—but the most vivid memories from those years
are of these grade school friendships. Boys surely had their own whirl, their own buddies
and gangs and social codes; but their friendships seemed to be louder and more physical
and less demanding than ours. Girls' friendships were gusty and shot through with intensity,
intrigue, and rivalry. You'd have your group, a coterie, who could fill up most of the
lunch table, giggle about boys together, and go shopping on Saturdays. You probably also
had an inner group of three, but that was perilous, as mothers everywhere warned: "Three
is always two against one." But most important, you had a best friend, for sleepovers and
shared confidences, for exchanging homework assignments and Archie comic books. Now
and then you'd fall out. Over what? Whether to play Monopoly or Scrabble. Whether to
draw horses or poodles. Or who ate the last Milk Dud. And in a moment, she was gone,
slamming the screen door behind her, stomping down the sidewalk and away, while upstairs,
your tears were hot on the pillow. Who would make the first phone call, before school on
Monday, that would put everything right? Somebody had to; otherwise, you'd see your best

friend sashaying down the hall with the second-best friend, whispering behind her hand, while the rest of your friends took sides. Finally, you'd meet by the jungle gym and make up, with a toe scuffing the gravel, and make plans to go shopping on Saturday and then read each others' diaries. And the sun shone again.

I remember floods of children ebbing and flowing around the neighborhood, the little ones intermixed in their friendships, the bigger boys and girls divided by gender. How many clubhouses did we set up, each with the same hand-lettered sign "NO Boys Allowed"? Ours, a treehouse, held treasures within—three Nancy Drew books, a tin of cookies, a flashlight—and was once defended by five girls and an entire crop of crab apples delivered with sharp accuracy. That was good. Of course, much of what we were up to would have been humiliating if discovered. Like the entire summer we spent pretending to be horses, whinnying and cantering our way across the yard for hours,

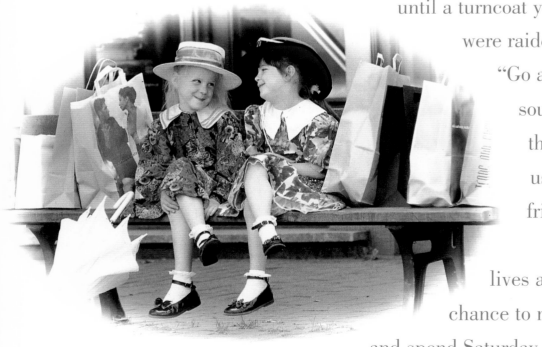

until a turncoat younger sister told the boys, and we were raided. Mocking neighs. Screams. Cries. "Go away!" "I'm telling!" These were the sounds of crisis that brought mothers to the doorway or sweeping down among us—but they cemented our friendships.

These days, it seems, children's lives are more scheduled, there's less chance to meet up with the girl across the street and spend Saturday digging a hole just to see how far

you'd get. What with ballet lessons and soccer league, math tutoring and parents' caution, play dates are planned weeks in advance. Why put on a play in the garage when the local drama group has its children's theater classes?

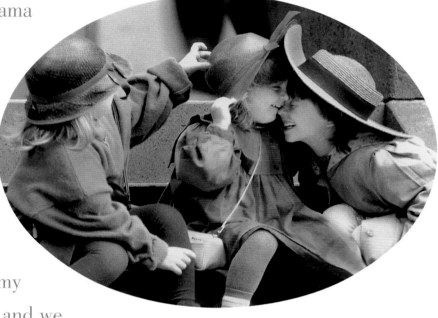

And yet, I know that children's friendships, in all their excess of joy and sorrow, are still the emotional touchstones of their lives. "Mom, Kate is mad at me because I said I'd be her partner at lunch, and then Georgia said she would, and I forgot and Kate cried," my youngest laments when she comes home, and we debate the merits of the case over milk and crackers. There are good times ("Jennifer says I'm her second-best friend!") and bad ("Charlotte says only silly girls wear hair ribbons"). I listen, and nod, and repeat the mother wisdoms I used to hear myself, about the Golden Rule and not gossiping and trying to understand Kate's point of view, until she storms off to her bedroom and says I'll never understand.

And I am silent, lost in the memories of Robyn and Patty and Sharon and Susie, of slumber parties where the whispers lasted till dawn, and the phone calls that linked the neighborhood before supper, and the hectic rush to go back outside again and chase fireflies in the twilight, hands clasped, true friends in a whirling world.

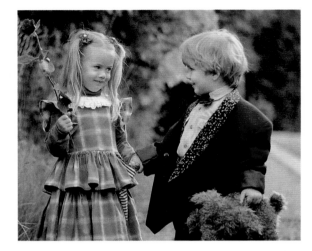

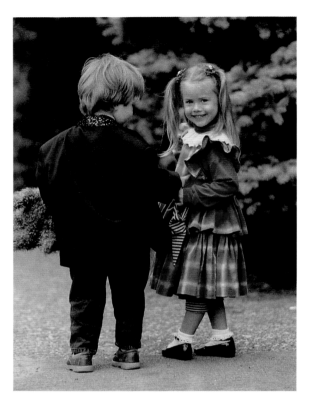

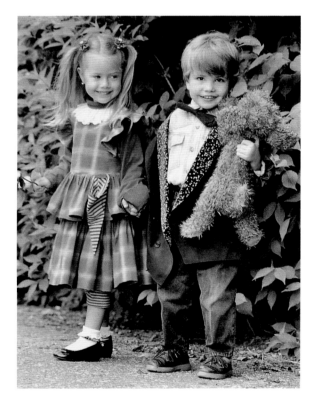

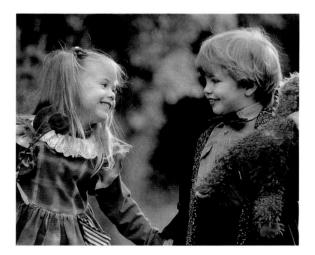

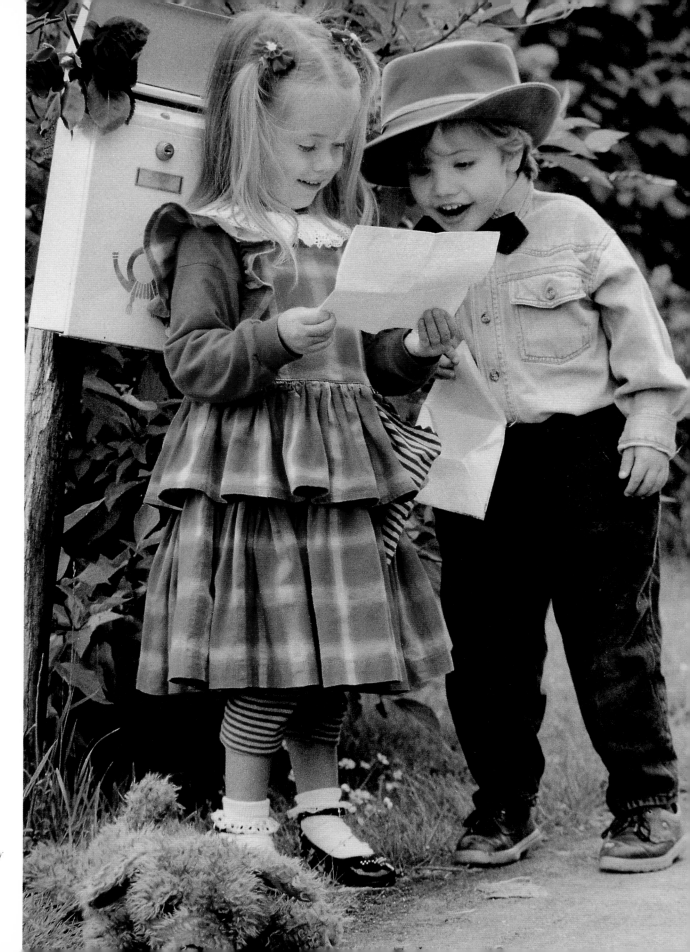

Special delivery

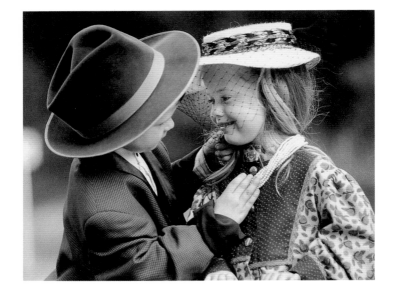

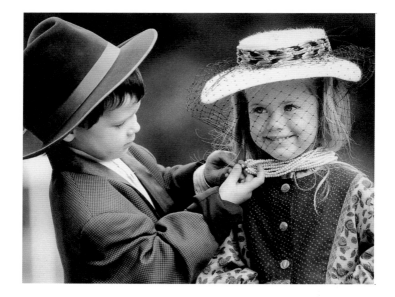

Helping hand

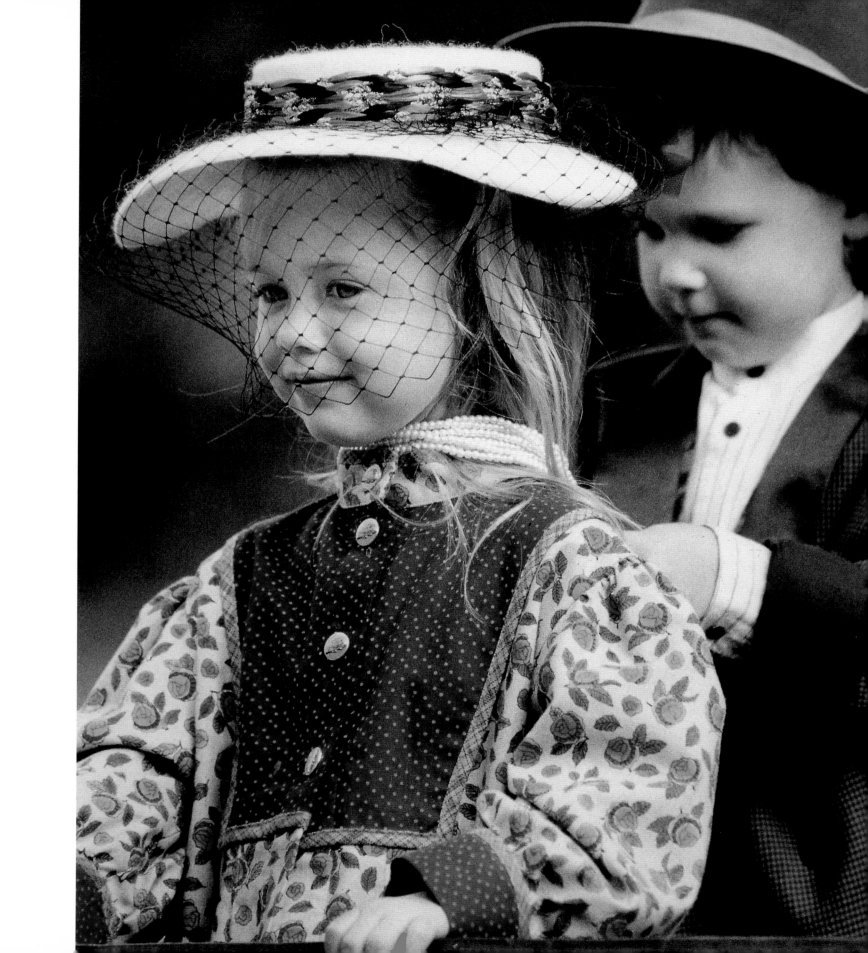

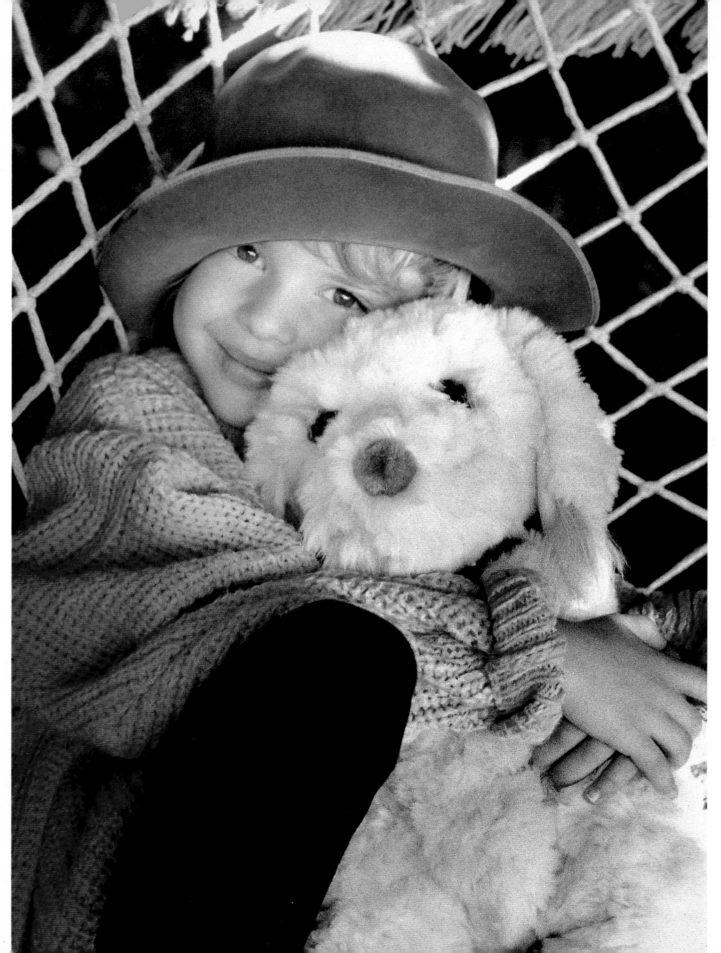

Cuddly companions

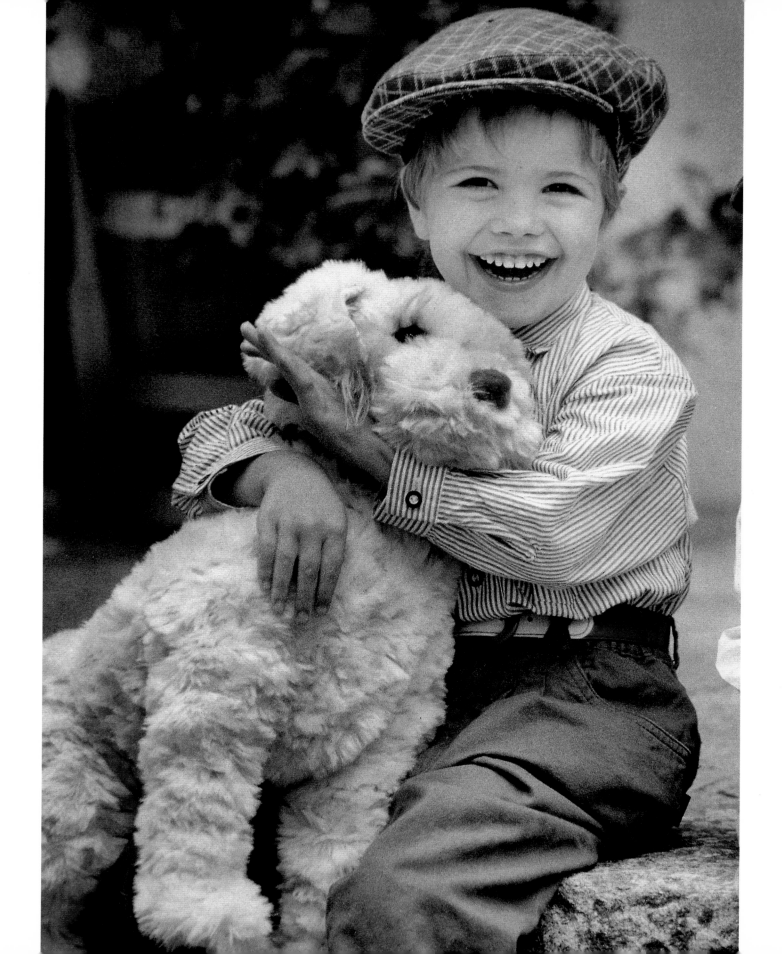

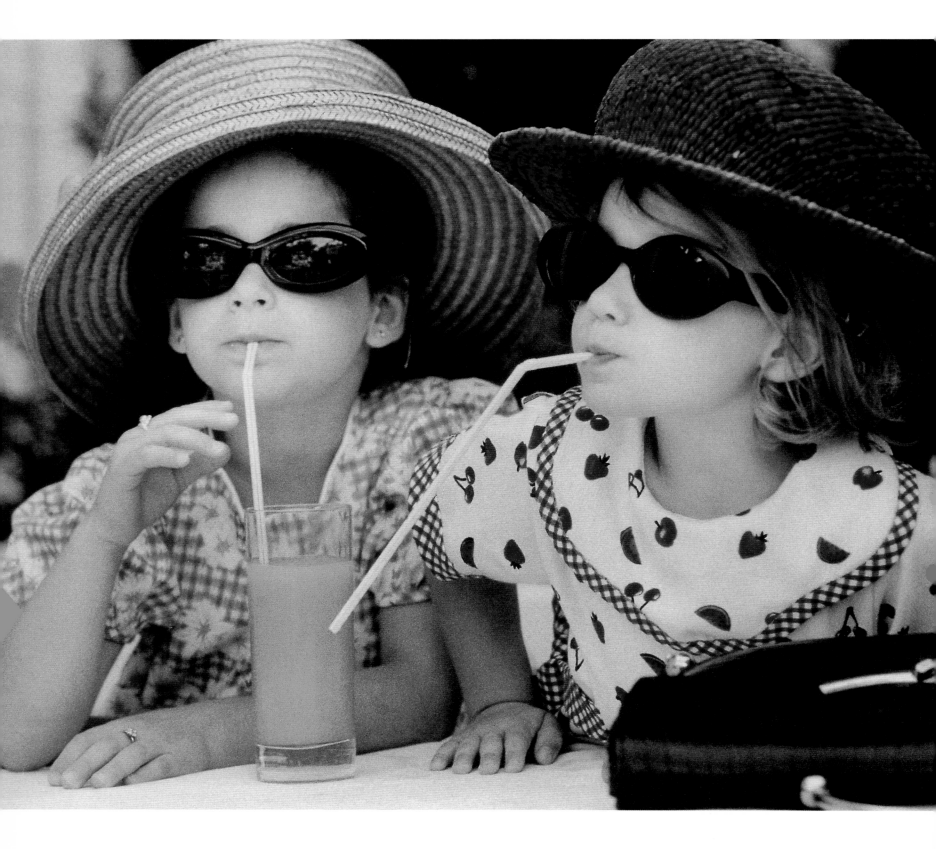

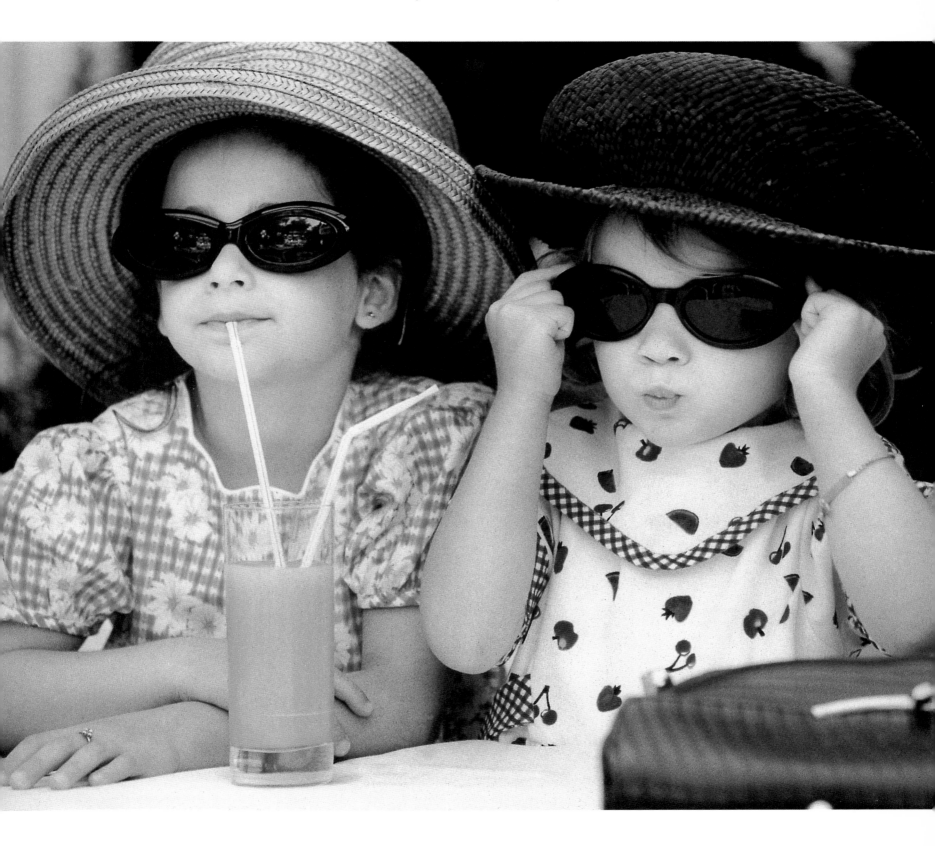

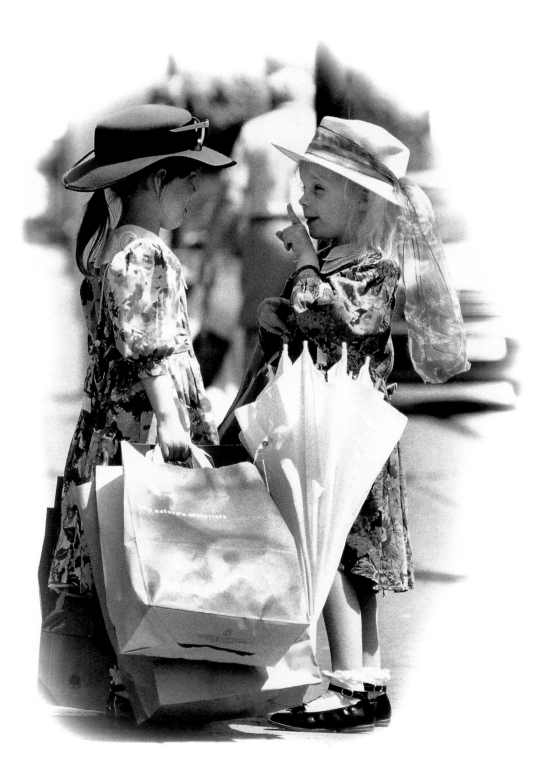

Secret
sharers

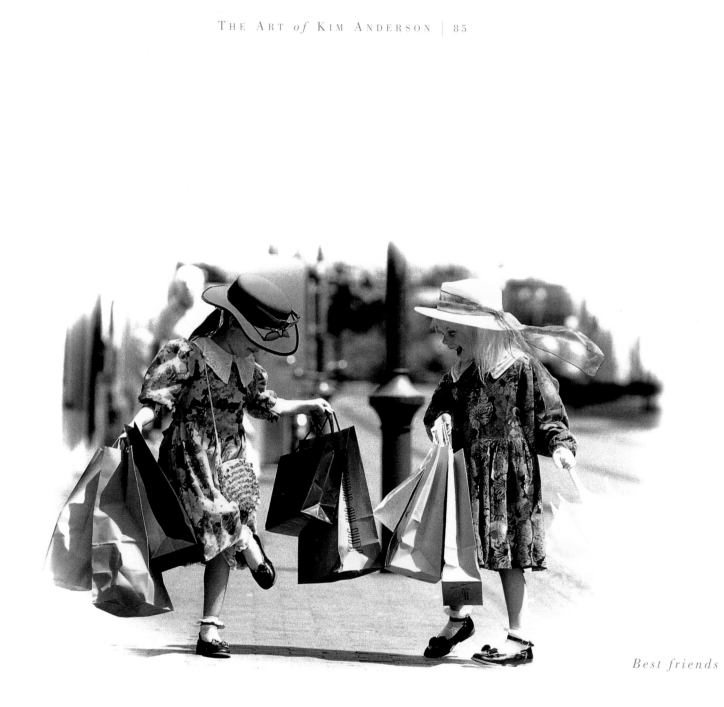

Best friends

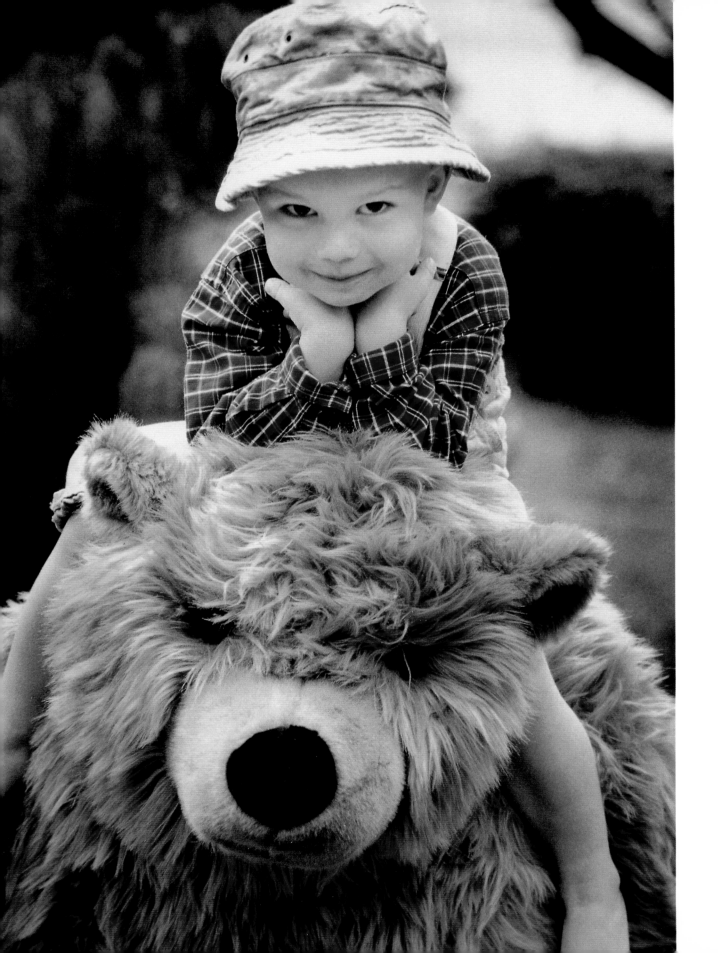

Bear hugs

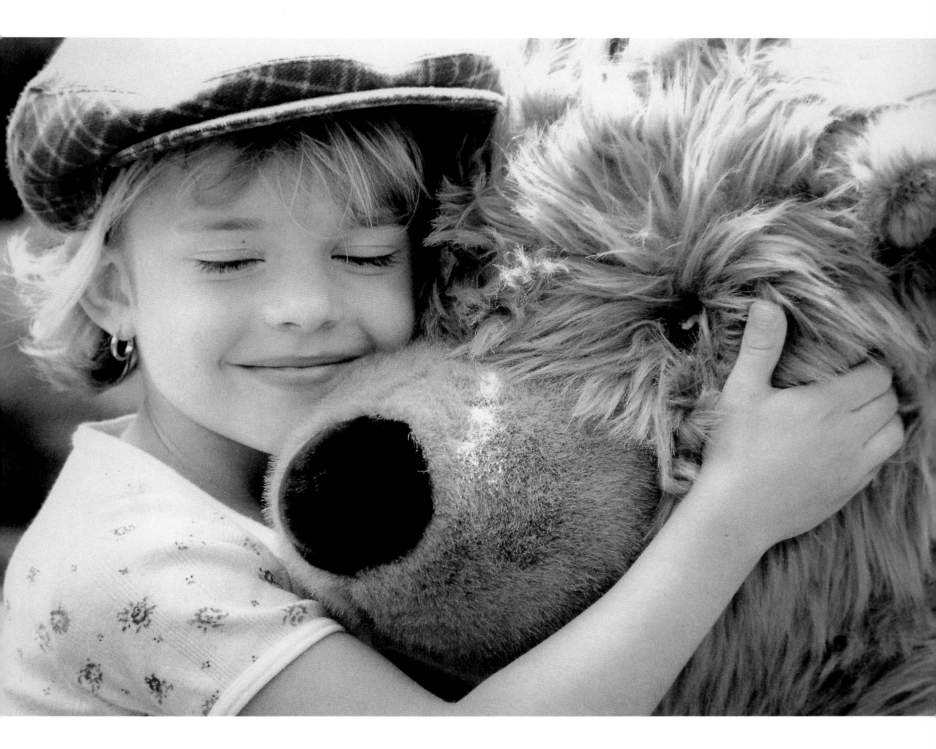

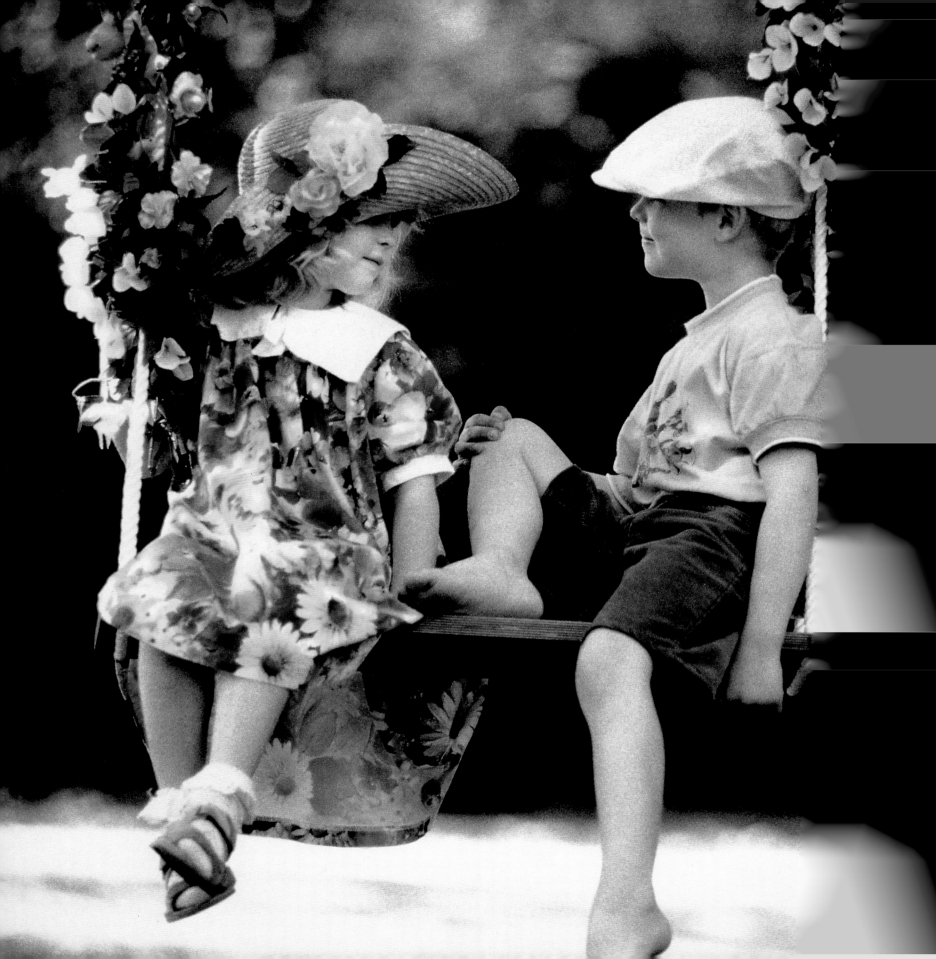

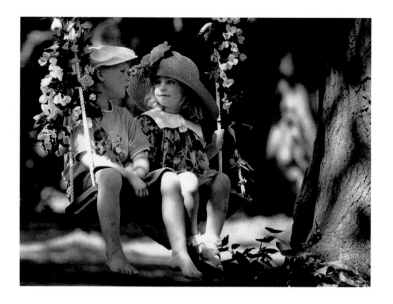

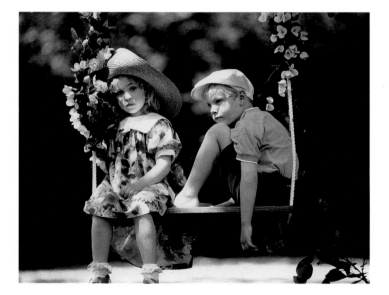

Summer idyll

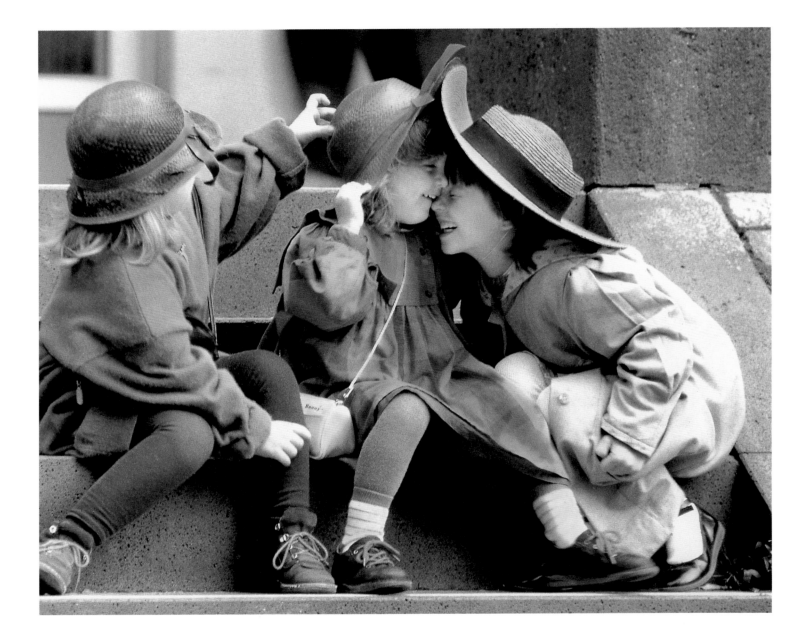

"A friend is a gift you give yourself." —Robert Louis Stevenson

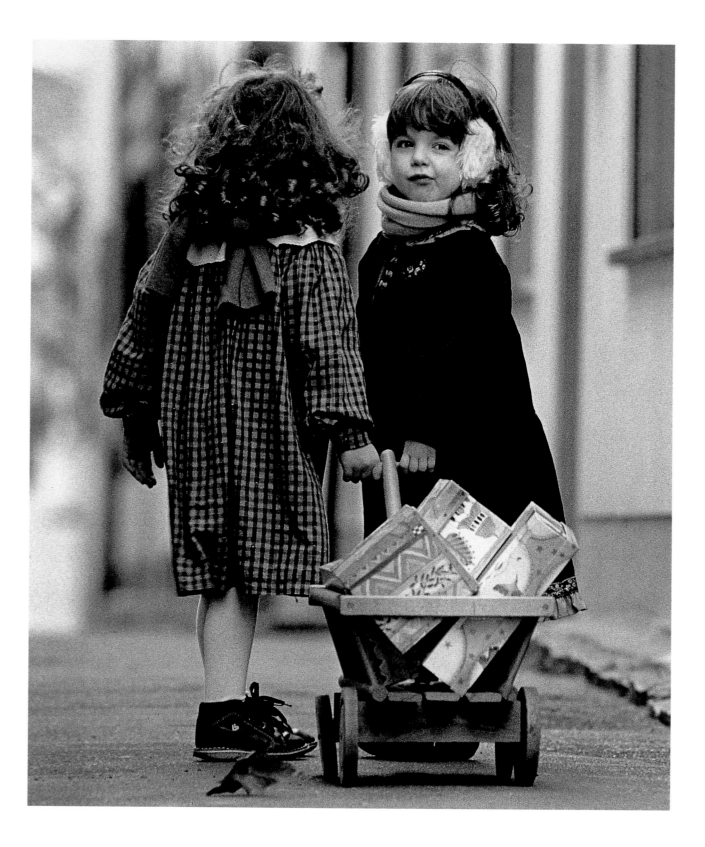

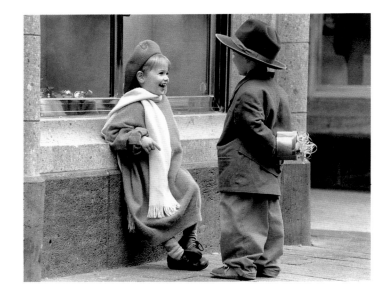

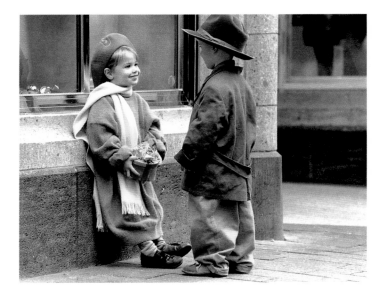

Childhood is fleeting . . .

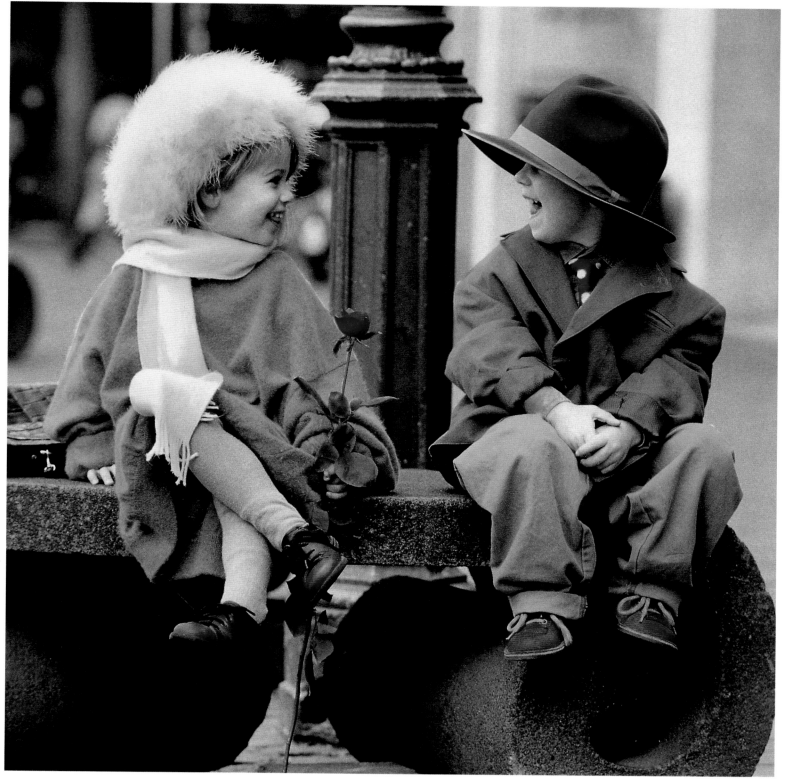

. . . friendship lasts

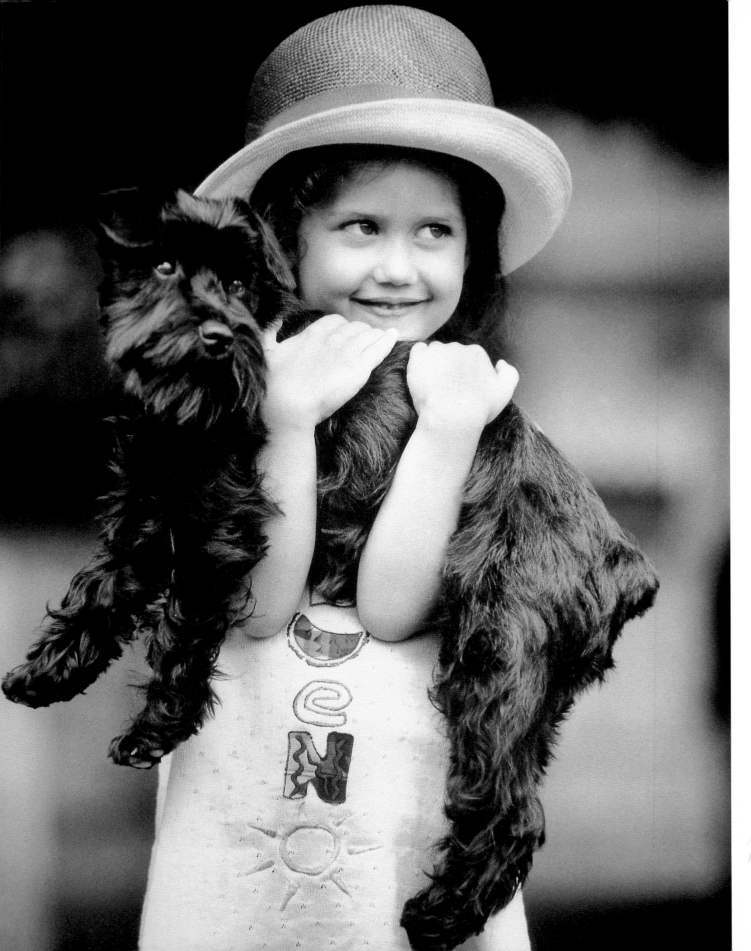

A girl's
best friend

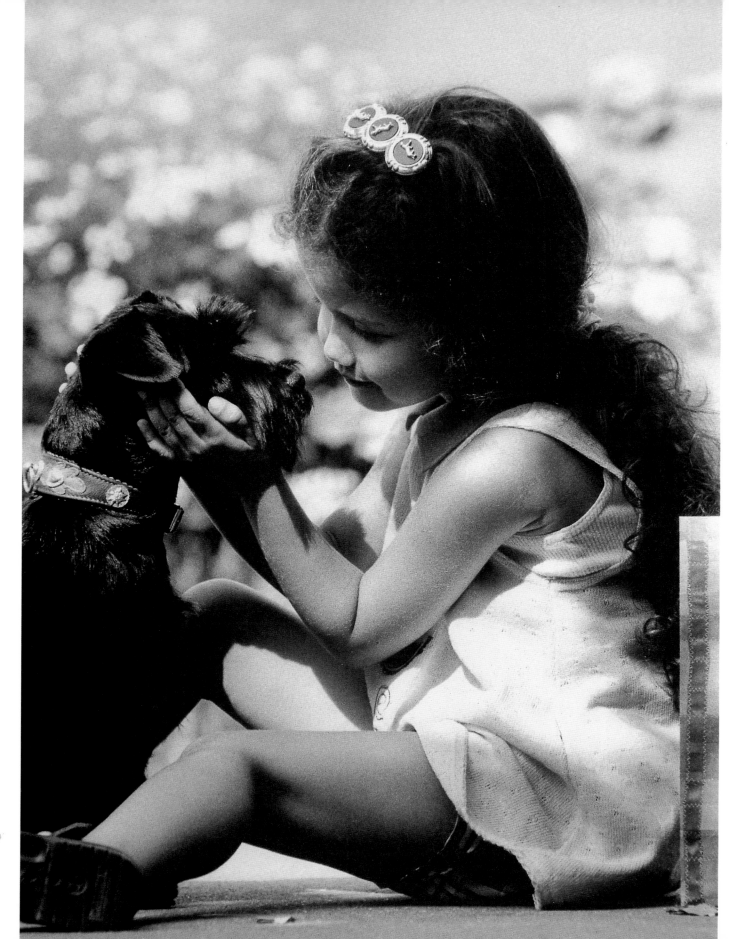

*Puppy
love*

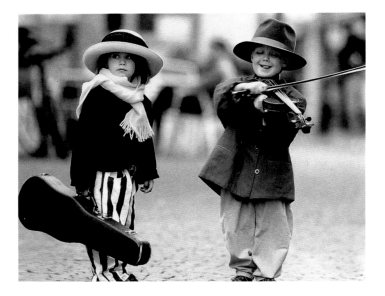

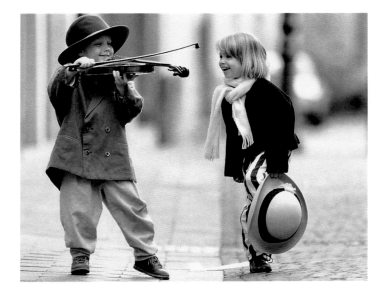

Maestro!

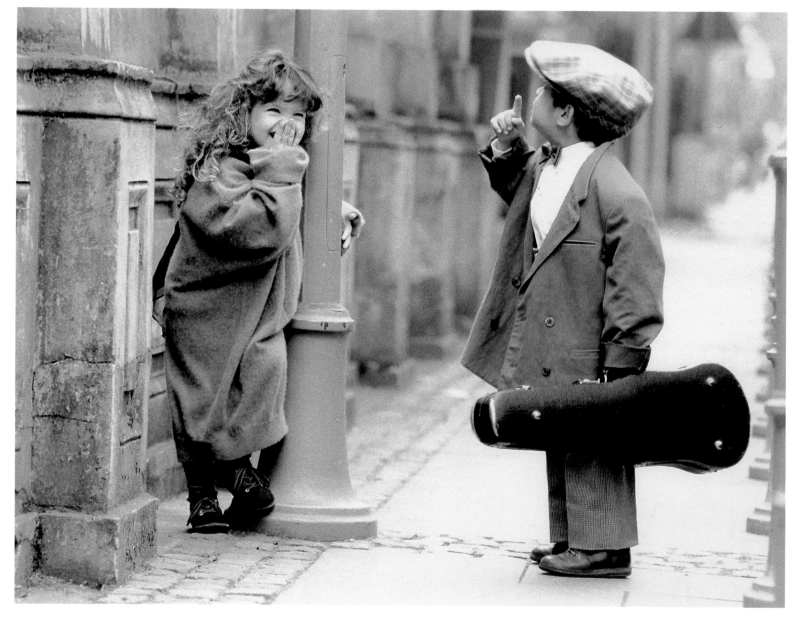

Laughter is the sound of friendship

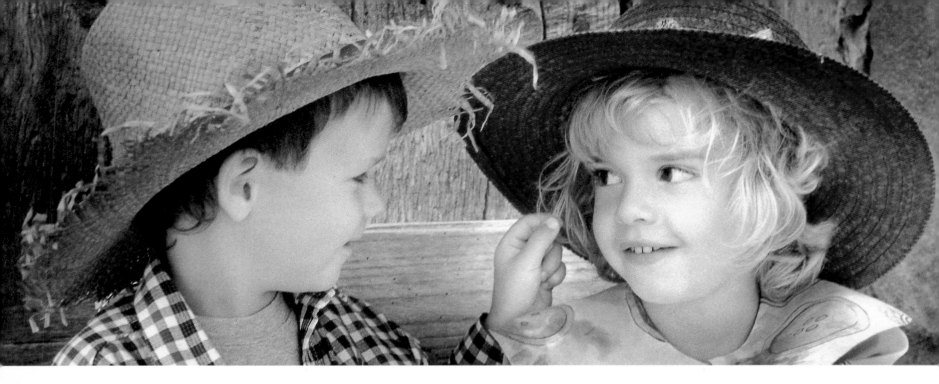

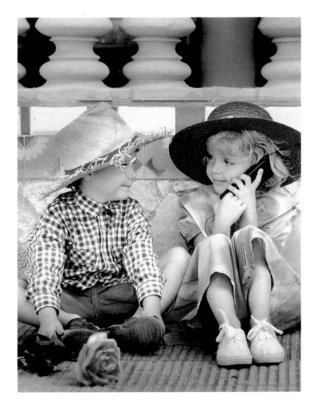

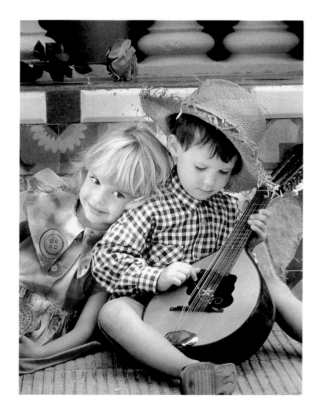

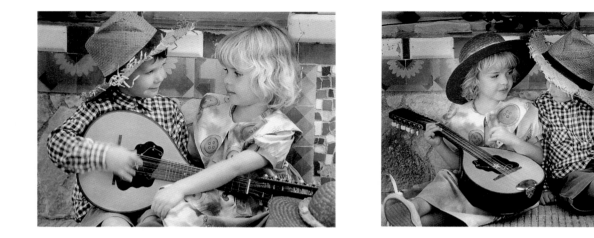

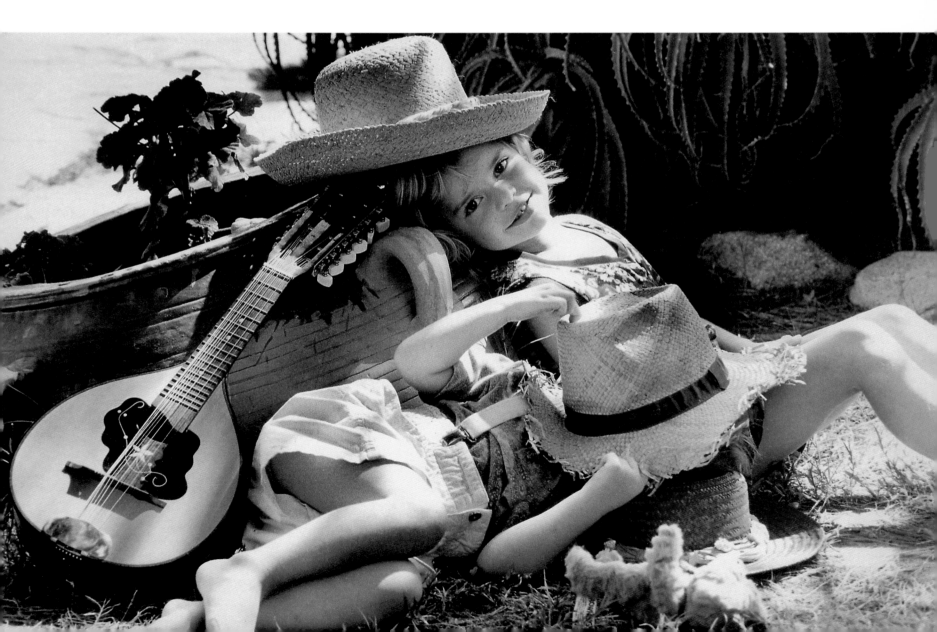

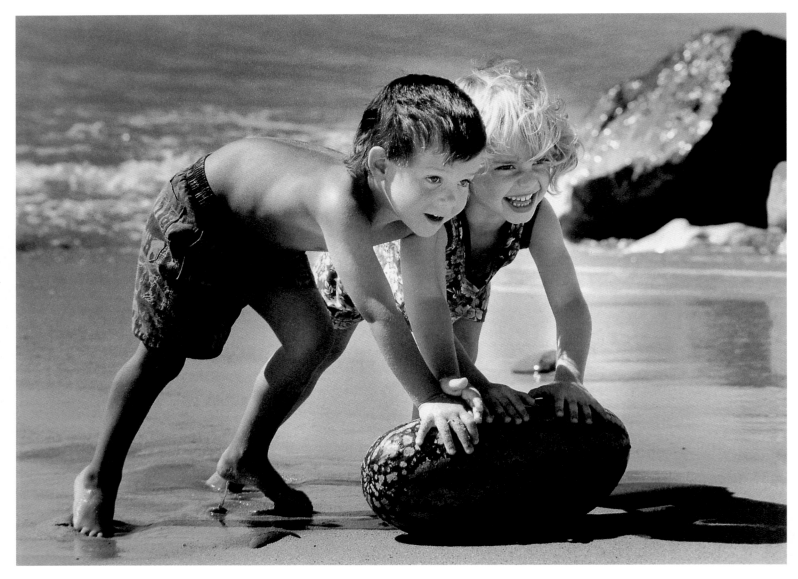

Teammates

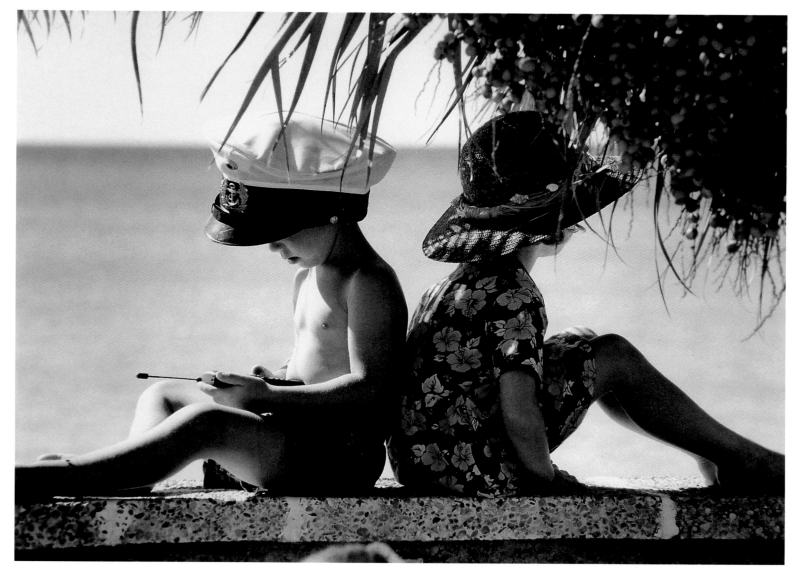

A kingdom by the sea

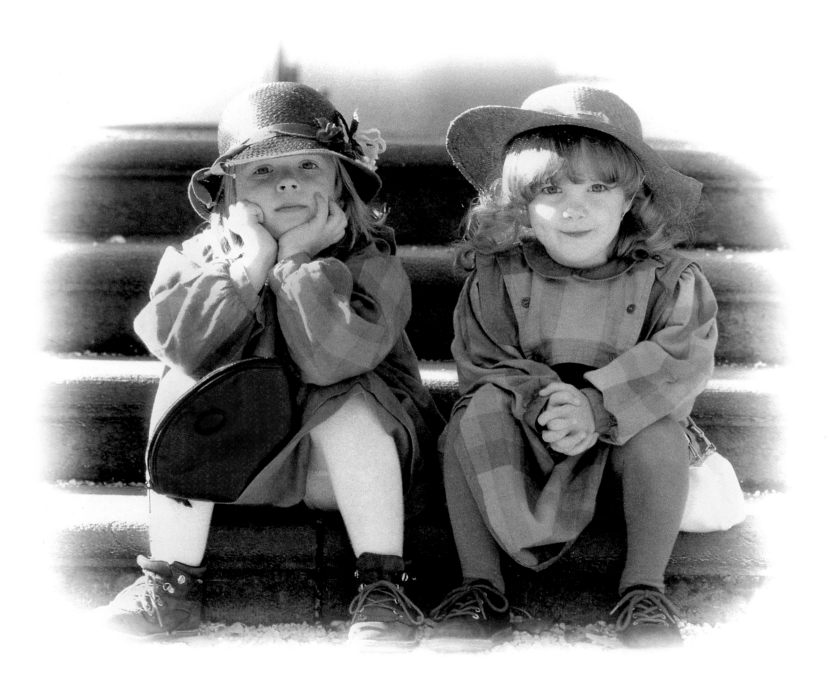

Hanging out

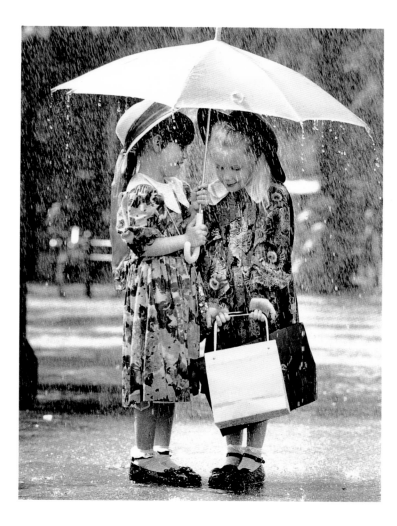

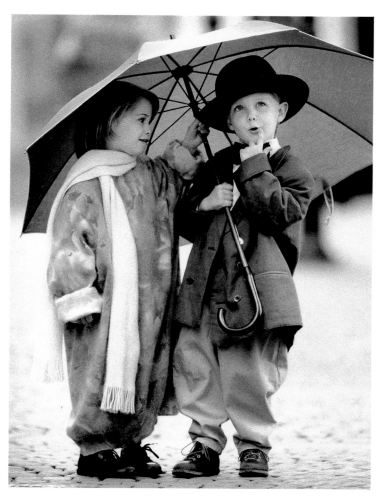

Rainy day friends

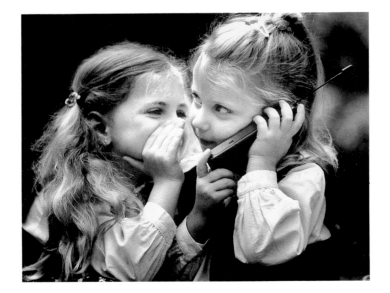

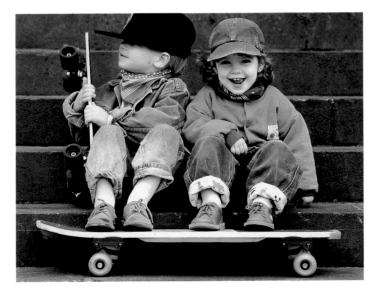

Secrets and skateboards

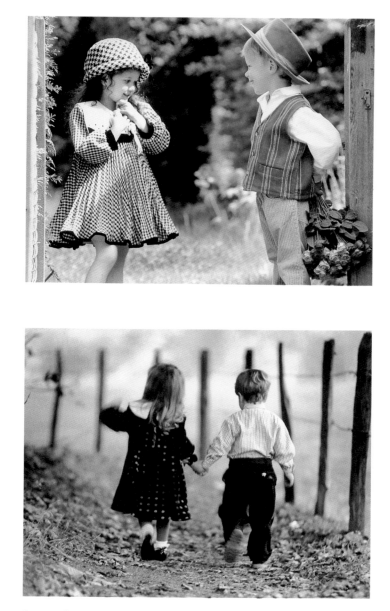

Into the woods

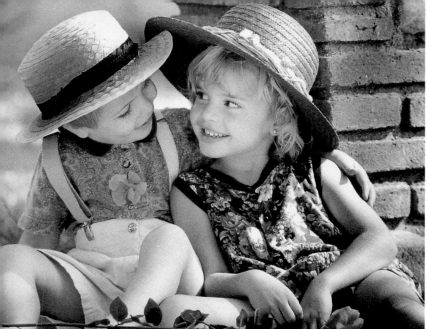

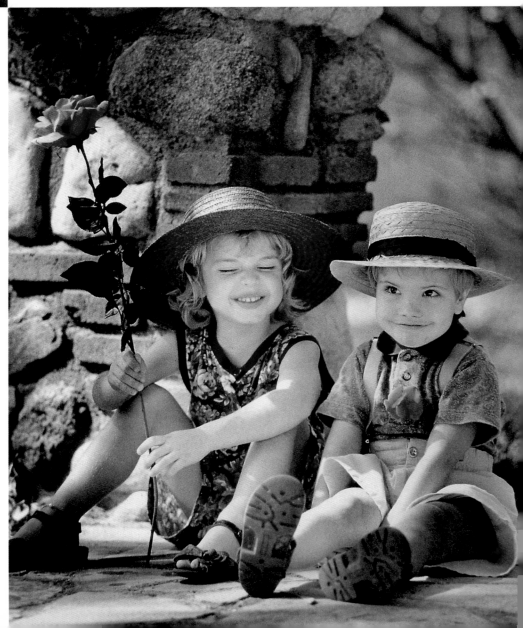

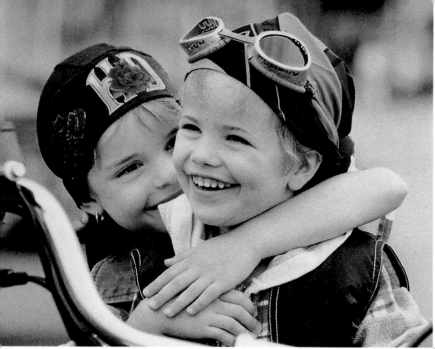

Happy days

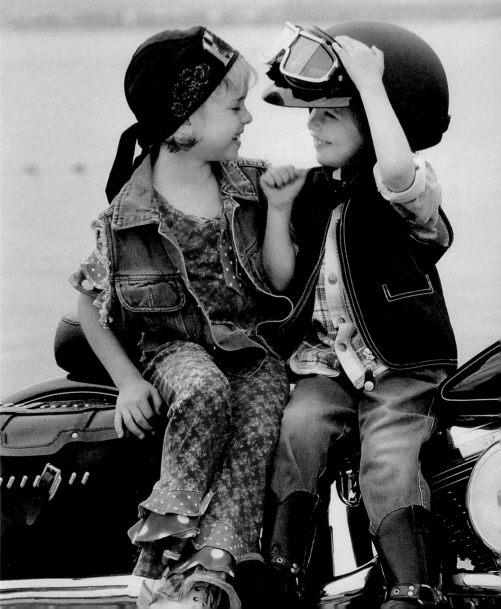

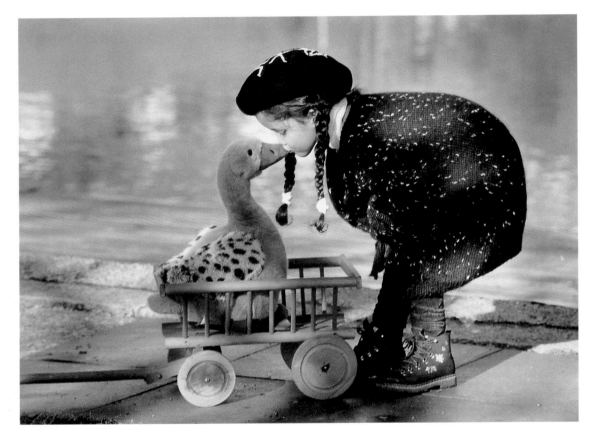

Silly goose

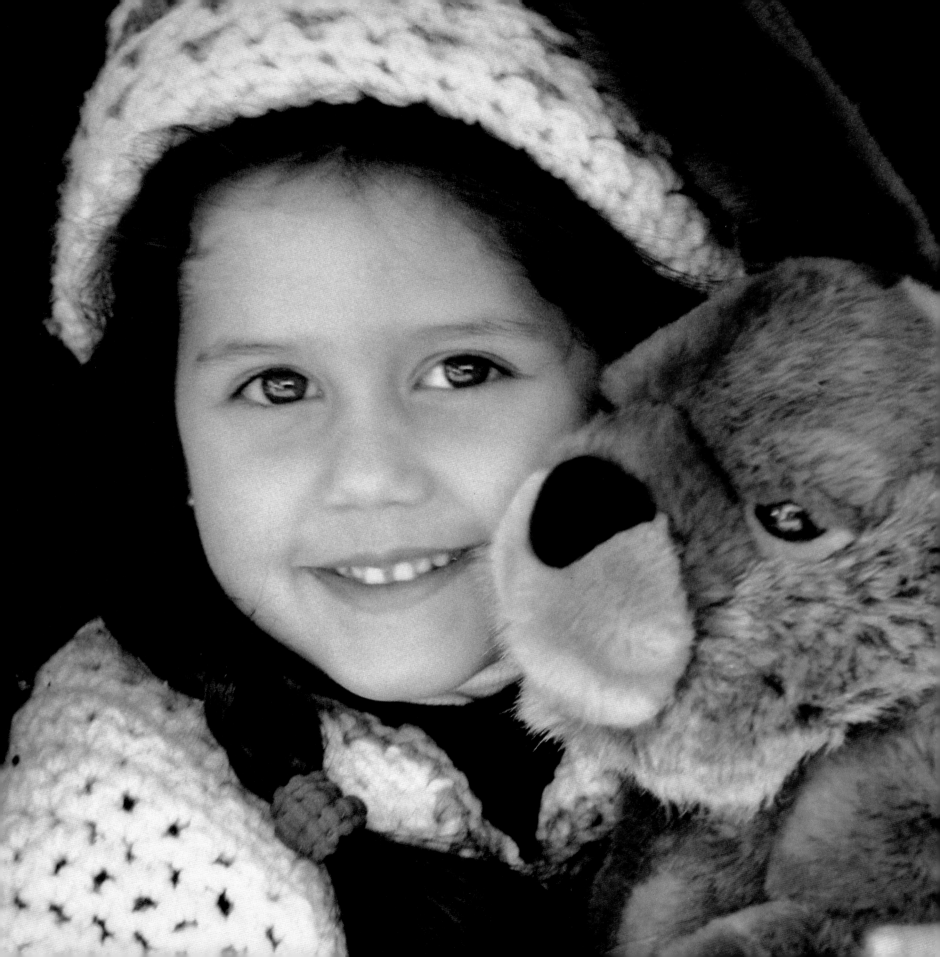

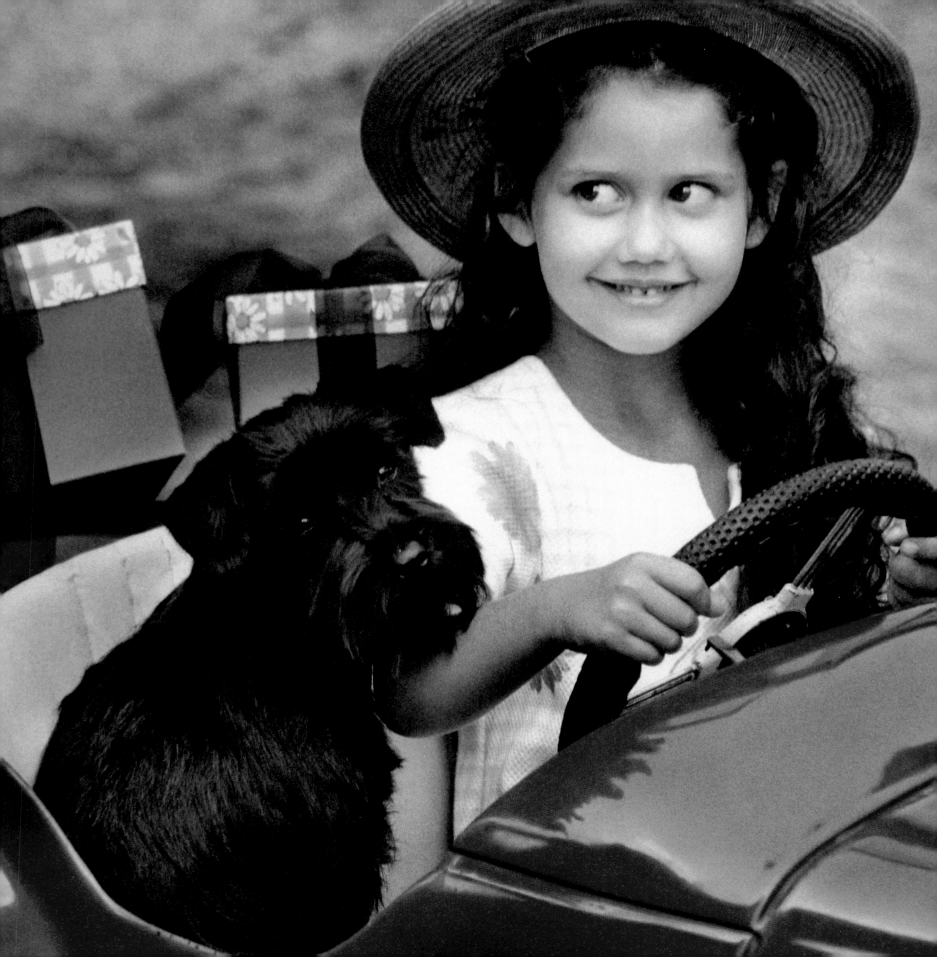

LET'S PRETEND

Essay by Francine Prose

Pretending is how we find out what it is like to be . . . to become. To be grown up, older, wiser, braver, independent. Different. By putting on a costume—our mothers' dresses and high heels, our fathers' roomy jackets, angel wings and glitter wands—we step into another skin, and we hope that skin will change us. Or at least that the game will let us experiment, try on how it might feel to be changed. The adult world loses some of its scary mystery when children pretend to be adults, and the secret sources of their parents' power are rendered less intimidating, more approachable, harmless—comical, in a way. Children pretend to be their parents, at home or at work, long before they have any idea what exactly their parents *do*.

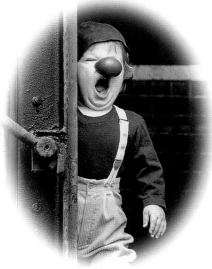

As children, we pretend to be what we *want* to be, or what we fear becoming, or to possess what we know we can never have and still cannot stop wanting. Meanwhile, we enjoy the intoxicating freedom to use our imagination, to exercise it the way we exercise our fingers with piano scales, to reinvent the world and ourselves. Playacting lets children step out of their familiar lives and enter into another realm limited only by how much and how far they can imagine. By pretending, they can escape from the most basic laws of science and nature—they can travel in time and space, defy gravity, change shapes, grow younger and older.

In Katherine Mansfield's exquisite story "Prelude," a group of little girls (exiled to the margins of the world of grown-ups too distracted by their own worries to pay much attention to their small daughters) have a classic tea party. At each place, one of the children sets out "two geranium leaf plates, a pine needle fork and a twig knife. There were three daisy heads on a laurel leaf for poached eggs, some slices of fuchsia petal cold beef, some lovely little rissoles made of earth and water and dandelion seeds, and the chocolate custard which she decided to serve in the pawa shell she had cooked it in."

What is it about a tea party that so entrances little girls, with its elaborate formal rituals of a bygone era? Even girls who spend most of their leisure time scrambling on jungle gyms, plummeting headfirst down slides, beating boys at races and games—even they can nearly always be tempted by the chance to dress up, set out little plates, and daintily decant homemade concoctions from one container to another. It's the dream version of womanhood, all elegance, friends, and bright chatter, a fantasy of our mothers glamorized, elevated, and freed from the sobering, unromantic encumbrances of dirty dishes and diapers.

With this magnificent miniature repast before them, the girls in the Katherine Mansfield story act out their drama of adults politely neglecting their children:

"Oh, good morning, Mrs. Smith. I'm so glad to see you. Have you brought your children?"

"Yes, I've brought both my twins. I have had another baby since I saw you last but she came so suddenly that I haven't had time to make her any clothes yet. So I left her . . . You needn't trouble about my children," said Mrs. Smith graciously. "If you'll just take this bottle and fill it at the tap—I mean at the dairy."

Much of the pretending is about self-determination—and about understanding. If we

can only look like our mothers, speak like

our mothers, perhaps we can figure out

where their authority comes from and

why they are the way they are.

Meanwhile, little boys seem to have

their own visions of power, not a few of which

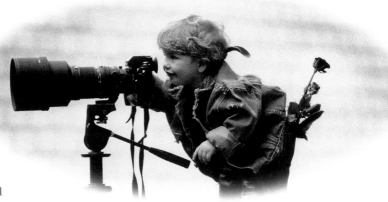

involve the ability—and the freedom and permission—to chase down bad guys and shoot

them dead. (Many parents, including myself, who discouraged or even forbade their sons to

play with guns, have been chastened in realizing that a thumb and forefinger, held at right

angles, packs plenty of firepower.) Games of pretend are also about magic and about the

wish for transformation—an expression of our instinctive sense that one life will not be nearly

enough for us—and of our desire to be as many different people as we can, to lead as many

different lives as we can. Pretend is also about looking for whatever qualities we know or

intuit, that we ourselves are lacking. Solitary children are most often the ones who have

imaginary friends. The timid pretend to be warriors, lion tamers, and explorers.

When I was a little girl, one of my favorite games of pretend involved the fantasy

that I was a tightrope walker in the circus. My high wire was a strip of cement, something

like a curb, perhaps three or four inches high, that marked the edge of our property and

divided our driveway from that of our neighbors. With my arms outstretched, balancing

precariously and theatrically, I'd walk the length of the curb, carefully placing one foot in

front of the other. I could almost hear the cheers of the crowd below and their gasps of

horror when my foot slipped off the cement and, howling as if I were falling, I plummeted

down toward the imaginary net. In retrospect, I can see precisely why this game delighted

me so. I was a reticent, shy child, more than a little bit awkward, and troubled by many irrational fears that miraculously disappeared as I confidently and gracefully walked that wire suspended way up in the big top.

Some of the games that give children the most pleasure involve pretending to be creatures or things that no sensible human would ever want to be, or pretending to suffer terrible fates that no one would choose to endure. Let's pretend we're earthworms. Let's pretend we're bugs. Let's pretend we're big nasty dogs and bite your little sister. Let's pretend we're martyrs being burned at the stake. Let's pretend we're spies and we're being tortured so that we'll give up our secrets. And of course there's that perennial children's favorite that we loved to play and that I would have been very upset to catch my own children playing: Let's pretend it's a funeral and we're dead—and see how sorry everyone is.

When my brother and I were small, one of the games that held the most enduring claim on our attention was the decidedly undramatic and unromantic game of "grocer." What was it that fascinated us? I assume it was partly the attraction of playing any kind of adult—butcher, baker, candlestick maker. But beyond that it must have been the sheer pleasure of buying everything— and only what we wanted. All the candy, the cookies, the ice cream. We were in charge.

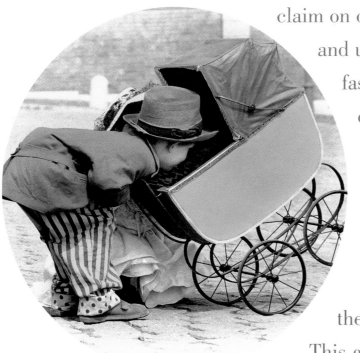

My all-time favorite game was "invisible," the point of which was exactly what it sounds like. This game took some complicity from whoever was

around—the others had to agree to pretend not to see me. Other kids didn't have patience for this—*they* wanted to be the invisible ones—but adults seemed fairly good at it and were quite happy to do whatever they were doing (cooking, reading, mowing the lawn) without having to notice that I was there. I remember a few times becoming a little worried that I'd really done it, that no one could see me. And I hadn't the faintest idea how to reverse what I'd done.

The hardest thing to remember about childhood games of pretend is how real they can seem, how fine the line between inside and outside the game. I remember pretending that I had stepped inside my favorite illustrations in my favorite fairy-tale books. I can remember the *fact* that I felt as if I had left my house, my room, and walked into the enticing, thrilling, faintly terrifying landscapes in which Hans Christian Andersen and the Brothers Grimm stories were being enacted—East of the Sun and West of the Moon. But of course I cannot recall the *feeling* of melting through the surface of the picture, blending into that other place, that castle or meadow or forest from which I would have to find my way back to the actual world.

Perhaps this is a talent that actors hold onto—and go on to spend their adult professional lives pretending. Writers, con artists, compulsive liars all must retain some of that ability to be convinced, entirely convinced, by whatever story they happen to be telling. Still, it's not nearly the same. There is something unique and fleeting and amazing about children playing pretend, children who don't realize that never again in their lives will they be able to slip so fluidly, so seamlessly from one skin into another. Never again will it be quite so easy, so effortless to cross that mysterious, radiant zone, to make that magical transition between pretending and becoming.

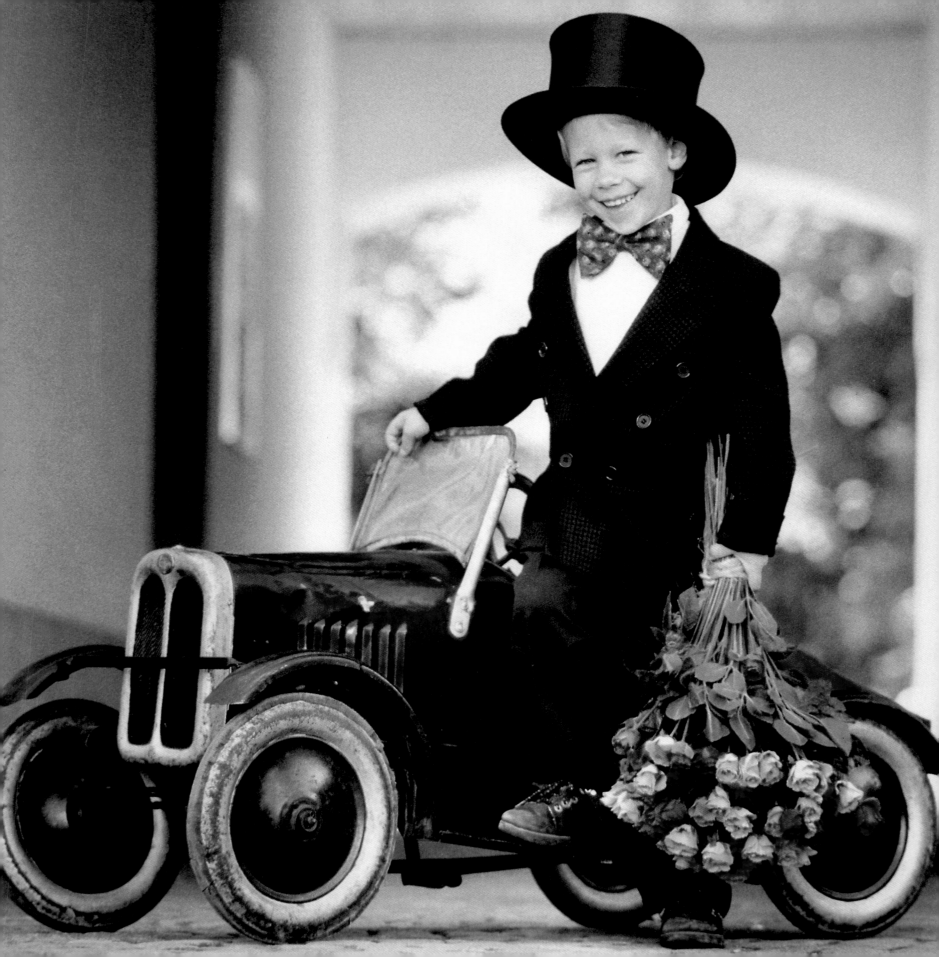

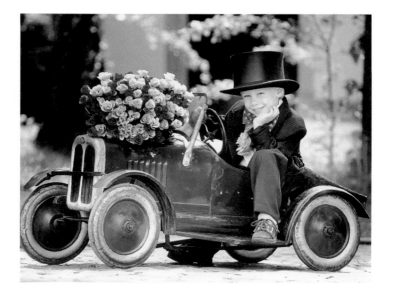

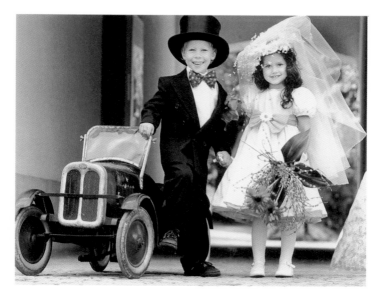

"And now King Babar and Queen Celeste, both eager for further adventures, set out on their honeymoon." —Jean de Brunhoff

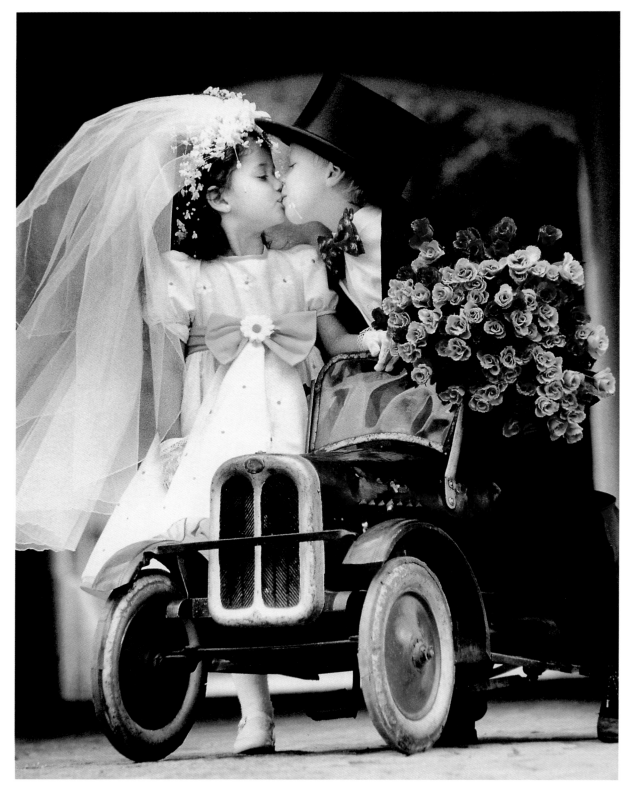

*What
shall
I be
today?*

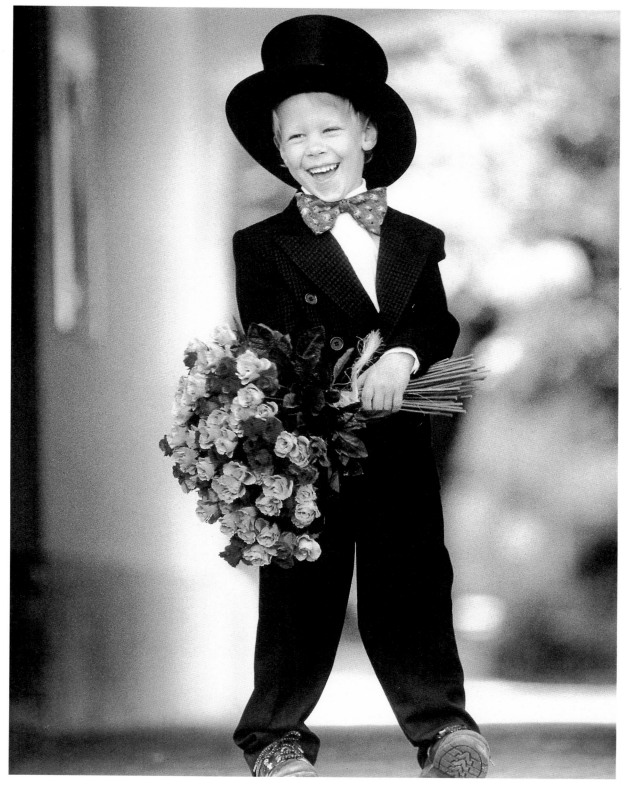

*Dressing
the part*

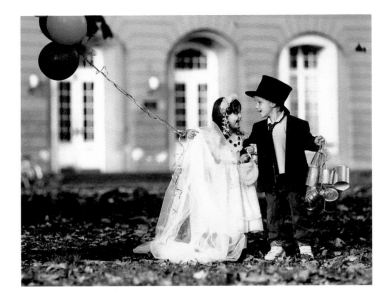

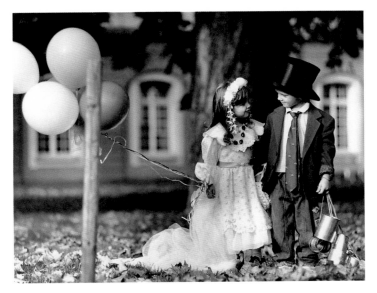

From this day forward

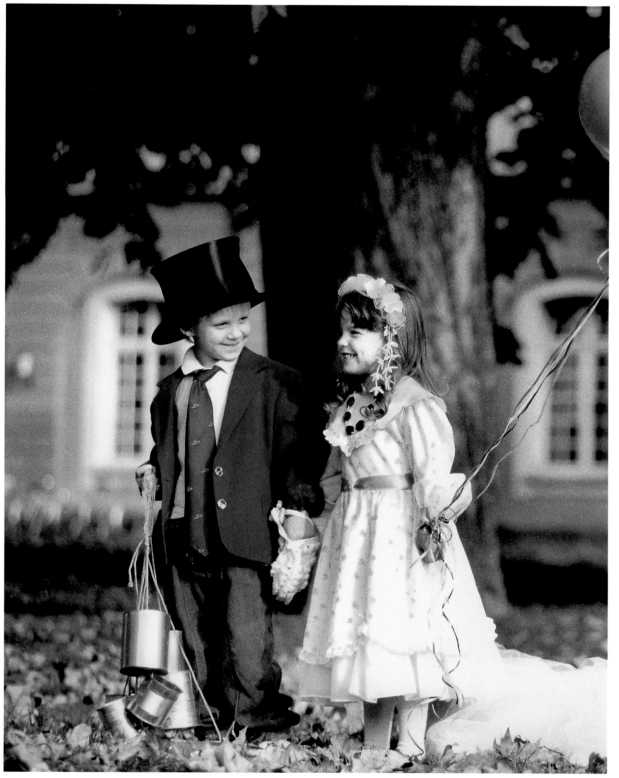

For
better
or for
worse

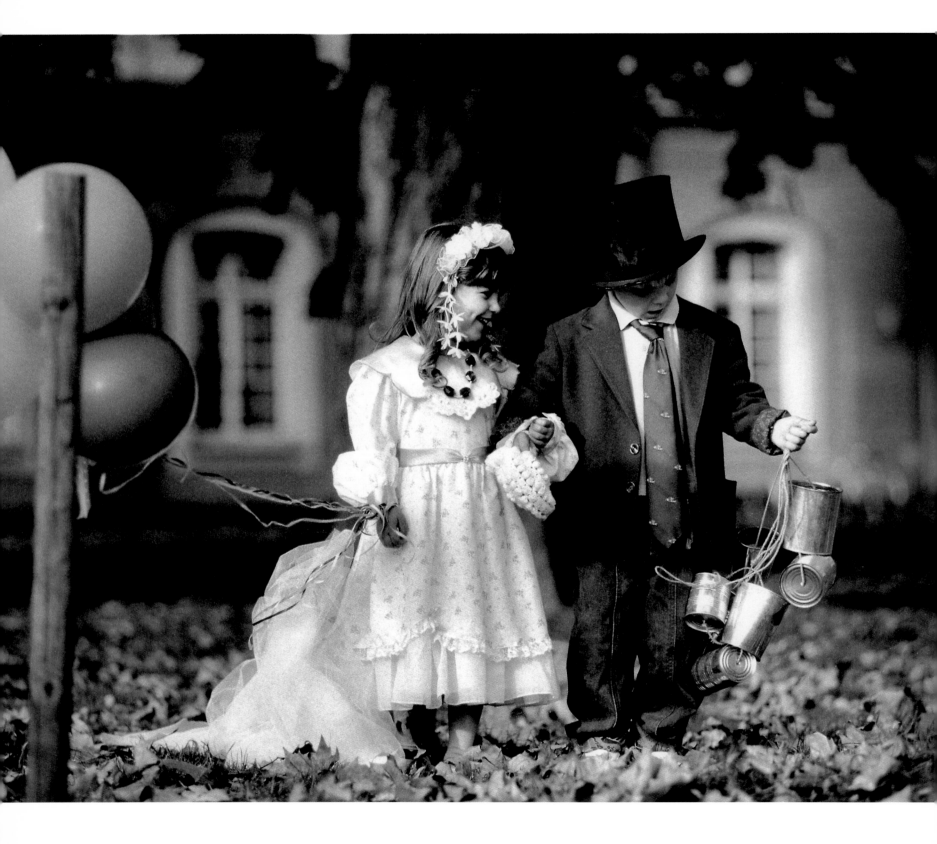

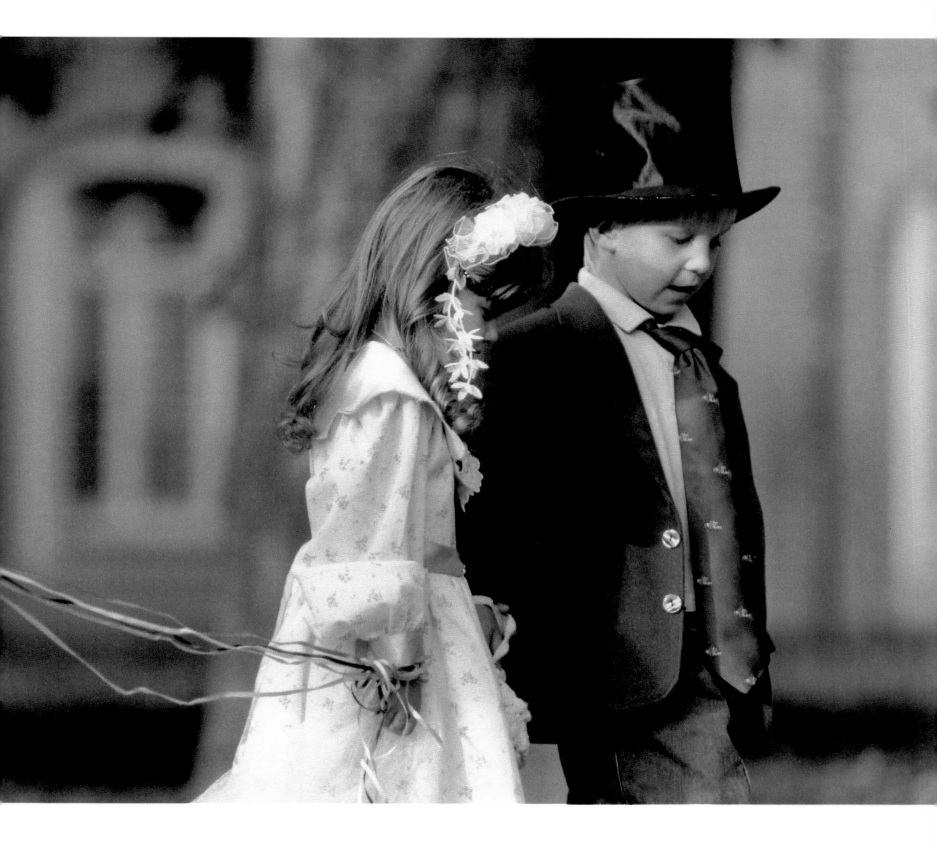

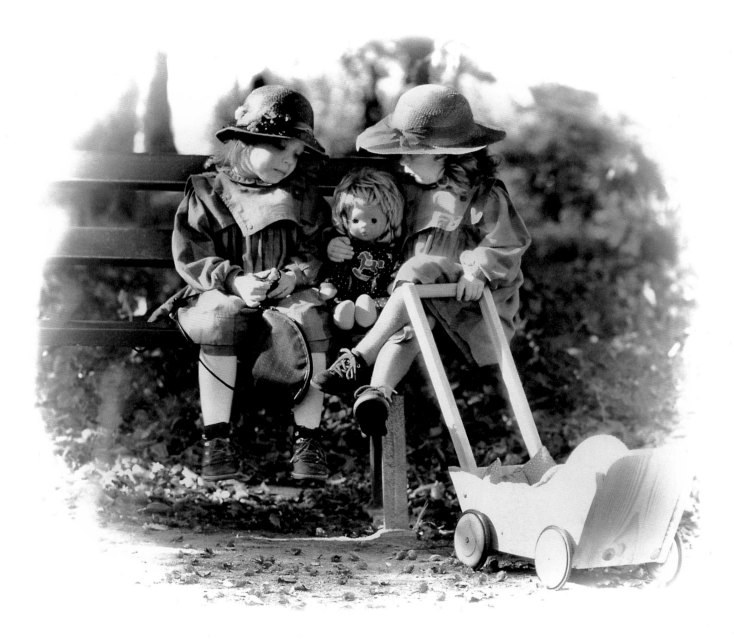

Play date

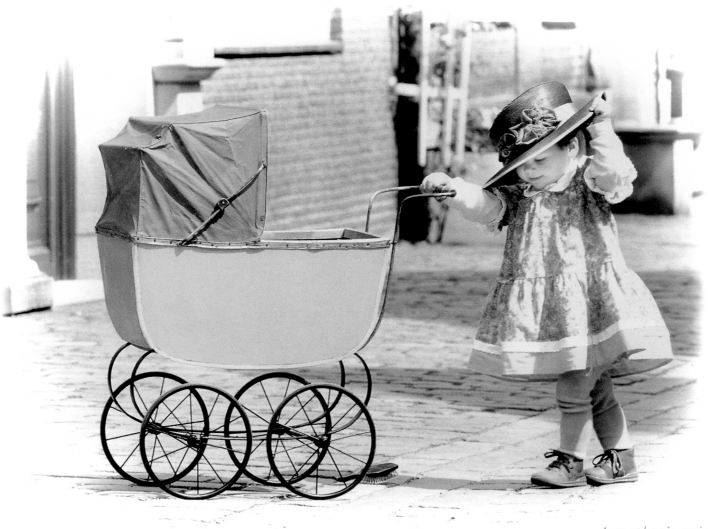

A mother's pride

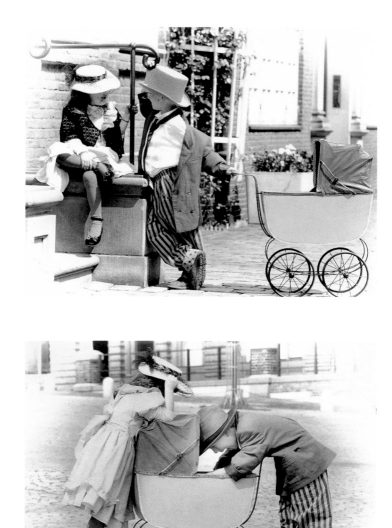

Guys and dolls

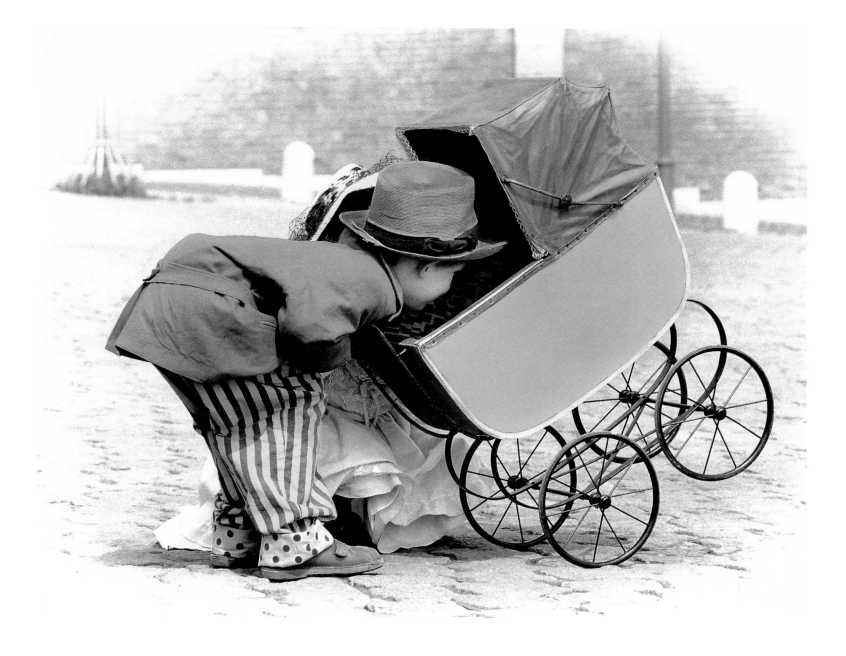

Queen for a day

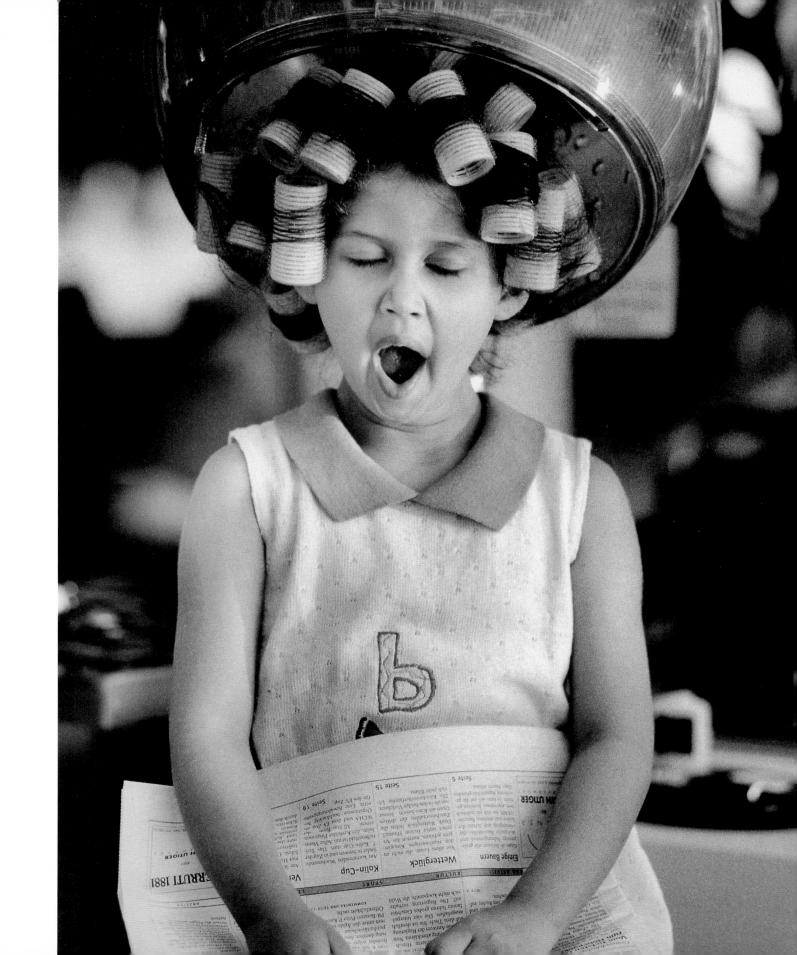

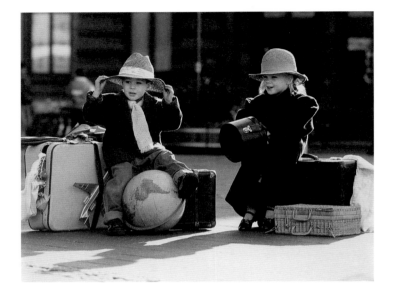

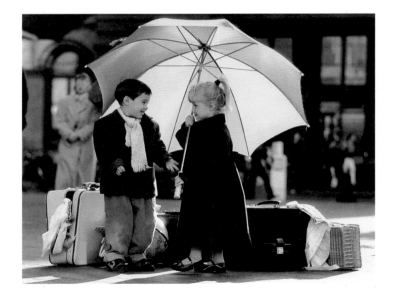

Jet set

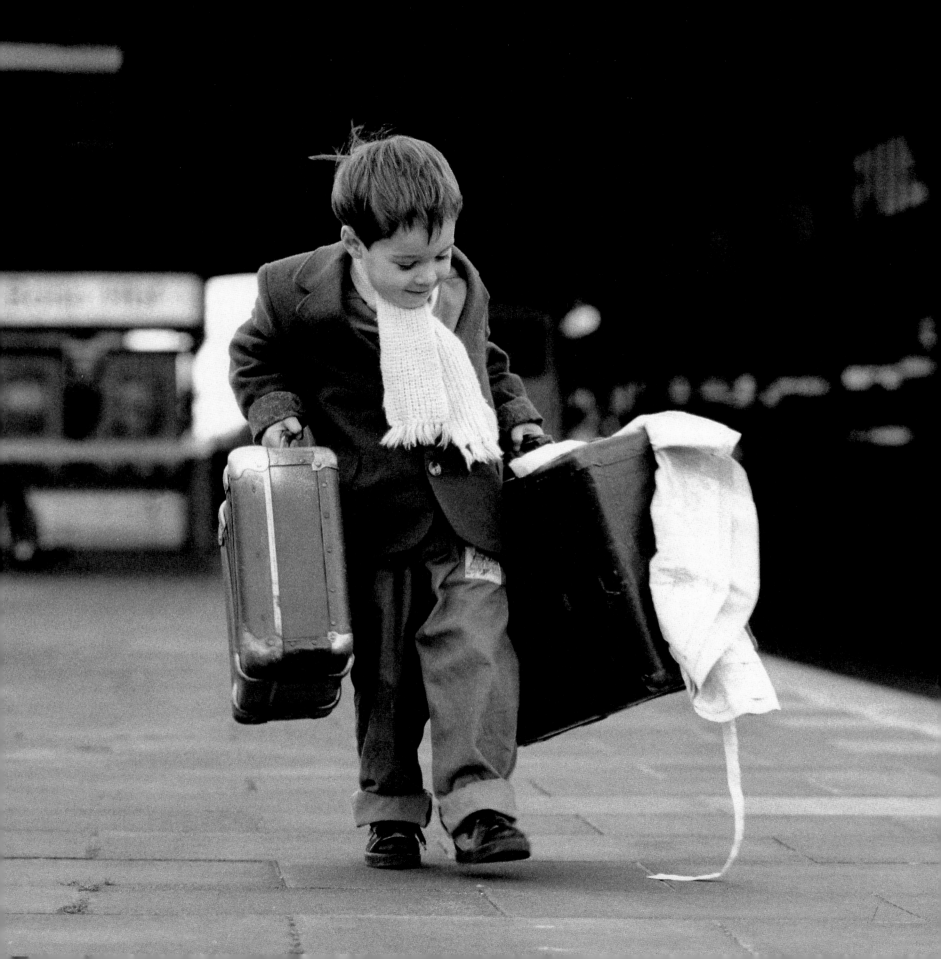

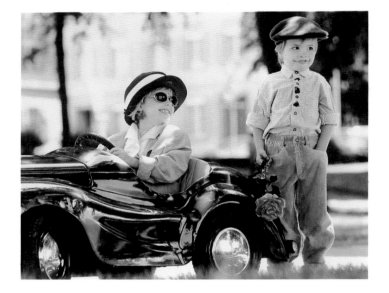

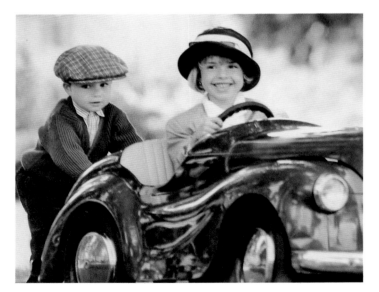

Two for the road

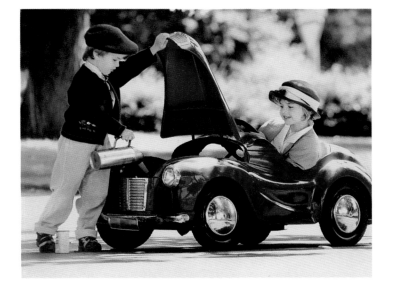

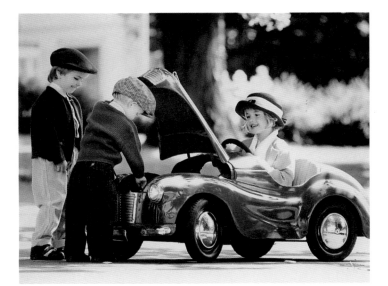

Jump start

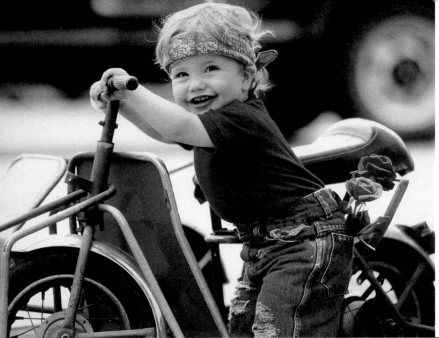
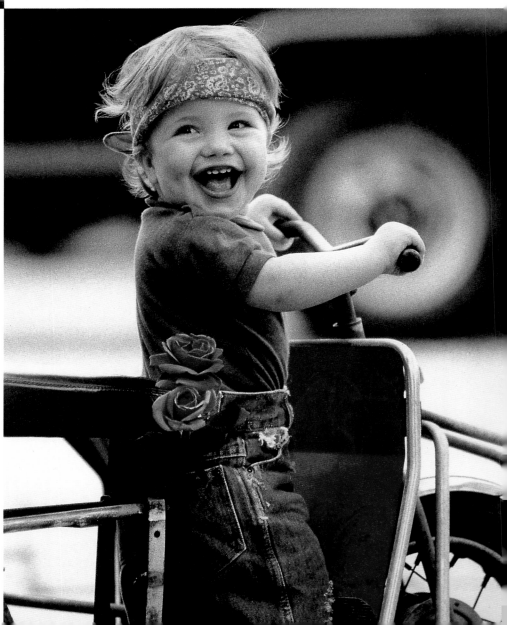

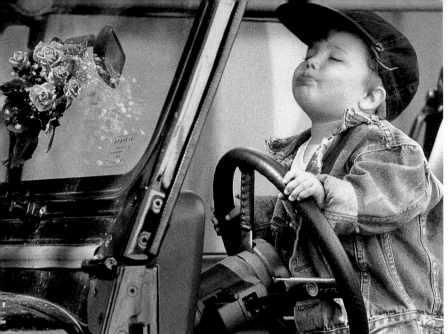

Ready, set, go!

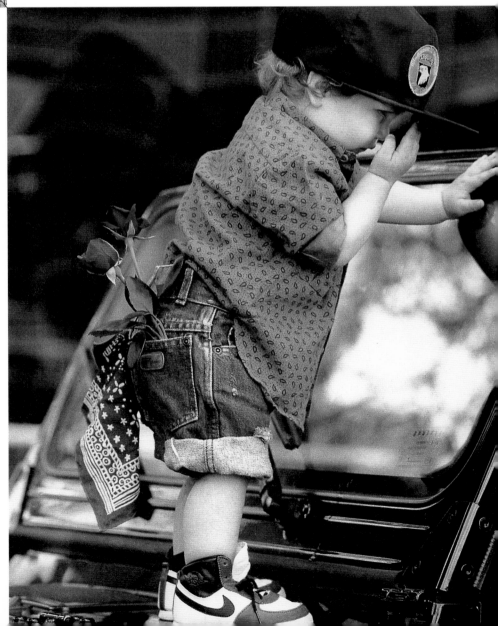

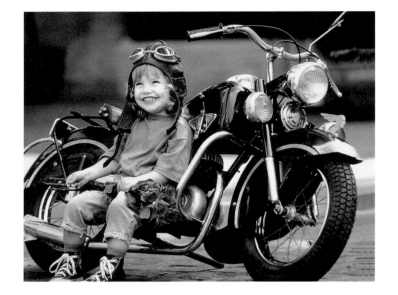

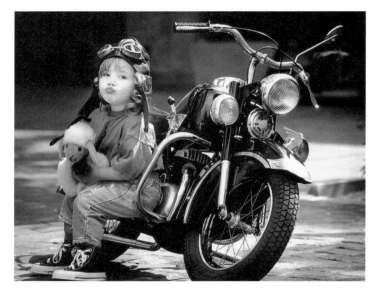

All revved up

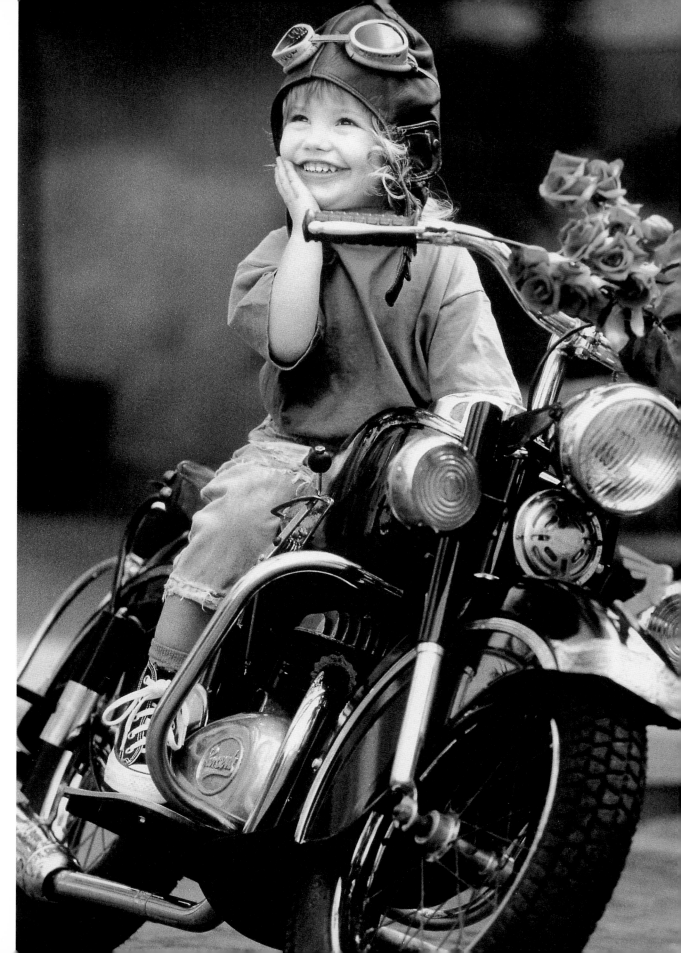

Breezy rider

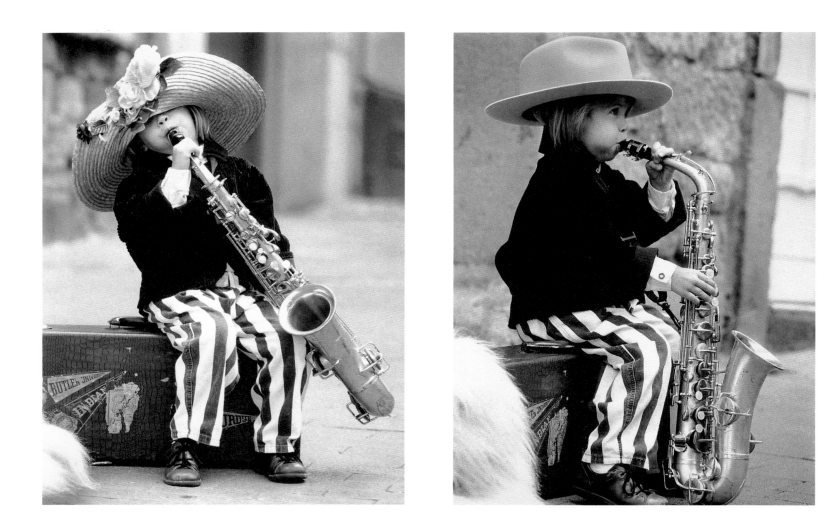

"Heard melodies are sweet, but those unheard are sweeter." —John Keats

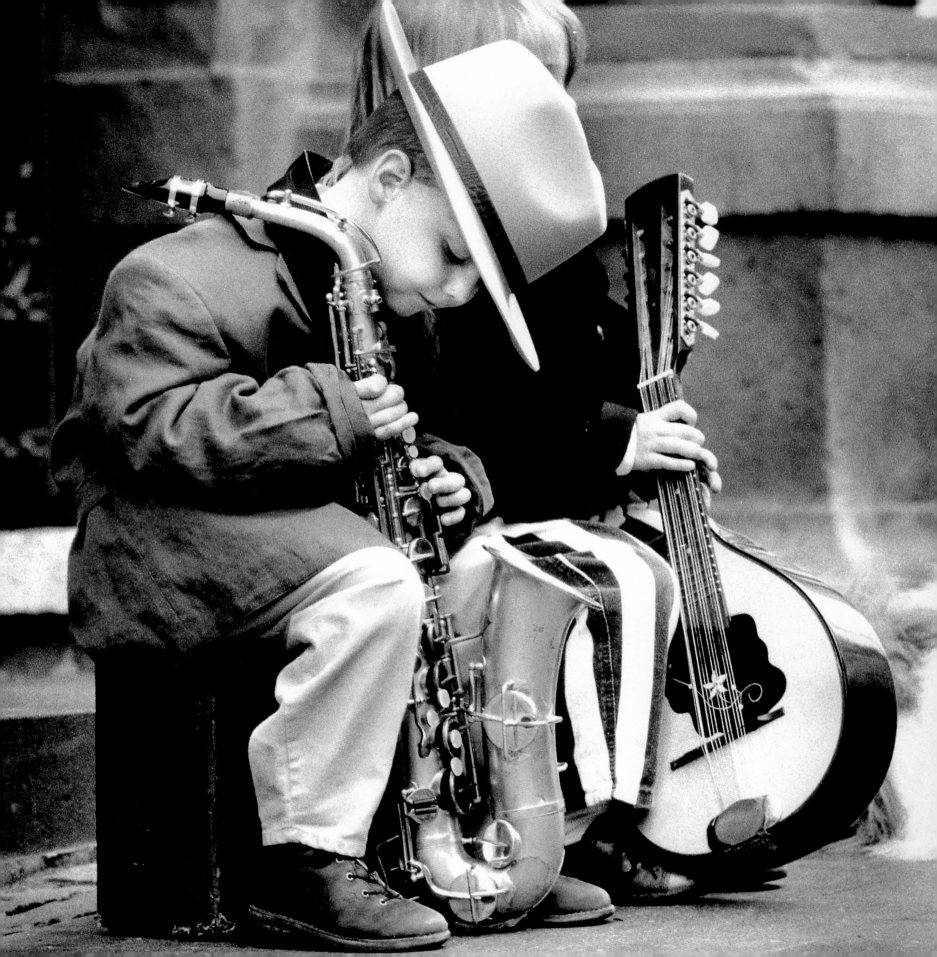

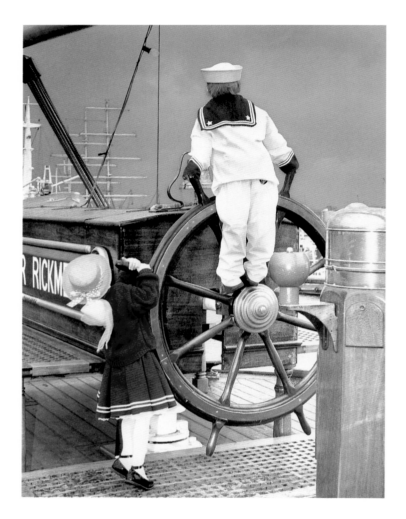

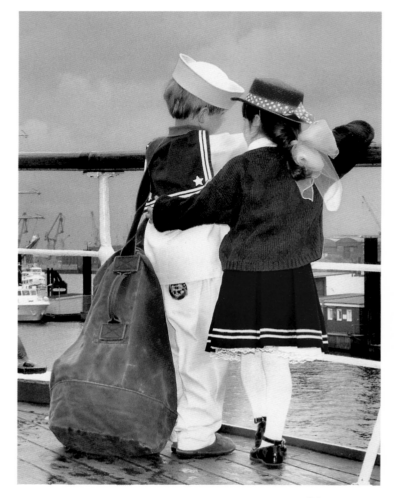

First mate

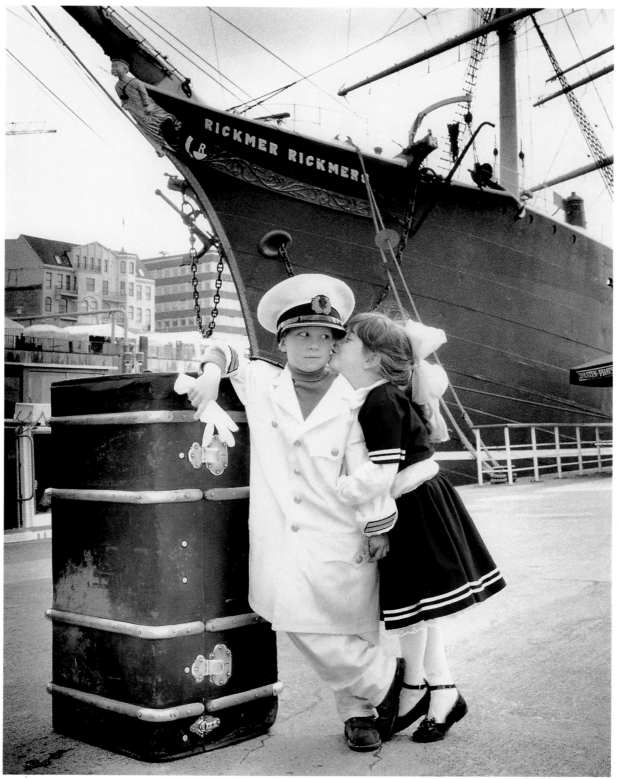

*Bon
voyage*

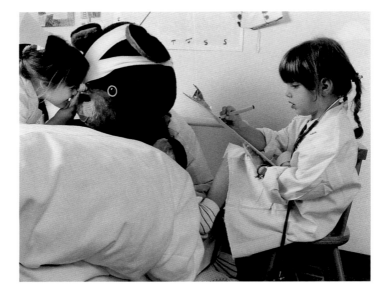

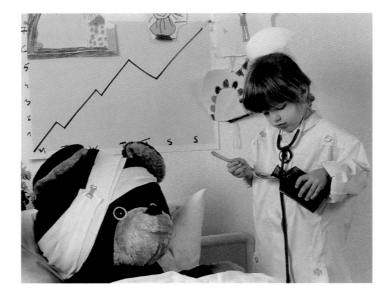

Bedside manner

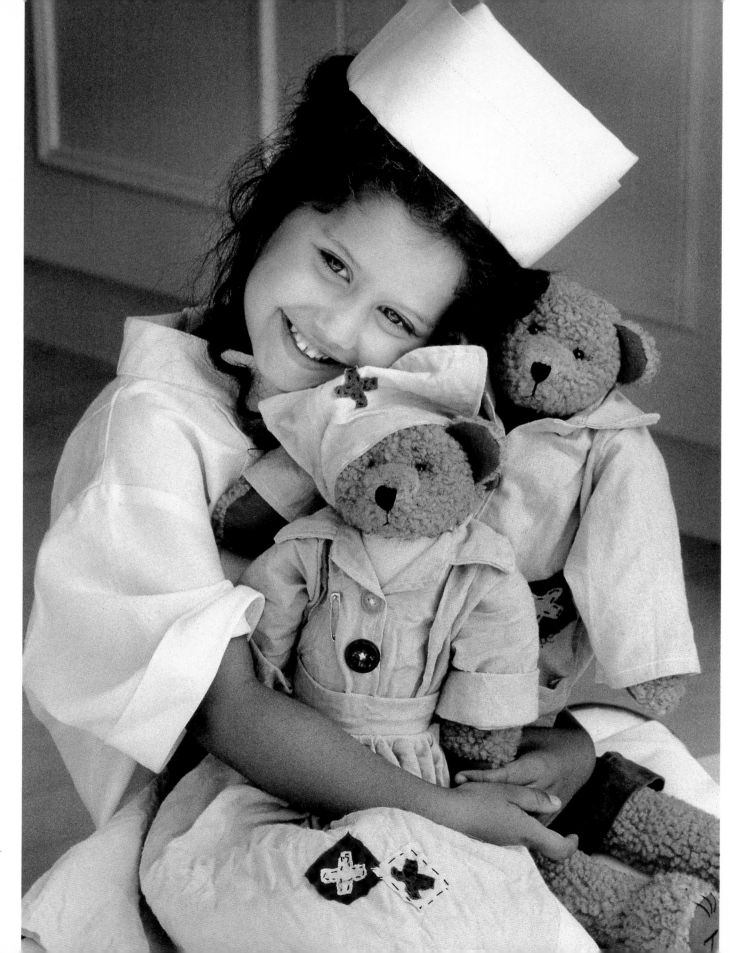

All better

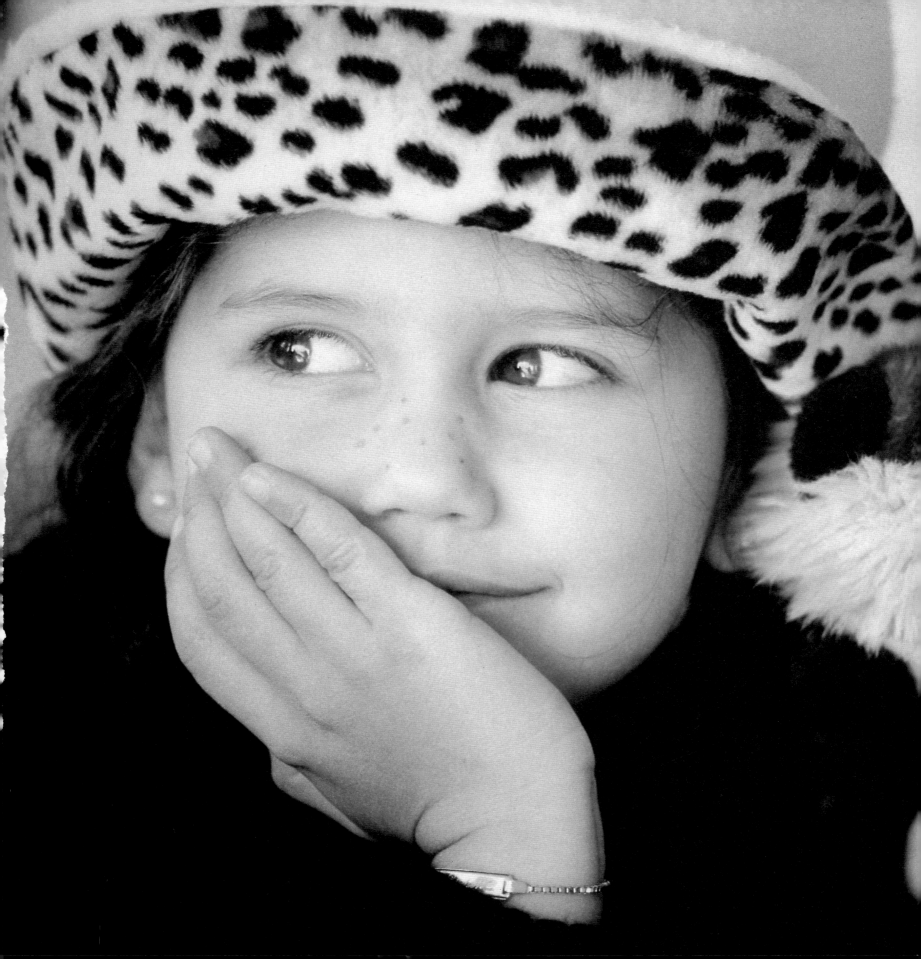

LITTLE GIRLS

Essay by Letty Cottin Pogrebin

Henry James once said that the two most beautiful words in the English language are "summer afternoons." Obviously, he'd never heard the words "little girls."

Whether it's the elfin damsels in these photographs or any Muffet you've enshrined on a tuffet of memory, little girls are the human embodiment of all things sweet and lovely. Little girls are summer afternoons. Also ice-skating ponds and warm chocolate pudding. Straw bonnets with satin streamers. Pretend tea parties. Arms open wide for a hug. Little girls personify trust and purity, our once and future innocence, unsullied and unscarred. 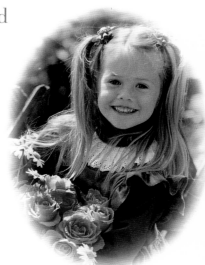 But sweetness accounts for only half their glory. The other half is grit—the firm set of a small jaw, the strength and reach of sturdy arms and legs, the courage that inspires our daughters to outgrow us in every way. That today's little girls can be both beautiful and brave is one of the lasting rewards of 20th-century feminism. That I gave birth to two wee wonder women—twins who are now in their thirties with children of their own—is one of the eternal miracles of my life.

Entering time's tunnel, I can conjure my little girls with ease. The memories, sweet and savory, bubble up with unfailing effervescence. In one precious image, Abigail and Robin are two-and-a-half years old, flower girls at an uncle's wedding. As instructed, they toddle down the aisle in their white organdy dresses, carrying wicker baskets from which they carefully extract

one rose petal at a time and drop it to the floor. Suddenly, Robin looks behind her at the trail of flowers on the carpet. "Uh-oh," she says to her sister. "Mustn't litter." Then, faces clouded with concern, they retrace their steps, pick up the petals and replace them in the baskets.

They were good girls. But also bold and creative, joyful and funny. At three, elbows scrimmaging behind the living room drapes, their baby voices called out, "Take your seats. Curtain going up." Moments later, they burst out of the folds singing the civil rights anthem, "We Shall Not Be Moved."

Though both turned out to be writers, their childhood was about performance. They loved to entertain and mounted literally hundreds of extravaganzas, from nursery rhyme cabarets and tu-tu dance concerts to elaborate theatrical productions. Makeshift stages were always materializing between closet doors and tacked up sheets. My wardrobe was their costume chest. Their younger brother David and assorted friends were enlisted to play multiple roles, from the Tin Man to Toto, from Kanga and Roo to Nancy Drew. As their tastes and talents matured, they learned to play the guitar, do impersonations and foreign accents, act scenes from Broadway shows. Best of all were the original works "Written, Directed, and Choreographed by Abigail and Robin."

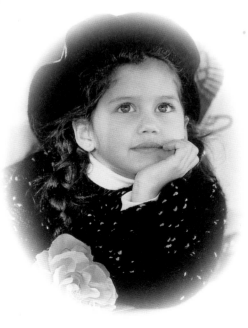

Our house has been a far less magical place since our little girls grew up.

Images fall from the past like pressed roses. In every scene, I confess with some embarrassment, I remember what my daughters wore. I loved dressing them up. Today, when they browse through family albums, they can't believe their feminist

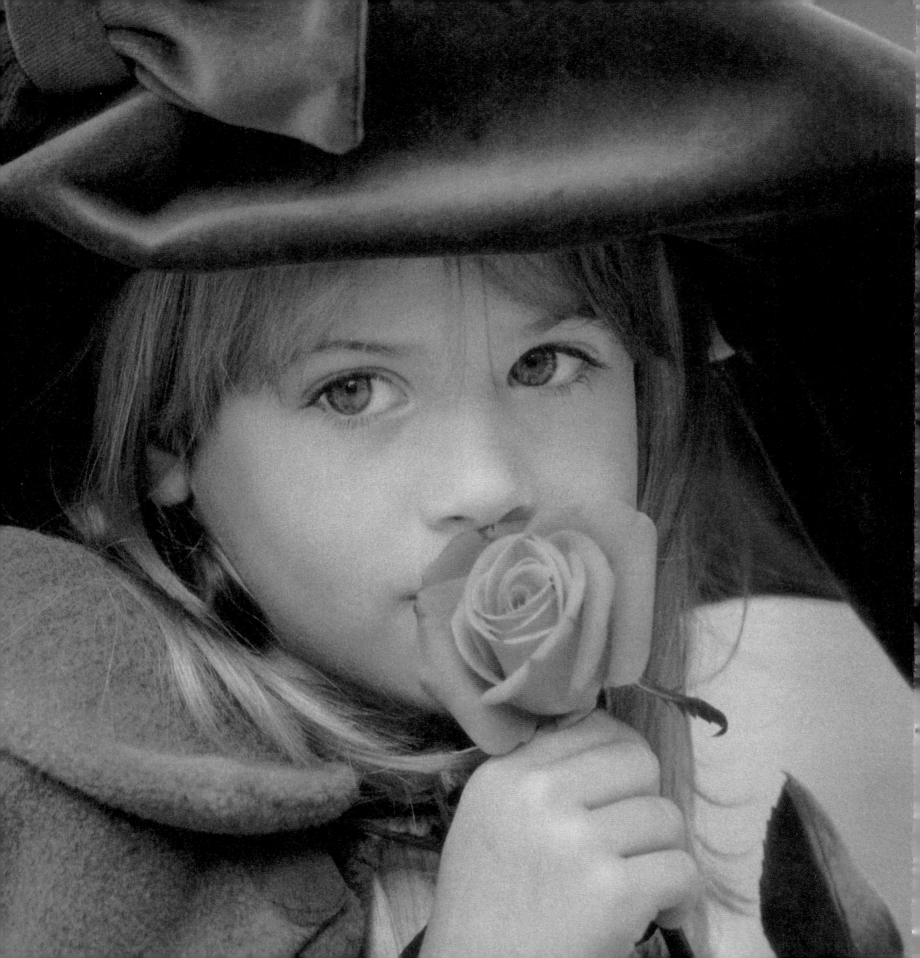

mother sent them into the world wearing bonnets and berets, floor-length dresses, velvet jumpers, flowered tights, and patent leather Mary Janes. But I did and I'd do it again in a heartbeat.

The other day, I was sitting on a plane next to a little girl who took me back thirty years. She was three or four, wearing a smocked calico dress of the sort I used to favor for my daughters. Her hair was cut in bangs, like theirs, a cross between Buster Brown and Louise Brooks, and she had big brown eyes and a chirpy voice and was just as impatient as I was about being stuck on the runway.

"When are we blastoffing?" she asked her daddy.

He grinned at me and said, "Don't you just love this age?"

Yes, I love that age, its inventiveness, its fresh take on the world, its unmitigated chutzpah. Robin and Abigail always coined their own phrases and spoke their minds. "I'm starving tired," they'd say. Or, "There's no room on your lap because your breasts are in the way."

Suddenly, I missed my children's childhood with a longing as deep as a sigh.

I wish we could start all over again, but that's what grandchildren are for. After Robin and Abigail each had a baby boy, they are now turning out daughters. "Sons branch out, but one woman leads to another," wrote Margaret Atwood in "Five Poems for Grandmothers," and like millions of women before me, I feel cradled in the web of female continuity. With my daughters as their mothers, my granddaughters are guaranteed a lifetime supply of girl-grit and gumption. My job is simple this time around—to cherish them and enjoy their company, to be their advocate and confidante, and to buy them velvet dresses, white tights, and Mary Janes. And maybe some matching bonnets.

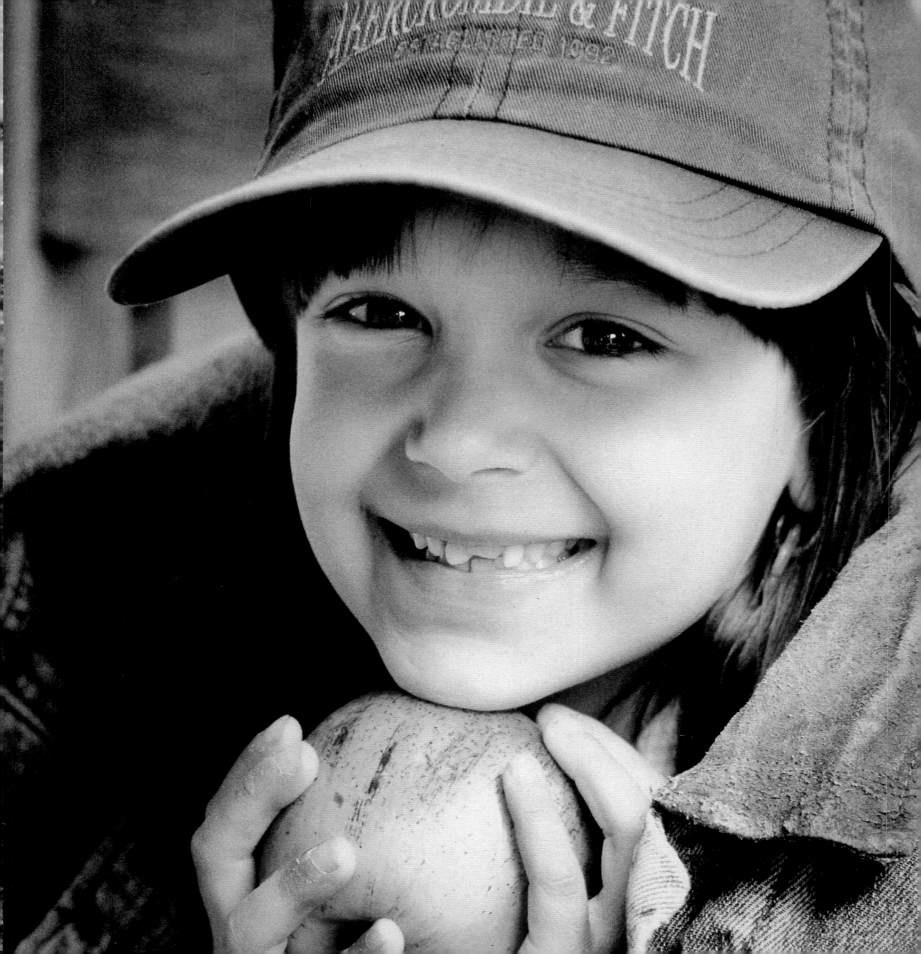

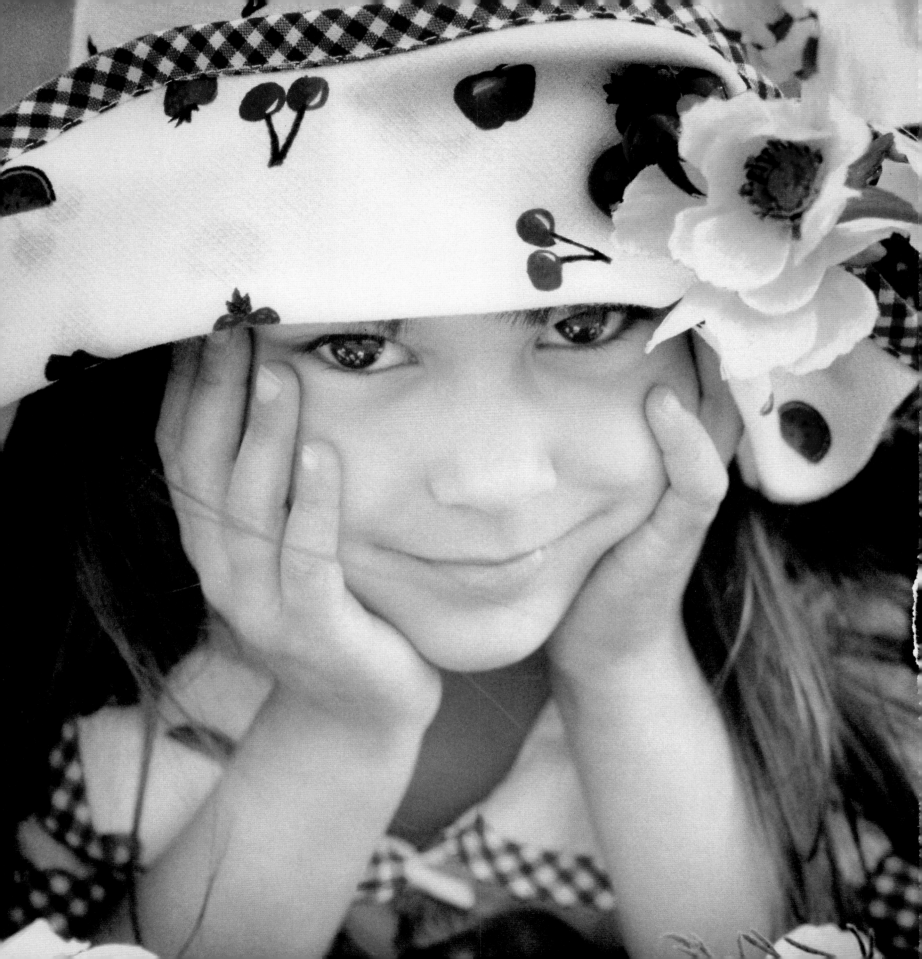

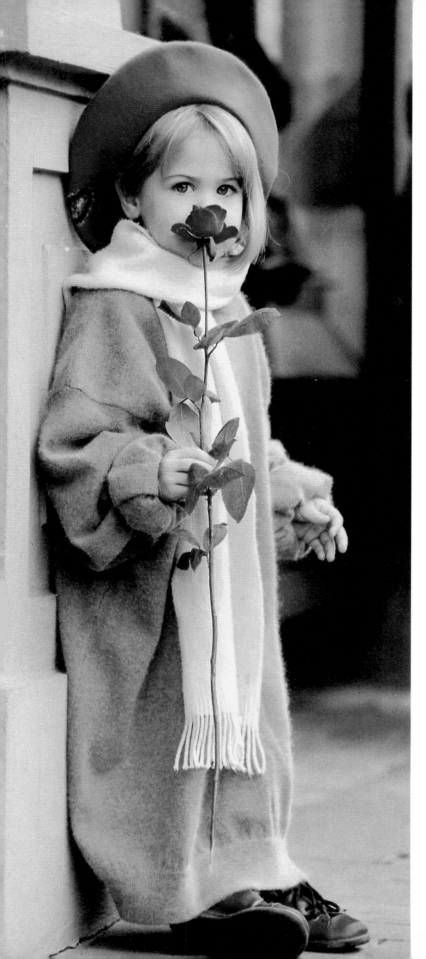

What are little girls made of?
Sugar and spice,
and everything nice.

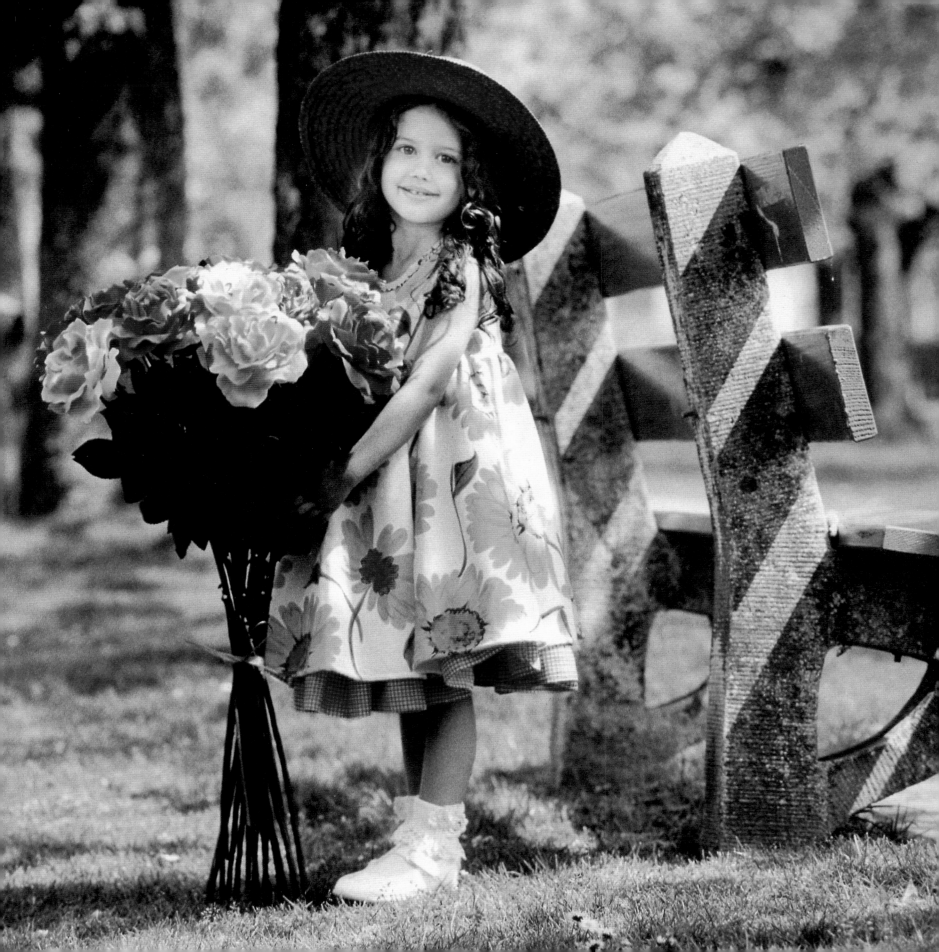

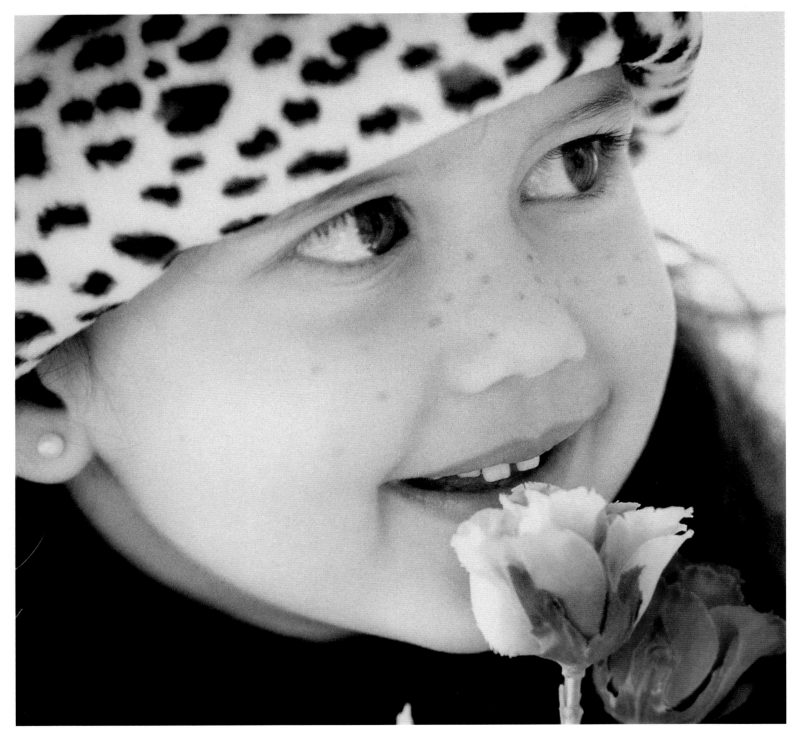

Younger than springtime

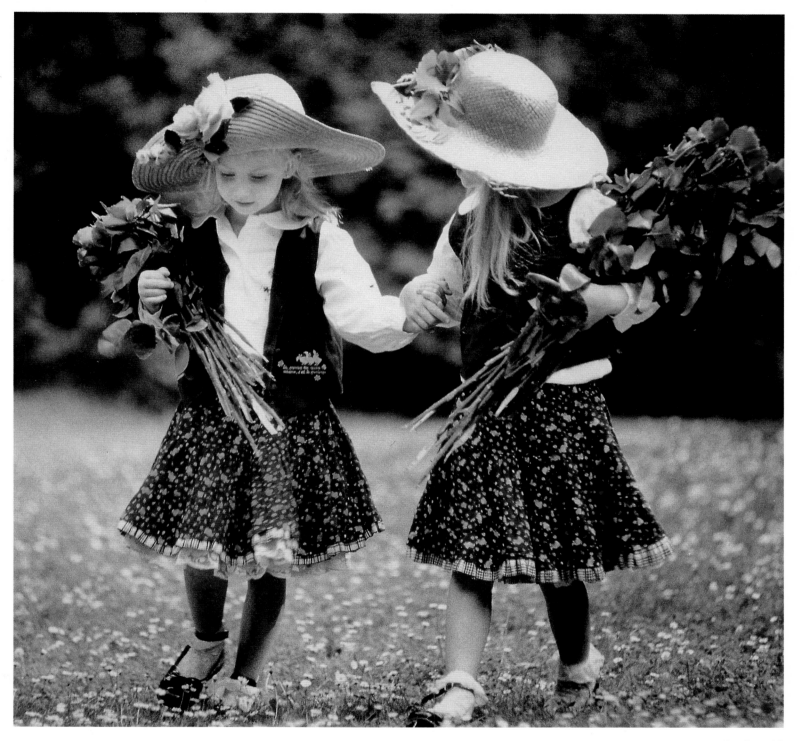

Girl talk

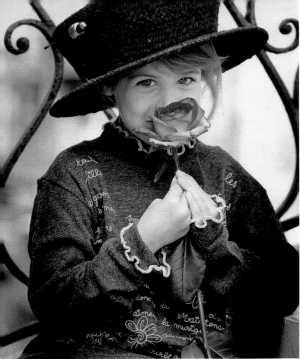
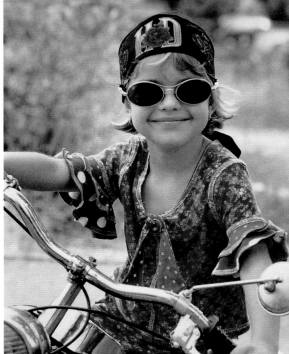
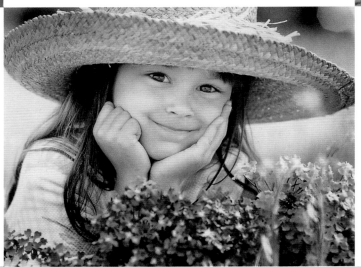
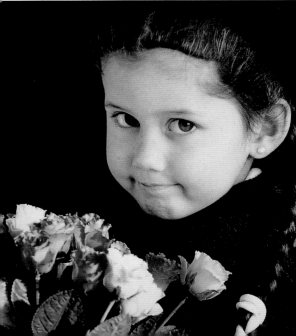
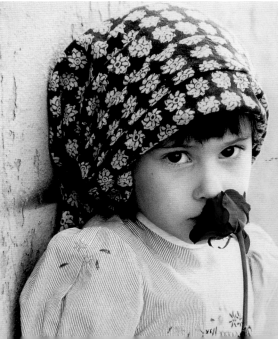

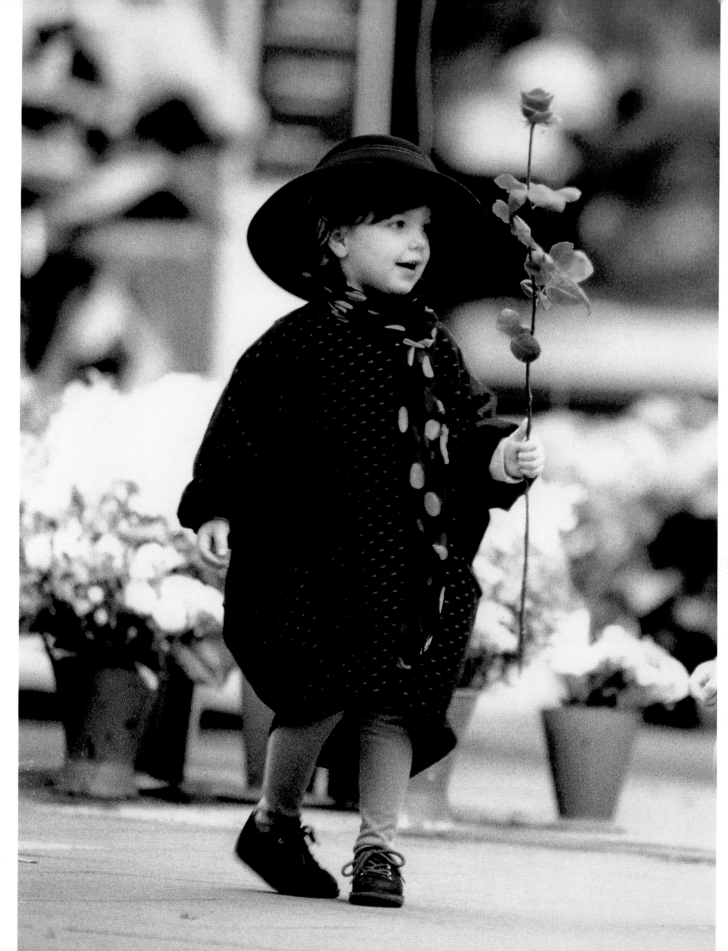

*Ladies
in
waiting*

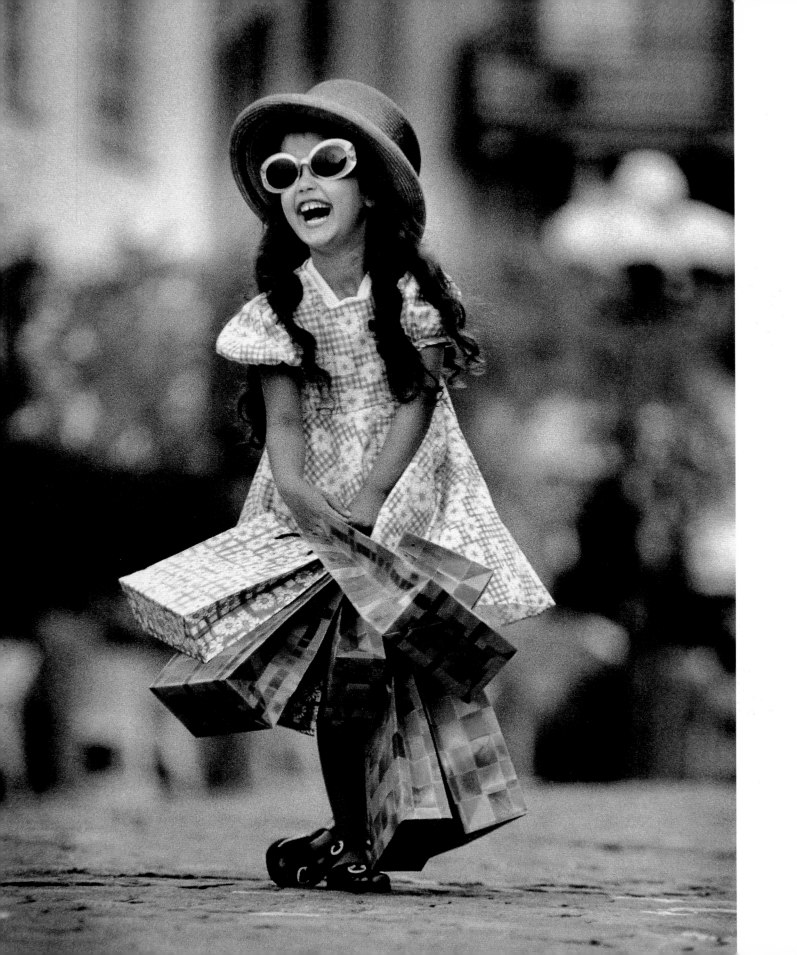

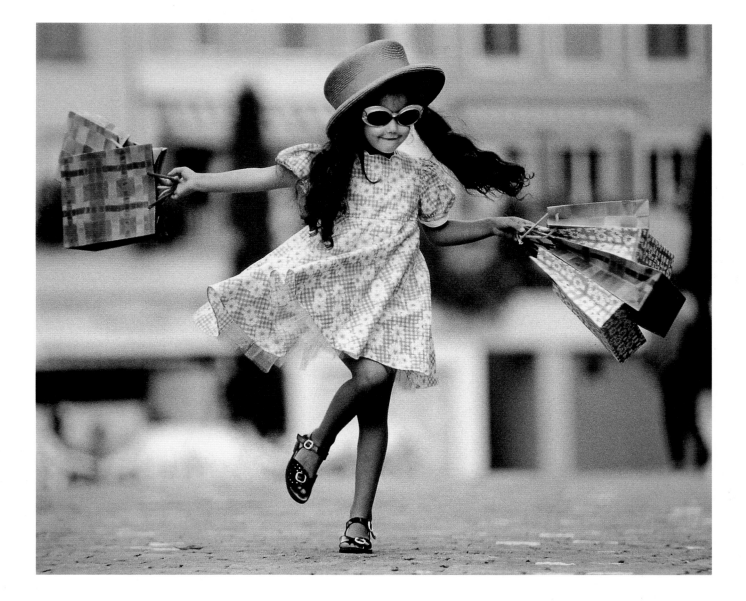

"I am constantly surprised by everything. In this world that is the only way to be." —Ludwig Bemelmans

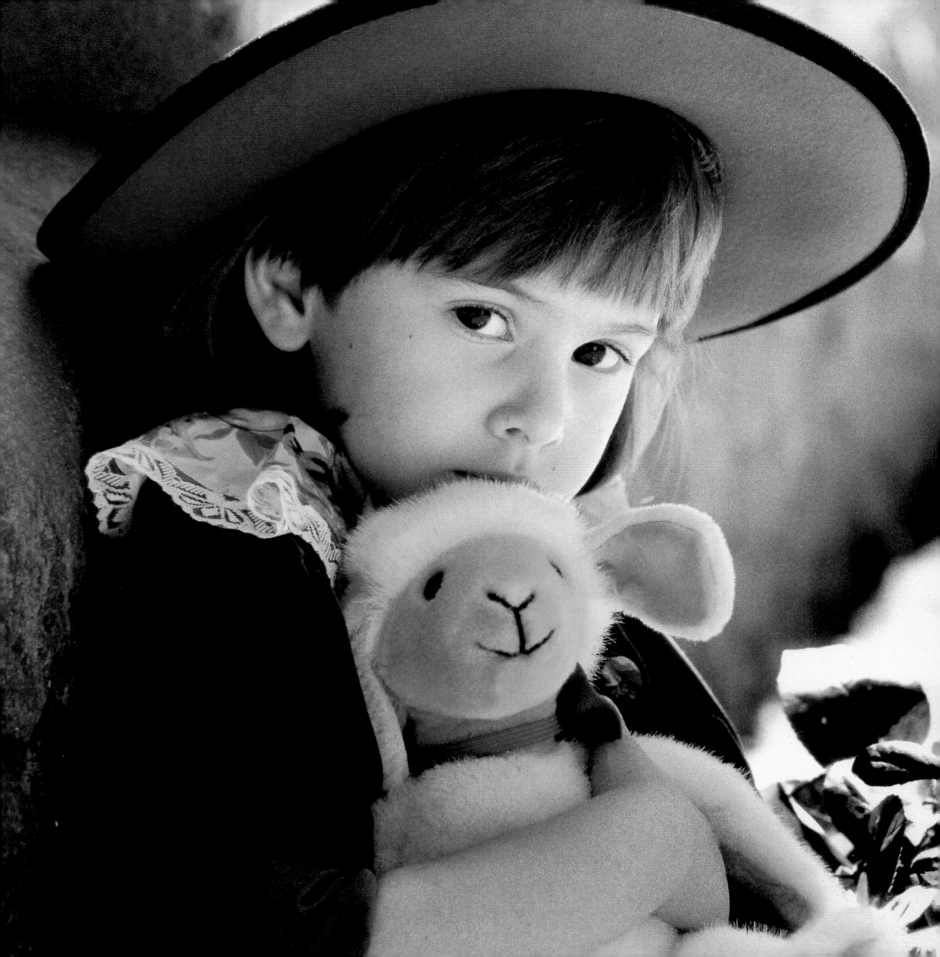

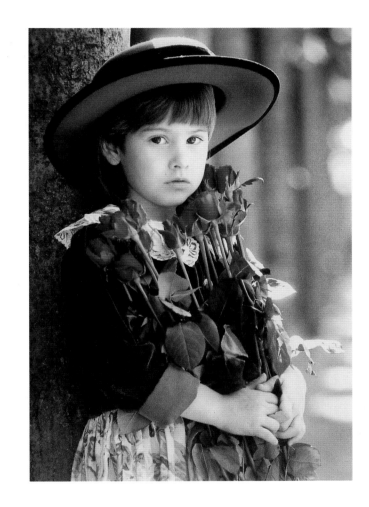

Deep in thought

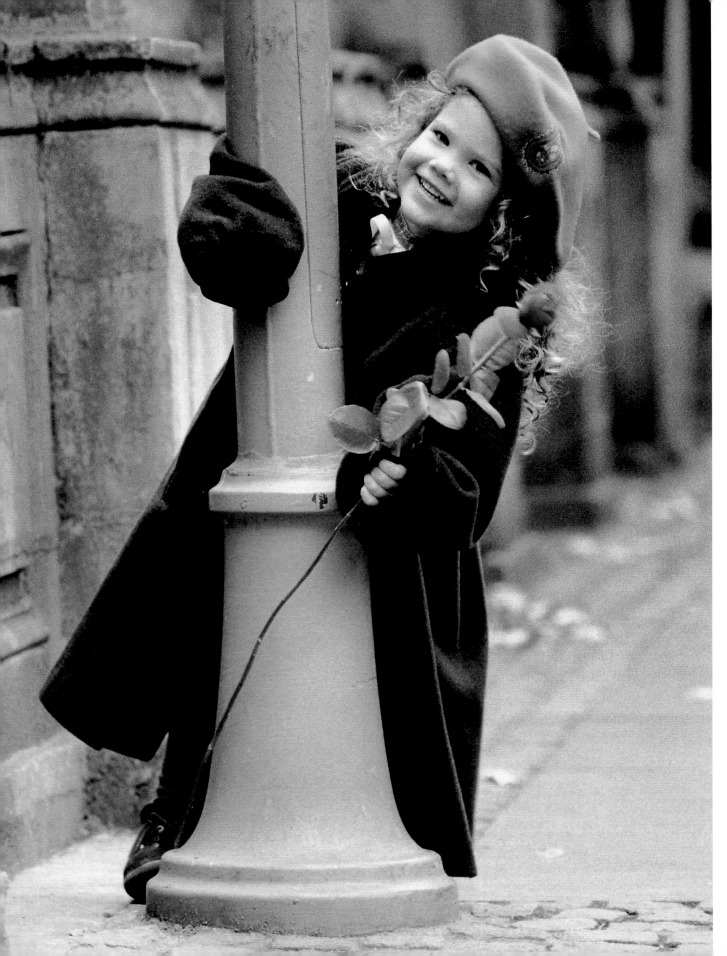

Elfin damsels

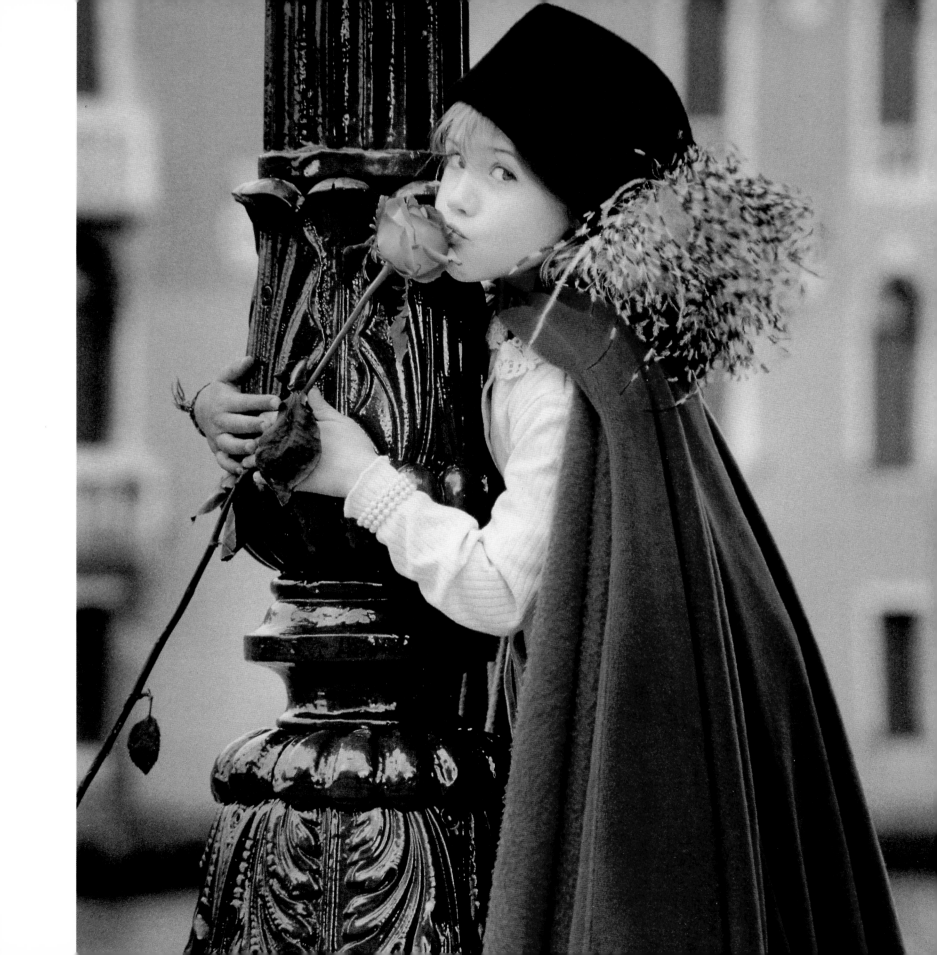

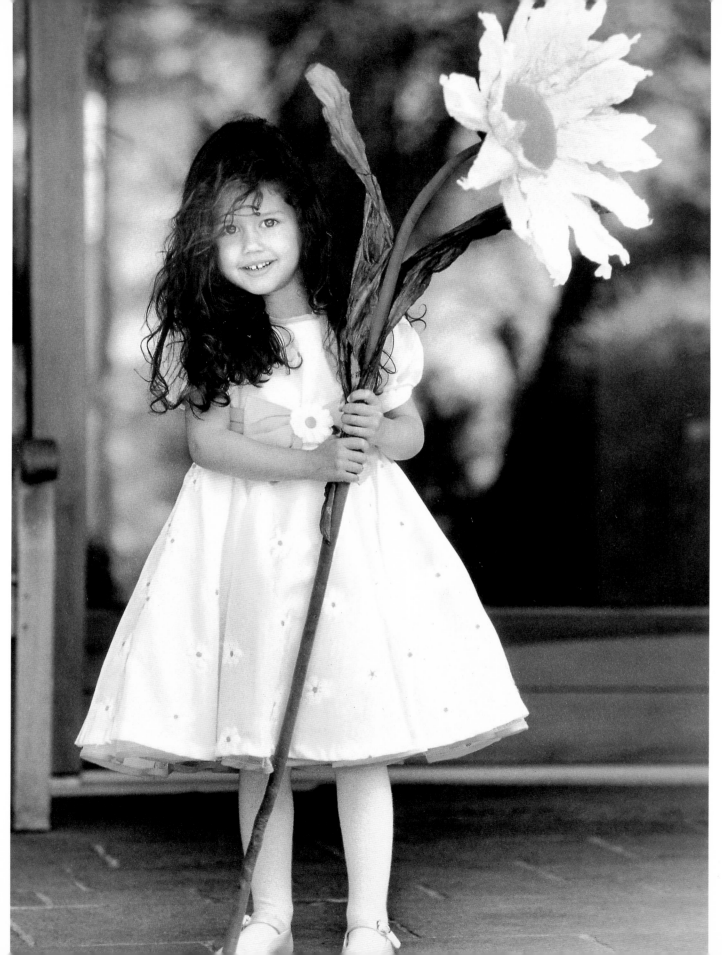

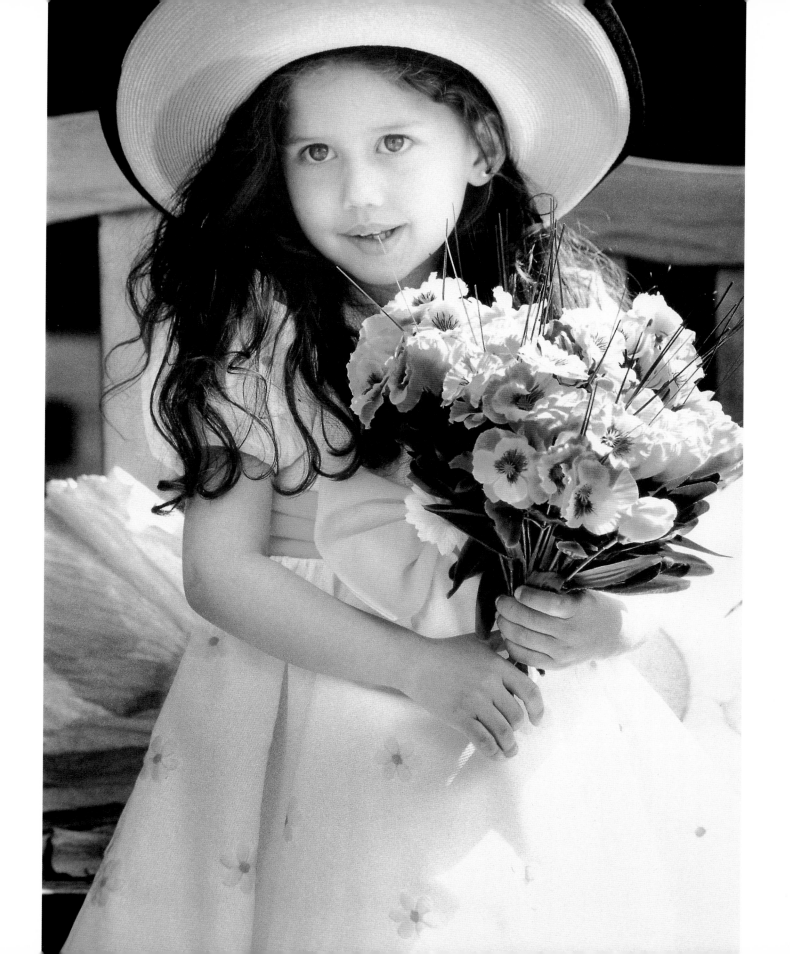

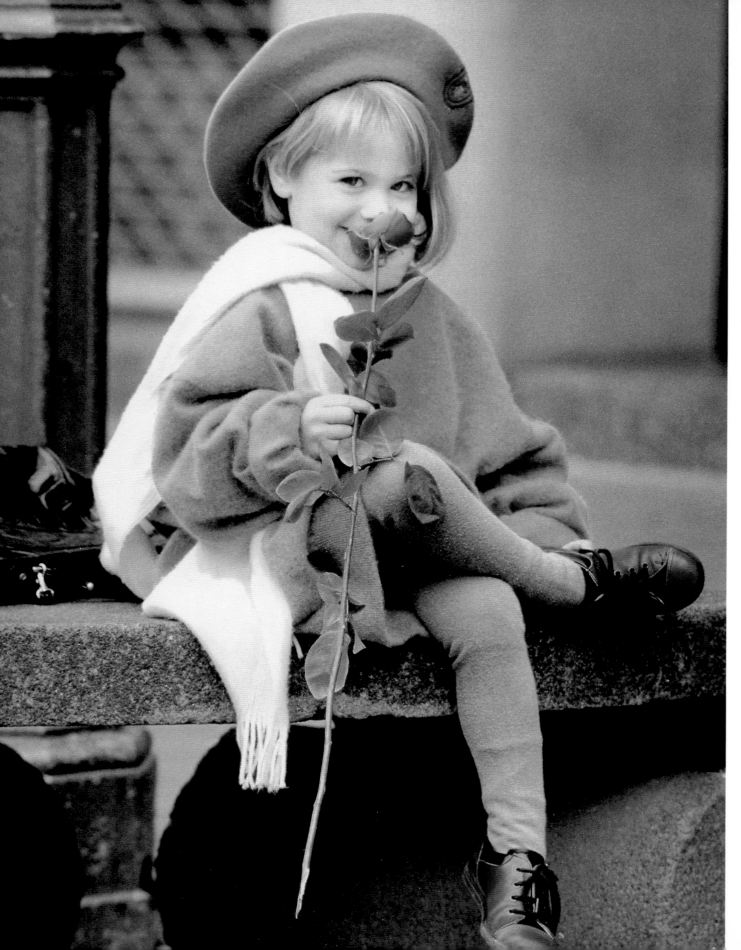

Sitting pretty

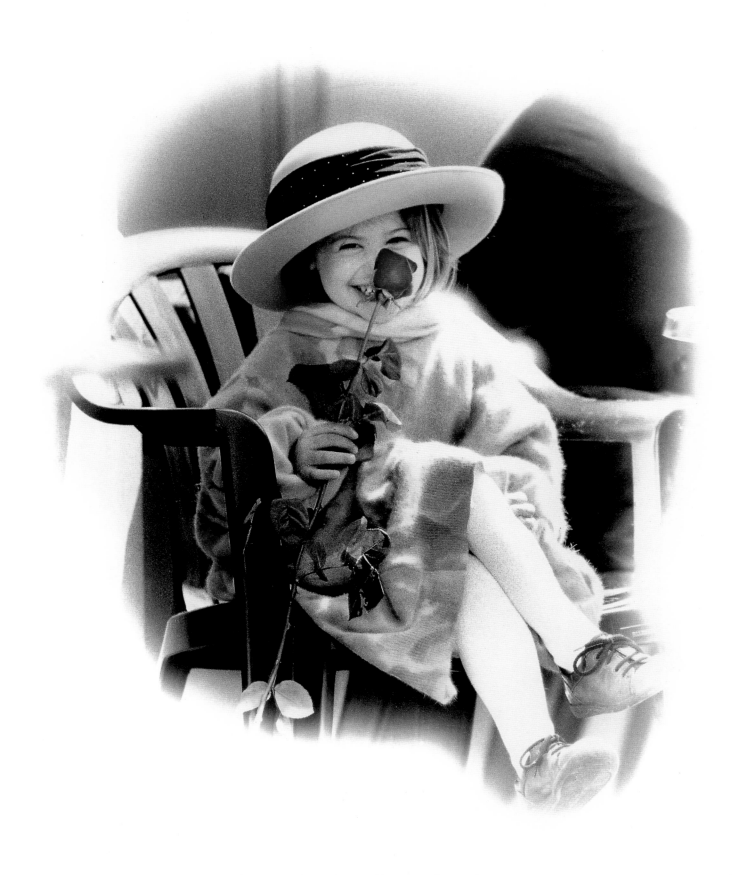

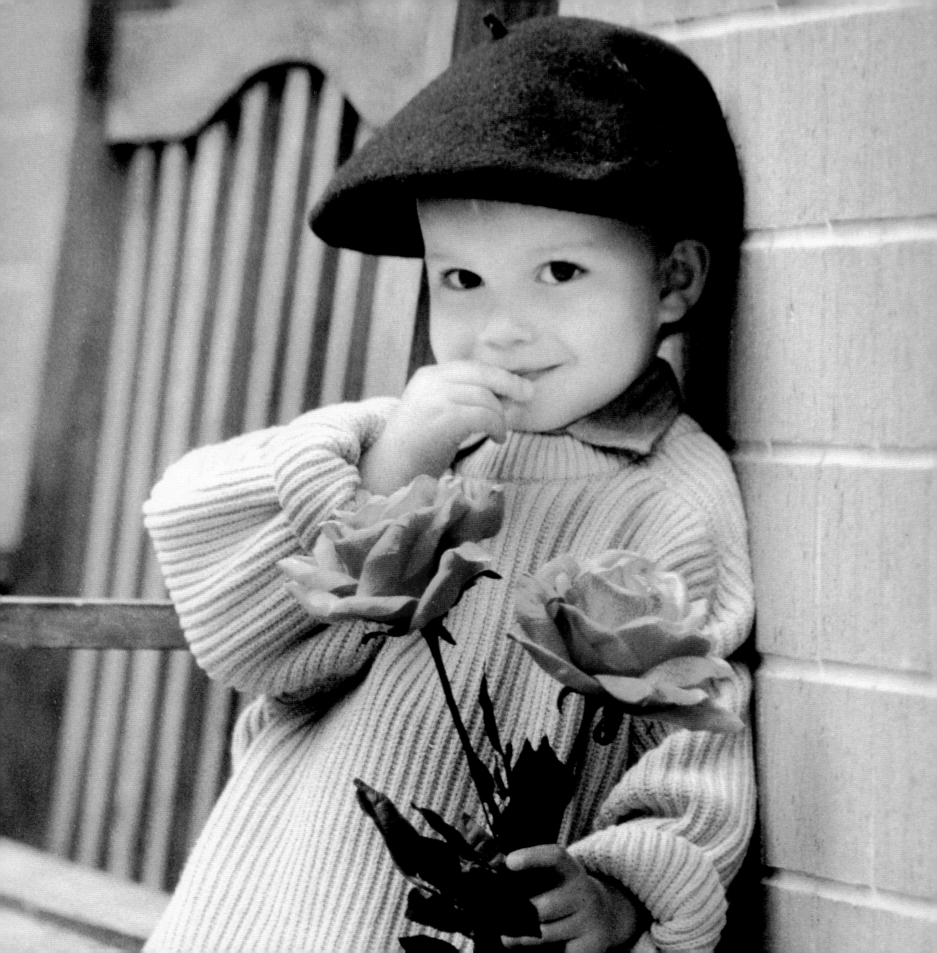

LITTLE BOYS

Essay by Susan Cheever

Little boys live in the enchanted land of in-between. They are big and little, bunny cuddly and lion wild, fearless in playground battles as they strut from slide to swings, but frightened of the monsters who live in the darkness under the bunk bed. They are too silly to sit still for a haircut, but as serious as King Solomon about the rules of a soccer game. Their favorite game is playing at being men. My son likes to shave his smooth cheeks—with a blunt kitchen knife. "Please, I'm working!" he says when I interrupt his games of small soldiers. He loves to get mail addressed to him.

In the morning, my son can explain as persuasively as any grown-up defense lawyer why he shouldn't have to go to school. He already knows what they are teaching that day. The third grade educational system is too rigid for real learning. He's sick. Then in the doctor's office he's a baby again when the pediatrician suggests a shot.

Little boys love anything to build and anything with a motor and anything that makes a lot of noise. A bunch of flowers or a yo-yo trick makes them beam rows of pearly baby teeth. My son puts each tooth carefully under his pillow for the tooth fairy, and treasures the prize she leaves behind. "Are you the tooth fairy?" he asked me last year. "What do you think?" I said, but I couldn't help smiling. "You *are!*" he was delighted to have guessed a grown-up secret. Then he understood what he had lost and

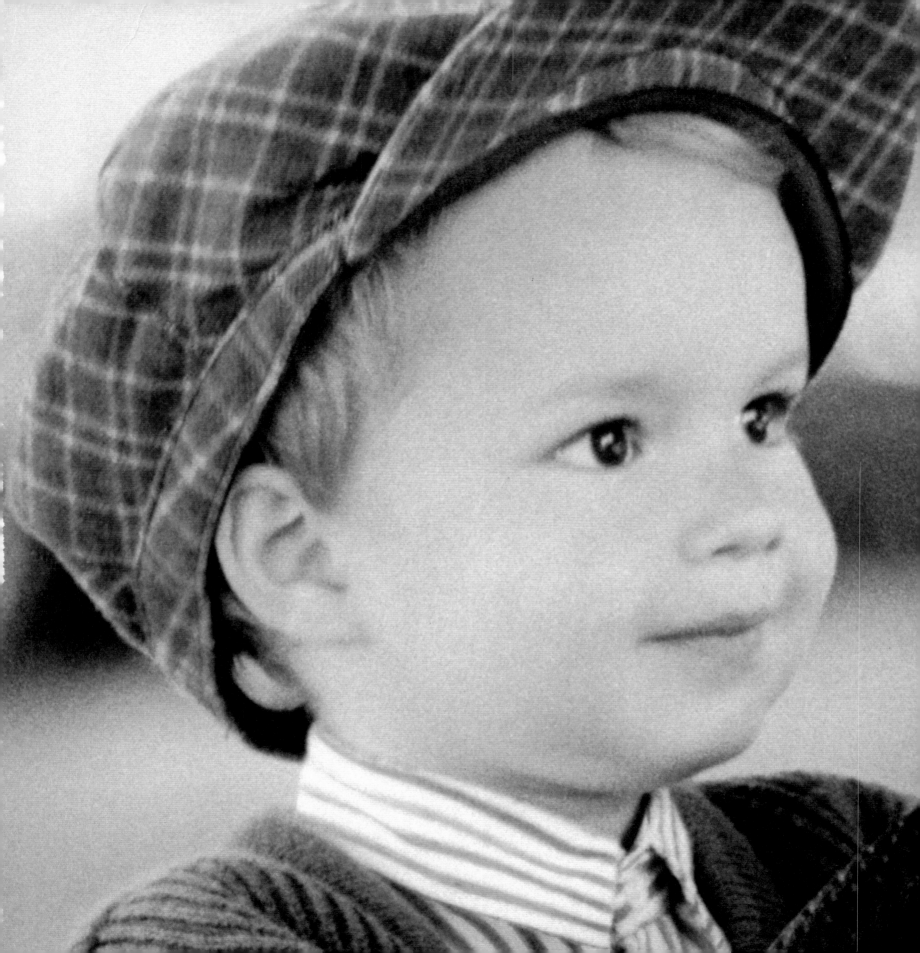

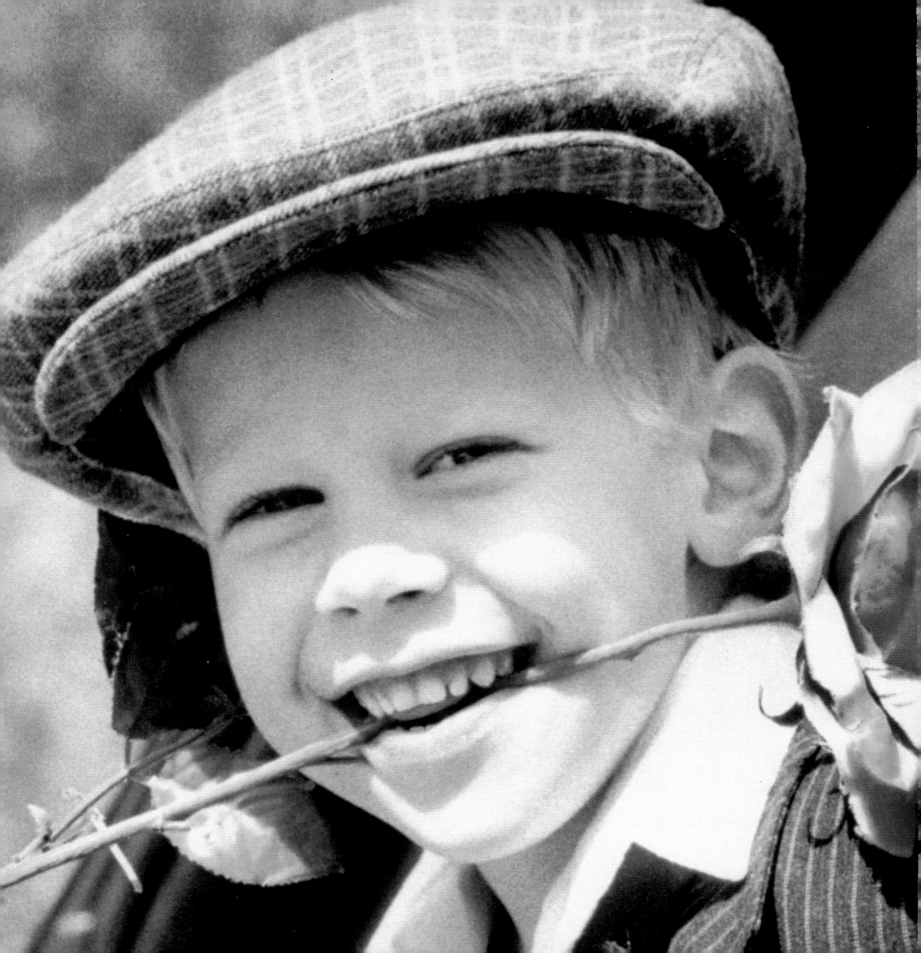

changed his mind. "No, you're not," he said, "or else where are all the teeth?" I didn't answer. Now he writes a note for the tooth fairy asking her not to take the tooth when she leaves the dollar.

At five, little boys are tricycle-riding toughs, but still burst into sobs when they skin a knee in a four-trike pileup. They crow with pleasure at three scoops of ice cream in a cone or a visiting kitten. They sleep with their teddy bears. They love caps, baseball caps worn backward, oversized caps that hide everything but a smile. They love all animals, from puppy dogs to lizards that slither away in the summer grass. Little boys are so small that they sometimes look like a grin on legs, but they're big enough to inspire poetry. "Oh glorious to be a human boy / Oh running stream of sparkling joy / To be a soaring human boy," wrote Charles Dickens. Cupid is a little boy, a naughty boy whose antics drive us all crazy, crazy with love.

When my little boy is afraid of the dark he jumps into my arms and cuddles next to me. He gives off a feeling I call "the sweetness" because there is nothing else as sweet on earth. I love the way his neck smells and the way the hair grows in a cowlick at the top of his head. The next day, he'll spend hours waiting with a net trying to catch a frog, and laugh happily when the frog gets away. Last summer, we caught a frog in my mother's pond. At the end of the afternoon, a snake darted out of the wall and struck the frog. My little boy screamed. My daughter and I skewered the snake with a garden pole and saved the frog.

As soon as he could write, my son made a sign for his door: NO GIRLS ALLOWED, it

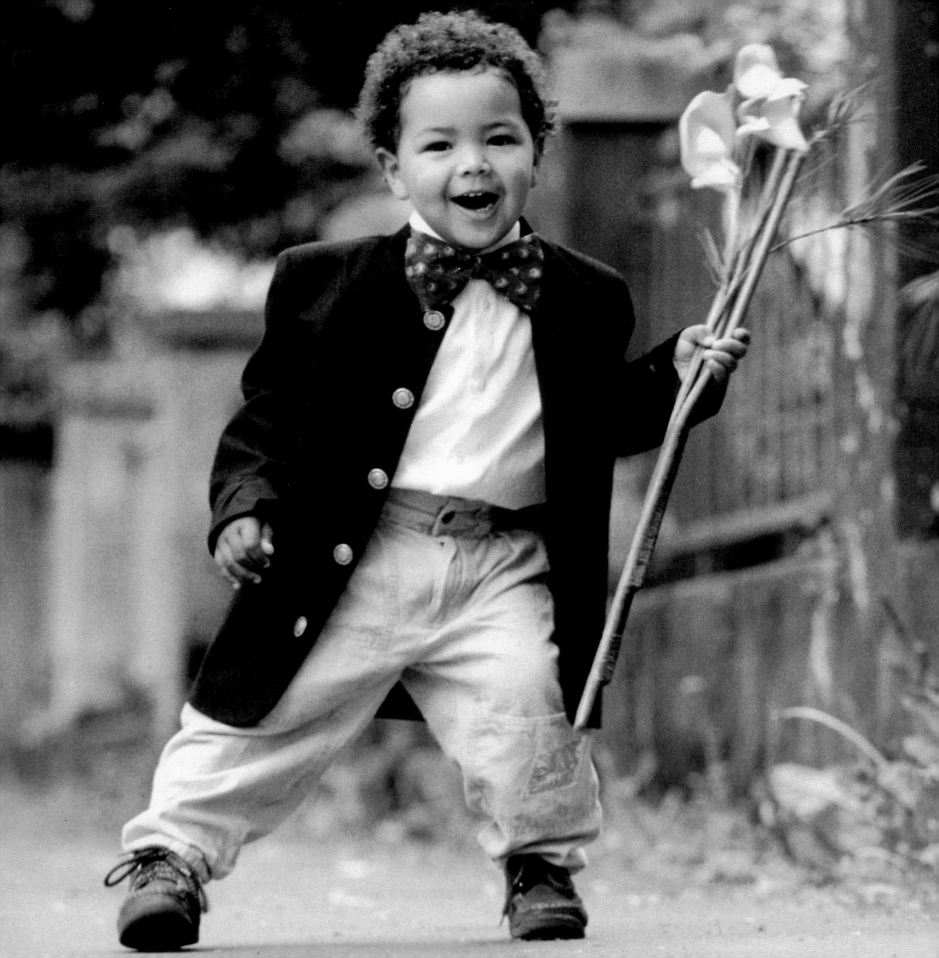

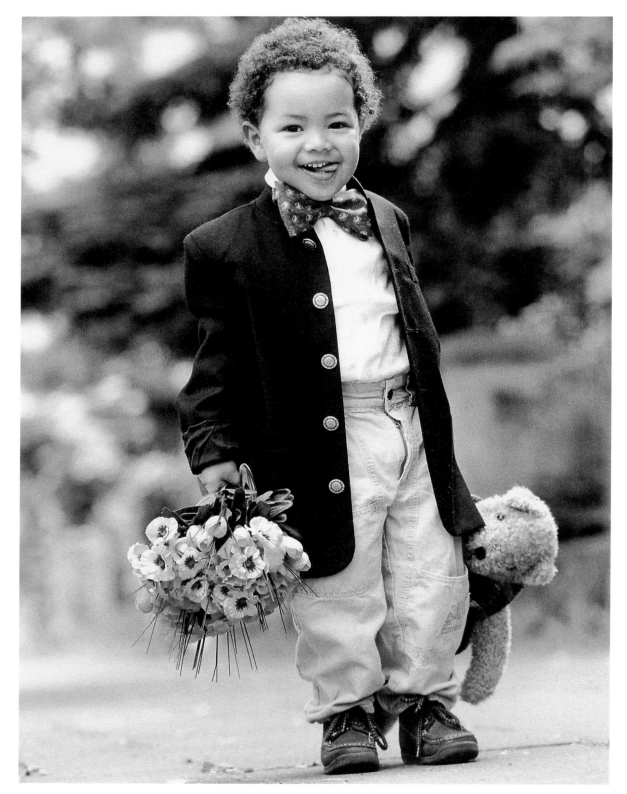

Prince
Charming

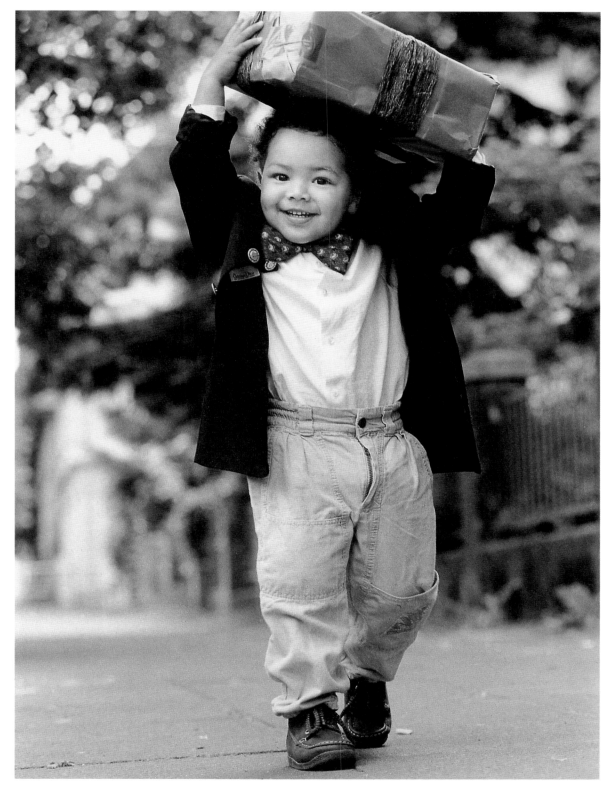

King of
Hearts

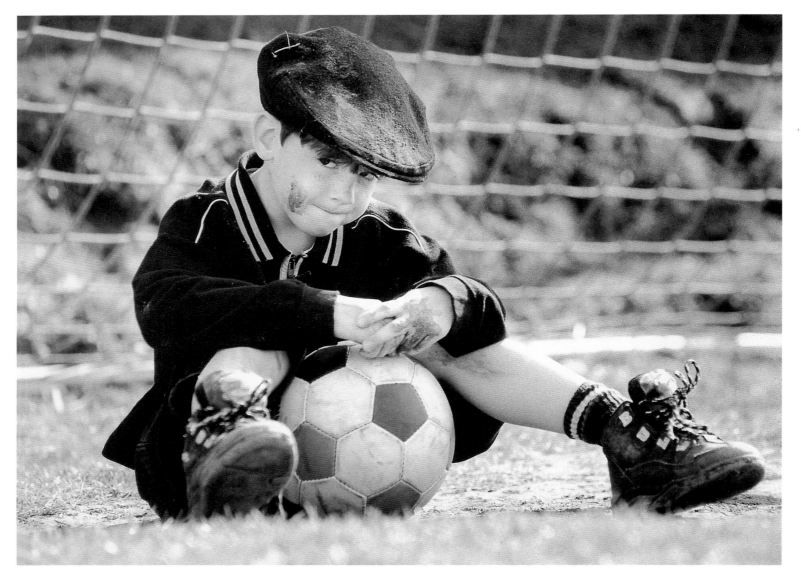

Finding just the right key . . .

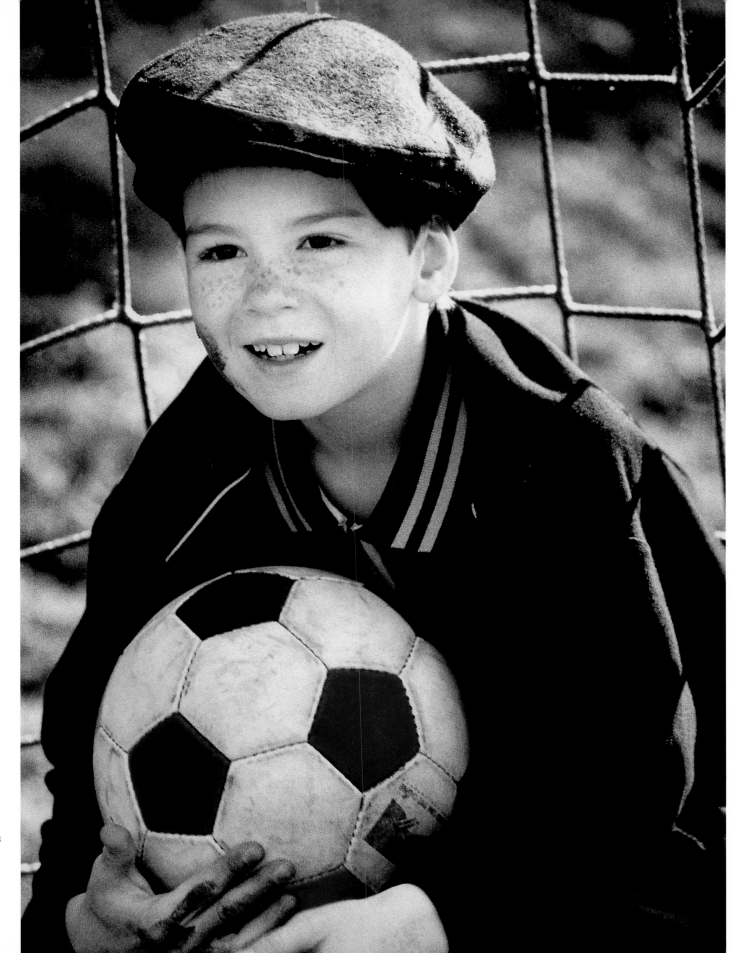

. . . to
a child's
heart

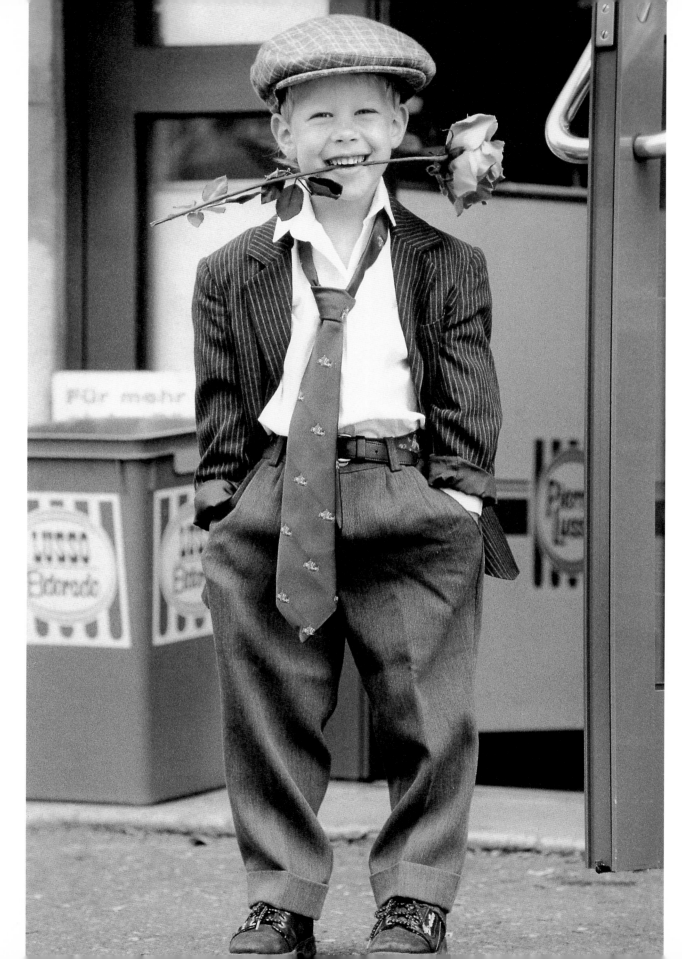

"The child is father of the man."
—William Wordsworth

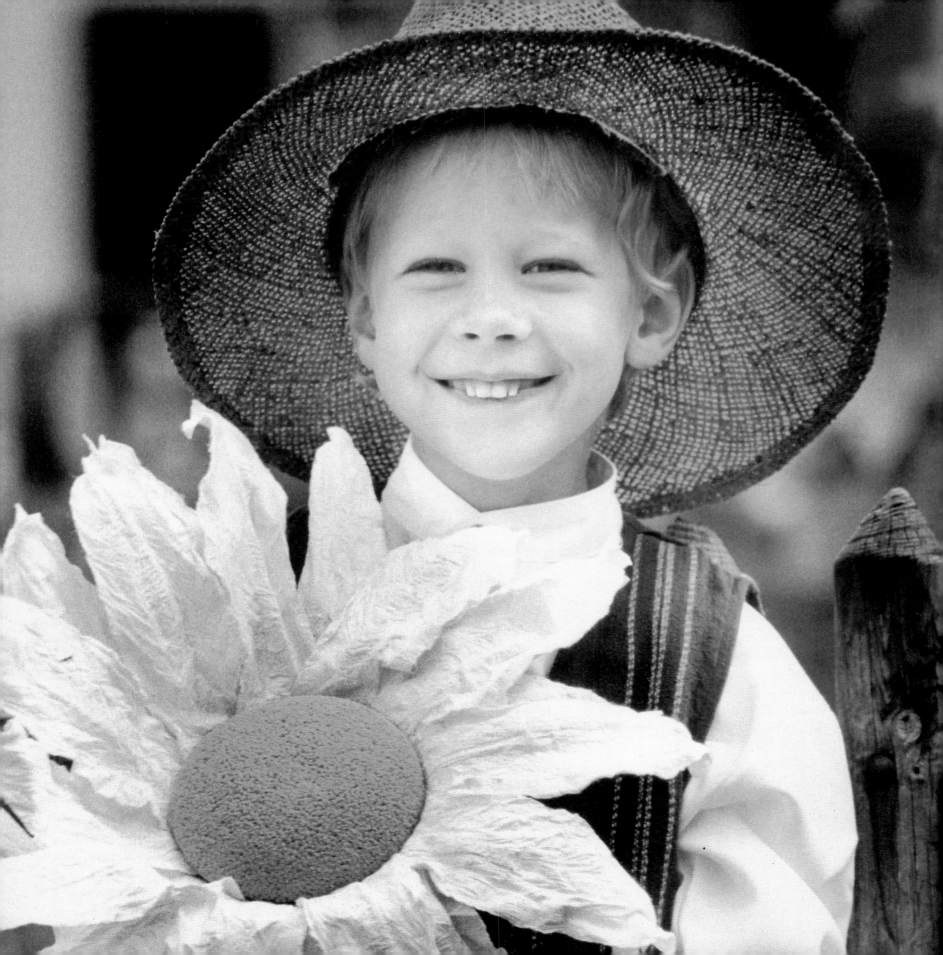

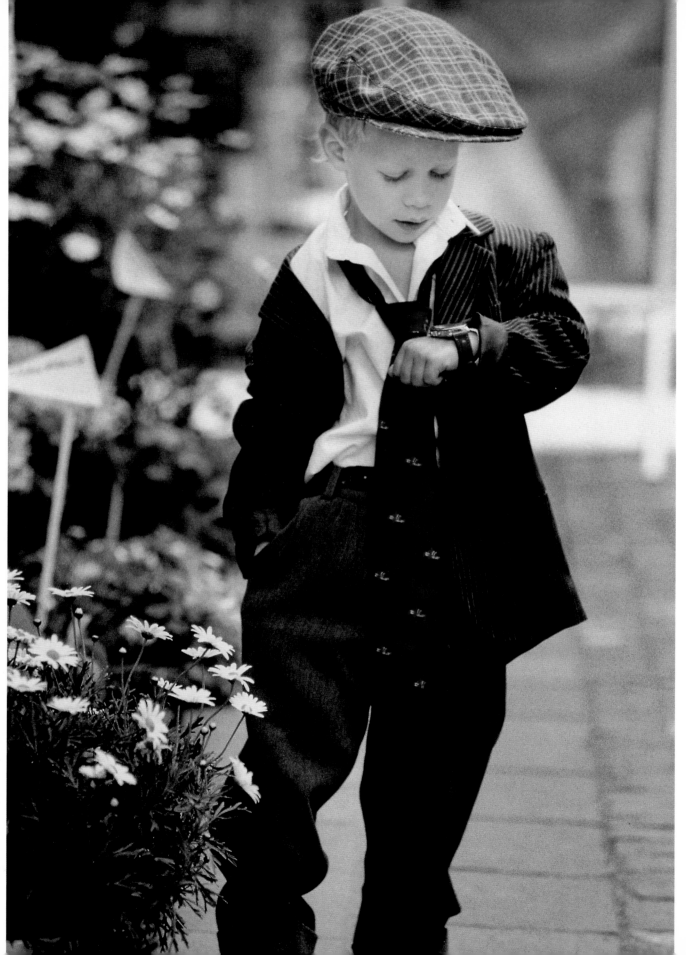

Manly
gesture

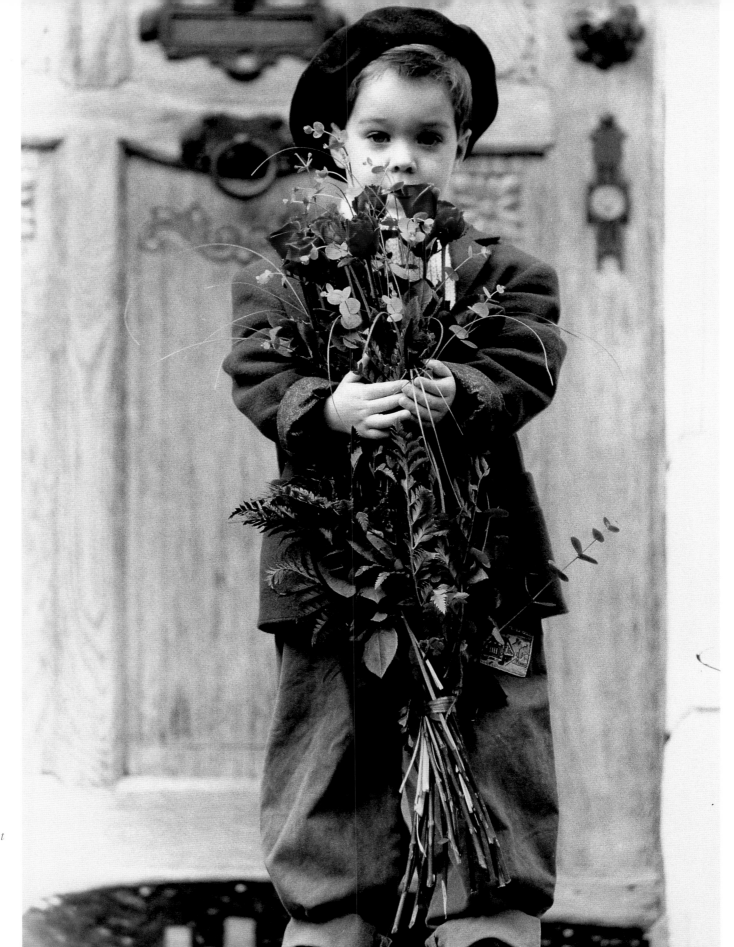

Important date

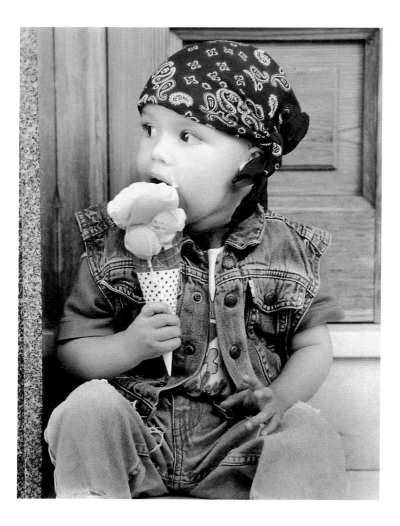

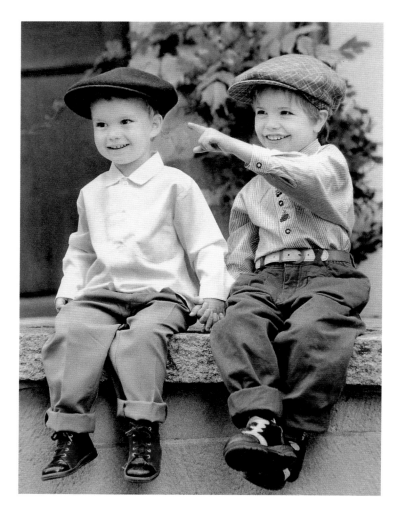

"What fantastic creatures boys are!" —E.B. White

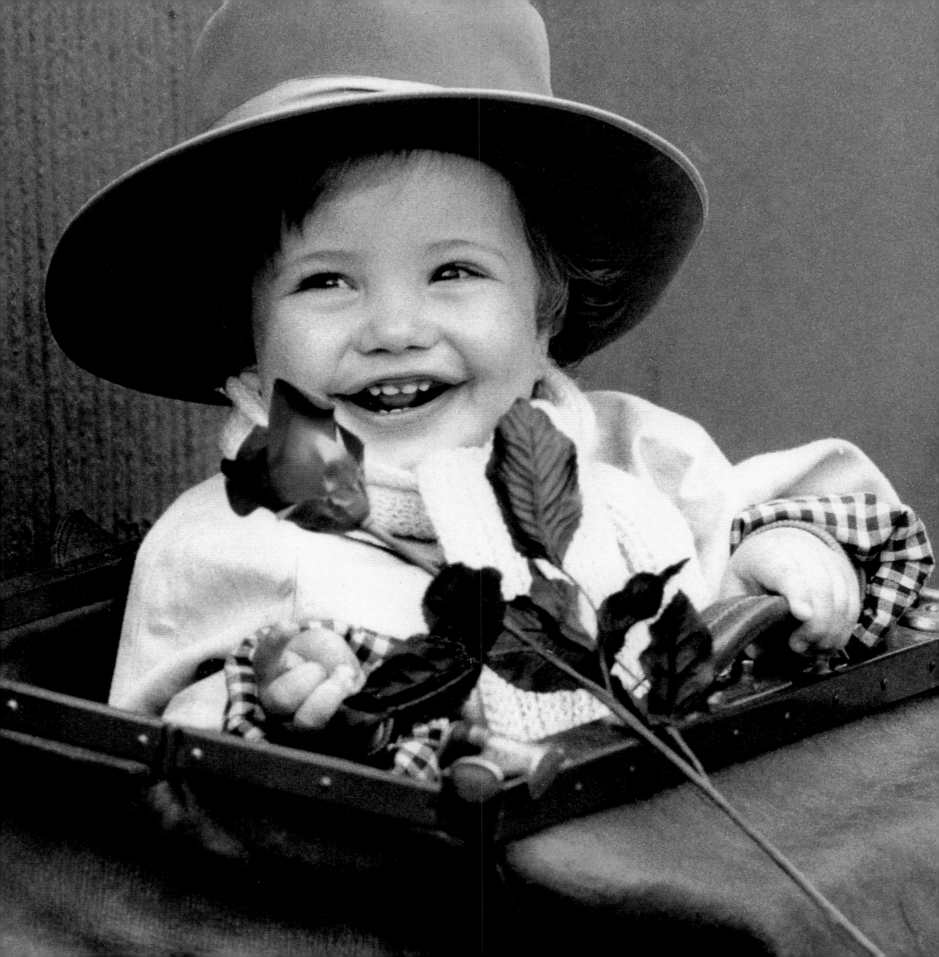

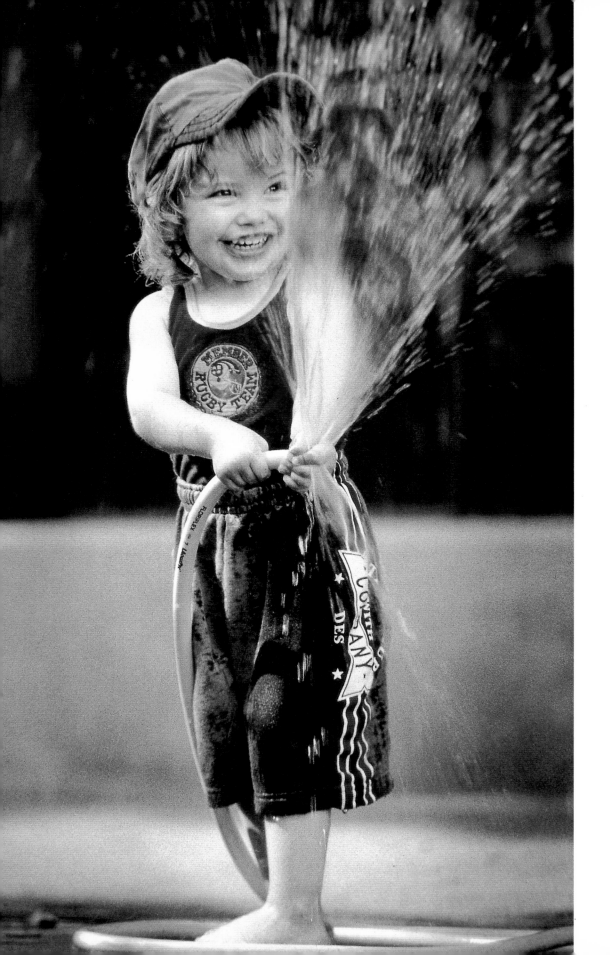

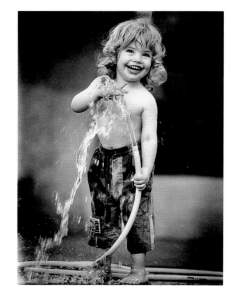

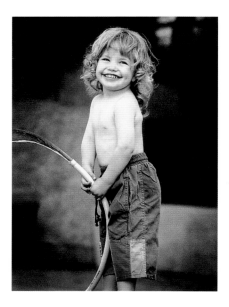

Delight in simple things

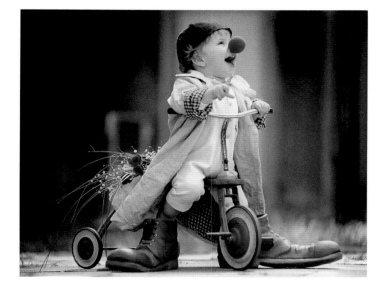

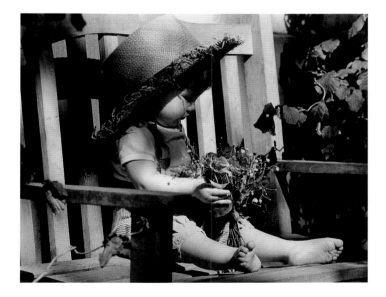

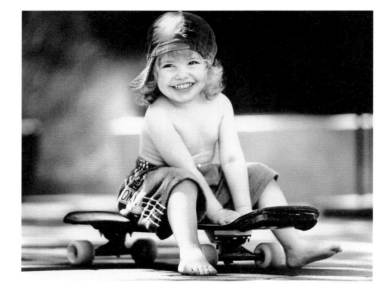

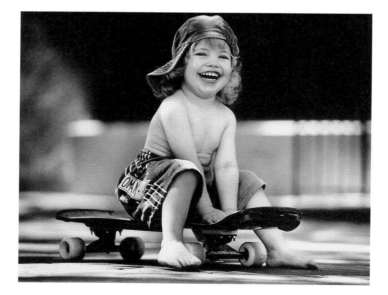

Free spirit